WATERCOLOR CLASS

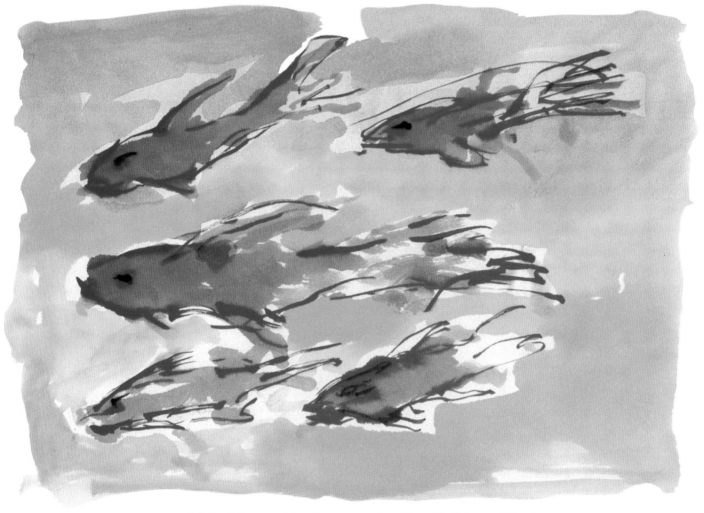

Michael Crespo, *Schooling*, watercolor, 8" × 11" (20 cm × 28 cm)

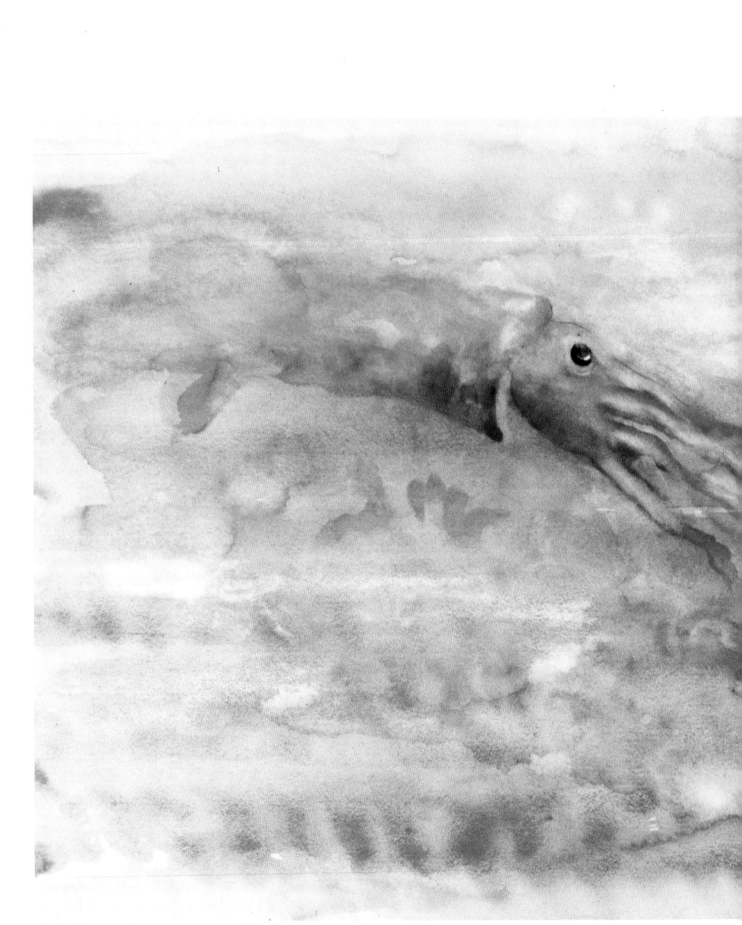

Michael Crespo, *Murmur,* watercolor, 22" × 30" (55.8 cm × 76.2 cm)

WATERCOLOR CLASS

MICHAEL CRESPO

WATSON-GUPTILL PUBLICATIONS / NEW YORK

Watercolor Class was originally published as two separate hardcover titles: *Watercolor Day by Day* (Watson-Guptill, 1987) and *Experiments in Watercolor* (Watson-Guptill, 1988).

Copyright © by Michael Crespo

First published in 1994 in New York by Watson-Guptill Publications, a division of BPI Communications, Inc., 1515 Broadway, New York, N.Y. 10036

Library of Congress Cataloging-in-Publication Data
Crespo, Michael, 1947-
 Watercolor class / Michael Crespo.
 p. cm.
 Includes index.
 ISBN 0-8230-5659-7
 1. Transparent watercolor painting—Technique. I. Title.
ND2430.C74 1994
751.42'2—dc20 93-45025
 CIP

Manufactured in Singapore

1 2 3 4 5 6 7 8 9 / 02 01 00 99 98 97 96 95 94

I thank all the artists and students
who allowed me to reproduce, and dissect, their fine paintings.

I thank Mary Suffudy
for her unending confidence, and another opportunity.

I thank Marian Appellof
for guiding the project to such a splendid conclusion.

I thank Clare and Pablo, my children,
for their constant, powerful, loving intervention in my life.

I dedicate this book to Libby,
whom I adore.

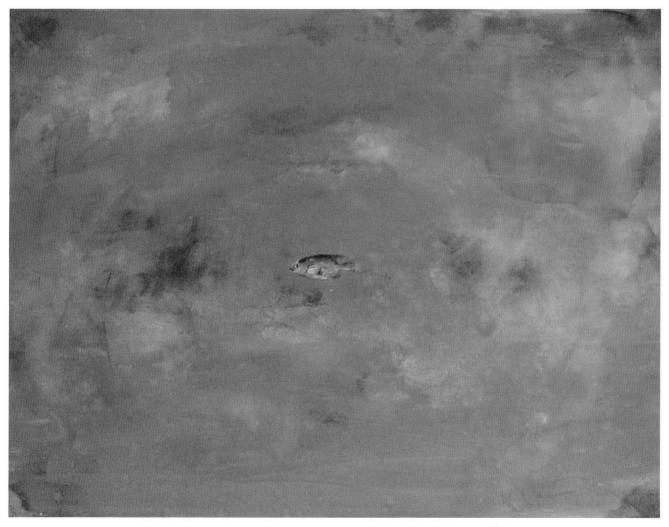

Michael Crespo, *Loss of Grace,* watercolor, 22" × 30" (55.9 cm × 76.2 cm)

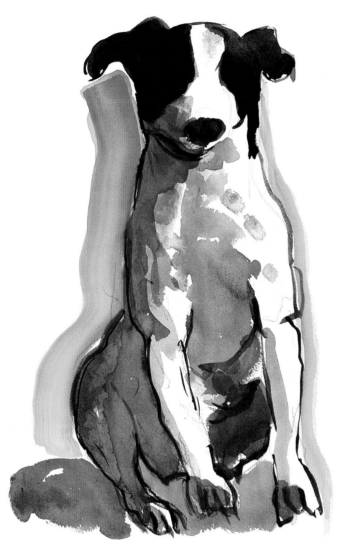

Michael Crespo, *Queenie Staring*, watercolor, 15" × 10" (38.1 cm × 25.4 cm)

CONTENTS

INTRODUCTION

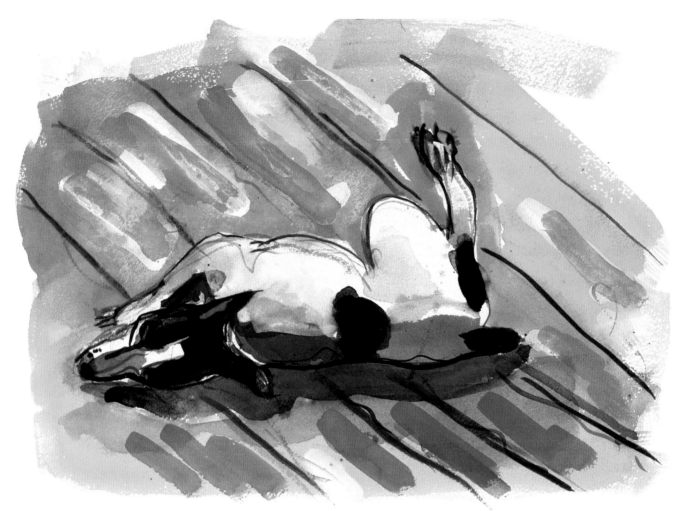

Michael Crespo, *Queenie Rolling on the Porch*, watercolor, 11" × 15" (27.9 cm × 38.1 cm)

Watercolor Class is based on two courses I designed and teach at Louisiana State University. Part 1, "First Semester," is an introduction to transparent watercolor that begins with a review of essential materials and working tips and follows with twenty exercises presented in a day-by-day format, as if you were attending my classes. Technique, always touted as the great stumbling block of the medium, is filtered painlessly, yet thoroughly, through the assignments. Where applicable, I have suggested specific setups, as these can be as much of a design problem as the paintings themselves. You will note that most of the motifs are still lifes and landscapes, as I believe that these subjects

provide a greater variety of shape, color, and scale than the human figure does. All the exercises, however, can be adapted if you have access to a model.

Part 2, "Second Semester," consists of twenty more daily lessons and assignments to encourage and enlighten you on your search for the balance of elements that best explains your most personal relationship with nature—nature meaning *all* that surrounds you, both seen and unseen.

The lessons included in this book are about the ebb and flow of technique and idea as interchanging motivations to paint. They are illustrated with my own responses and those of other artists I respect. But the most significant paintings

here are those of the students, who stir up such excitement with their intelligent, uninhibited explorations.

Whatever the level of your experience, try to clear your mind and hand of all previous practices and expectations. Approach Day 1 with the enthusiasm and vigor of learning to crawl before walking. Painting is a cumulative experience, and although you may not be as comfortable with some of my assignments as you are with others, work through them all in the sequence I have designed. Each lesson will progressively improve your skills and knowledge so that you can make the most informed choices regarding what you carry with you to the next painting. As you paint, remember to maintain the spontaneous, expanding role of student, keeping your eyes, mind, and heart always open to what you're making.

Do well and enjoy yourself.

MATERIALS

Before you begin, you obviously need to invest in certain materials. In addition to water, a brush, some colors, and paper are essential. Everything else can, with a bit of ingenuity, be fashioned from items you probably already have on hand.

My aim here is to suggest the most economical combination of materials possible, without sacrificing quality. It's true that pigments and brushes appear to be expensive, but consider how long these items last. Watercolor pigments are consumed at a much slower rate than oil or acrylic colors. And a good brush, properly cared for, can last for years.

Within the art-supply business, there is fierce competition, which helps to keep prices reasonable—provided you make the effort to shop and compare. Usually the best prices are found in the large mail-order catalogs. The main problem—unless you live near one of these establishments—is that you have to wait two or three weeks for shipment. If you want to get started right away, survey your local art-supply stores and look for the best prices. You may be surprised at how much prices can vary from neighborhood to neighborhood.

The materials you use will make a difference in your work, although not necessarily a difference in its quality. One painter may do exciting work with a stick, while another may employ the finest red sable brushes. Imagine beginning to paint with all the materials on the market at your disposal. You could simply edit and reedit your selection until only those best suited to your hand and expression were left. Obviously that's a fantasy. At best we begin to collect the tools we can afford, decide whether they suit our demands, stow away the undesirables, lovingly care for the chosen, and purchase new wares to begin the cycle again. It's really not such a bad life. Besides, there's always the hope that a major turning point will arrive with each new brush, color, or new sheet of paper. And sometimes it really does come.

On page 14 you will find a list of basic materials needed to complete the lessons in this book. If you can afford more, buy more. If you can't, don't worry—you'll paint to your potential with these.

Brushes. In one art-supply catalog I counted 123 different watercolor brushes. It's certainly not a barren market. I suppose one could cradle an ambition to own all 123, but of the 40 or so brushes that I own, I actually use only three or four with any frequency. In the end there's only one that does the majority of the work.

When purchasing a brush, first make sure it's suitable for watercolor. Avoid the hog-bristle brushes used for oil painting or nylon brushes designed for use with acrylics. All too often shop clerks unfamiliar with their merchandise sell these brushes for watercolor use. Although they can be used for certain marks, they're not good for general application. They are stiff and nonabsorbent compared with the soft, synthetic-sable watercolor brushes.

The most popular brushes are rounds and flats, which come in a variety of hairs, including red sable, squirrel, camel, sabeline (a mixture of hairs), ox, and different synthetic bristles. Sizes usually range from a tiny 000 to 14, although, unfortunately, these designations may vary from maker to maker. There are also several other styles of brushes; most commonly used are bamboo, hake, script, watercolor fan, oval wash, and large utility wash brushes.

The finest brushes made are those of kolinsky hair. I consider Winsor & Newton's Series 7 brushes to be unequaled. I own some small ones, but not the cherished no. 12, which is very

The no. 12 round is the brush I have in my hand 80 percent of the time and is by far the most easily manipulated.

A flat is great for broad strokes, applying large areas of color, and accurately pulling paint up to the outer edges of forms.

The bamboo is splendid for linear drawing and making shapes. When splayed it can produce wonderfully erratic textures.

The script brush functions almost solely as a line-maker.

The fan brush is used primarily for blending, but it also makes a good textural brush if you dab it.

The oval wash brush, thick with hair, can carry large amounts of color to the paper.

The large utility wash brush is essential to lay down a wash on a full sheet of paper.

At a certain point I had to completely ignore the fact that there was always another kind of brush to buy. I also gave up the idea that a new brush would revolutionize my stroke and solve my painting problems once and for all. While differences in size, shape, and type of hair do produce divergent marks, it becomes a major task keeping up with which brush does what—not to mention fumbling with twenty brushes in the course of one painting. In the end, the brushes you use are a highly individual decision. I've indicated the standard uses for some of the most common brushes, but their versatility should be explored with vigor.

expensive. I have used one and can vouch for its superiority. I do use a no. 12 kolinsky made for and sold by Utrecht Manufacturing Corporation. I'm perfectly content. It's a wonderful brush at one-third the cost. Yet even this alternative is not practical for the beginning student.

Enter the synthetic sable. Just about every manufacturer has a line of them. Although they do not absorb as much water as the natural sable, are usually not as well cut, and are in no way equal to the kolinsky, they are extremely affordable. Some experts shun them, but I find them a reasonable alternative. I even have a couple in my box I'm quite fond of. I recommend that my students purchase either Winsor & Newton's Series 239 or the Japanese-made Loew Cornell 7000. Both contain synthetic bristles, are highly versatile and durable, and are quite inexpensive.

In general look for a brush that is full with hair. Ask the clerk if you can wet the brush. (In most cases this will be allowed.) The brush is only as good as it is when wet. If it's a round, make sure the hairs taper to a fine point. The brush should also be somewhat resilient when pressed to a surface. Obviously, all this testing should not be wasted on a two-dollar brush. Essentially, you get what you pay for with watercolor supplies.

No matter which brush you purchase, its life span depends on how you care for it. Don't let it sit in water while you're painting, as the glue binding the hairs may erode. Clean it after each session using water only—no soap. Never carry

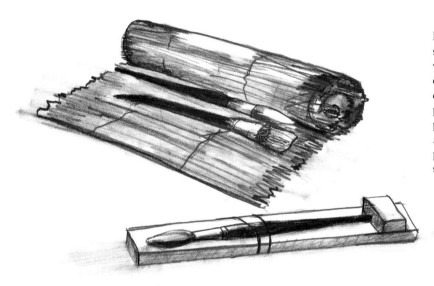

Brushes are usually protected well in the studio, as they sit up in crockery, porcelain vases, or tin cans. When you transport them outside to paint a landscape, however, the delicate and costly hair may be damaged. For protection, roll your brushes into a bamboo placemat and secure this with a rubber band. As I have some storage available in my portable paintbox, I utilize the wooden support pictured here.

Sponges seem indispensable for the watercolorist. I'd be lost without the common 3 × 4-inch (8 × 10-cm) cellulose sponge, readily available in any supermarket. It is perfect for blotting excess paint and water off your brush; it also makes a wonderful "brush" for applying texture and lifting paint. Moreover, a sponge like this is handy for cleaning palettes and for any accidental spills.

The other sponge shown here is a natural sponge, sold specifically for use in watercolor or applying makeup. It is generally reserved for applying or lifting paint.

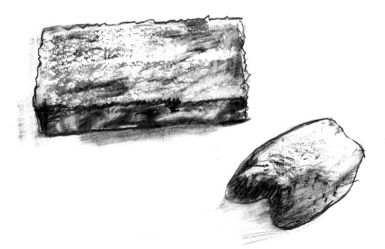

or store your brush in a position in which the hairs could be bent and smashed. Try a bamboo placemat as a brush carrier—just roll your brushes up in it for protection. Or—to carry brushes in a paintbox—attach each brush with rubber bands to a piece of lattice wood somewhat longer than the brush.

Should a brush accidentally dry in a bent position, wet it; then, using mild soap as a stiffening agent, reshape it and let it dry. Wash the soap out, and the brush should be in its original condition.

Use your watercolor brushes only with watercolor pigments. Ink and other media can drastically alter and sometimes destroy their fineness.

Paint. As a child, you probably played with watercolors, perhaps using the little round cakes glued to the back of a coloring book. Now, of course, you'll want to go up a bit in quality. Some excellent brands of cake paints are available. My wife often carries a small box of assorted pans of color when we travel abroad. They're compact and serve the situation well. I

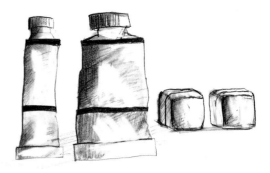

Shown here are 5- and 14-milliliter tubes of paint, as well as cakes of dry paint.

do not, however, recommend them for this course; instead, I ask you to purchase paints in tube form.

With tube colors, you can follow two different practices. I usually squirt half of the paint from a 14-milliliter tube onto my palette and allow it to dry. This I use in my daily work, activating it again and again with a spray of water before working. In this way I can have all my colors in "cakelike" form on my palette at all times, plus a liquid reserve in the tubes. This reserve comes in

Basic Palette

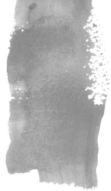

Burnt Sienna Alizarin Crimson Cadmium Red Medium Cadmium Orange Cadmium Yellow Medium

Ivory Black Sepia Phthalo Blue Ultramarine Blue Phthalo Green

handy when I need to mix a wash or large amount of a particular color.

There are many fine brands of paint on the market: Winsor & Newton, LeFranc & Bourgeois, Rowney, Grumbacher, Holbein, and Liquitex, to name a few. Most companies offer two series, which differ greatly in price: the more expensive professional line and the economical student grade. I don't really think that your paintings will fade in a month if you buy the least expensive. The permanence ratings are usually slightly lower, but my twenty-five-year-old student works still look good, and I definitely painted them with the cheaper paints. Let your budget be your guide. Remember that you use very little pigment in watercolor painting, so your initial investment will carry you through quite a number of paintings. You won't be racing through tubes of paint as you might in an oil painting class. I've still not used up some colors I bought three years ago.

Paper. If any material can radically alter the look of a painting, it's the paper. Many fine papers, both domestic and imported, are available. Some of the great papers, well worth trying, are d'Arches, Fabriano, Whatman, and Saunders.

In the beginning, explore as many different papers as you can. During the course of this book, you might paint on twenty or so different papers. You might join with friends to buy a sheet of every paper you can find; then divide each sheet into the number of contributors so everyone has a sample to play with.

Paper can be purchased in blocks, rolls, or loose sheets. Blocks, which come in various sizes, are tablets of paper glued together at the edges. They are quite popular with students because they are compact and easy to transport. They also have a sturdy backing, which makes them ideal when you work outside, in the landscape. They are usually, however, a bit more expensive than buying by the sheet, and the choice of weight and surface is limited. I recommend that you buy paper in loose sheets so you can experiment with different sizes and surfaces.

Watercolor paper comes in several standard sizes. Imperial (22 × 30 inches, 56 × 76 cm) is the most popular size sold. Other designations are Royal (19 × 24 inches, 48 × 61 cm), Super Royal (19$\frac{1}{4}$ × 27 inches, 49 × 69 cm), Elephant (23 × 28 inches, 58 × 71 cm), and Antiquarian (31 × 53 inches, 79 × 135 cm). Rolls of paper may be useful to those wishing to work larger than the sizes offered in sheets. But, like watercolor blocks, rolls are limited in variety.

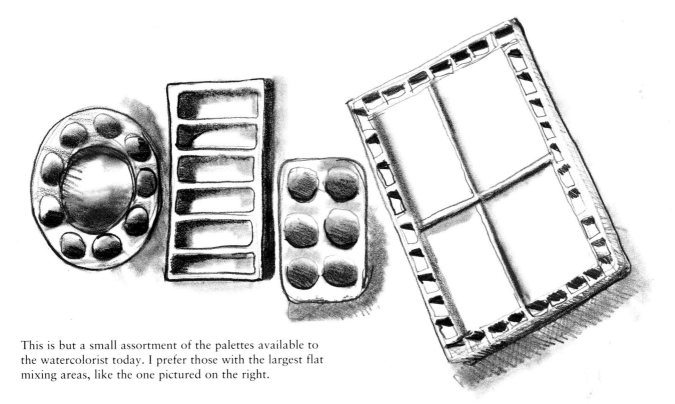

This is but a small assortment of the palettes available to the watercolorist today. I prefer those with the largest flat mixing areas, like the one pictured on the right.

BASIC SUPPLIES

Brushes
no. 12 round (natural or synthetic sable)
no. 3 script (natural or synthetic)
1-inch flat (natural or synthetic)

Pigments (in tubes)
Required palette:
alizarin crimson
cadmium red medium
cadmium orange
cadmium yellow medium
phthalocyanine green
phthalocyanine blue
ultramarine blue
burnt sienna
sepia
ivory black
Chinese white (not to be used until Day 19 of
"First Semester," as the use of this color trans-
forms transparent watercolor into opaque
gouache)

Optional palette
(for later explorations):

alizarin crimson	ultramarine blue
rose madder	cobalt blue
Winsor red	cerulean blue
Indian red	manganese blue
cadmium orange	violet
cadmium yellow medium	burnt sienna
lemon yellow	burnt umber
viridian	yellow ochre
phthalocyanine green	ivory black
chromium oxide green	

Paper
140-pound cold-pressed paper, either in loose
sheets or block form. Should you use a block, do
not purchase one smaller than 10 × 14 inches
(25 × 36 cm).

Additional tools
palette
2 jars or other containers for water (one for clean
 water to paint with; the other for cleaning
 brushes)
1 synthetic sponge (the small size sold in super-
 markets)
1 small sketchpad and drawing pencils
plenty of tissue

A student gave me one of these odd-looking containers, and I wouldn't be caught without it. The tub is divided into four separate water containers, so you have plenty of clean water while working on a painting. At the same time it takes up very little space on the painting table.

As already indicated, you can choose different weights of paper. The weight of a ream—500 sheets of paper—determines the weight classification. Watercolor paper should be in the range of 90 to 300 pounds. I would not recommend any paper lighter than 90 pounds (and strongly suggest that you use nothing less than the 140-pound weight); papers heavier than 300 pounds are practically wallboard. You may have guessed that prices rise with the weight.

Paper is also available in different textures. The standard is cold-pressed, or "not," paper, which has a moderately coarse texture. "Rough" paper, as the name implies, offers the coarsest texture; in contrast, hot-pressed paper has a smoother, less absorbent surface. These textures, however, vary some from maker to maker.

The most popular watercolor paper is 140-pound cold-pressed, but the choice is yours. Do purchase only 100 percent rag papers—anything less is not worth painting on.

Palettes and Containers. There are many varieties of well-designed watercolor palettes in the art-supply stores, most bearing the signature of a famous watercolorist. They offer wells for color, space for mixing, and portability. Some have snap-on covers; some provide brush storage. Beware of the light-plastic ones, as the paint wells tend to crack and leak.

Inexpensive porcelain butcher trays are now manufactured for the watercolorist. These make wonderful palettes, although mine seem to keep returning to kitchen use. Also available are paint-boxes with a palette enclosed and space for tubes of paint and brushes.

Should a store-bought palette be too much additional expense, you can use any white, nonporous, flat surface. You might try plastic or porcelain dinner plates, or the plastic plates that accompany frozen microwave foods. I insist only that you have at least the equivalent of a 15 × 20-inch (38 × 51 cm) surface, or 300 square inches (762 square cm) of mixing space.

When you examine the watercolor supplies in an art store, or open a mail-order catalog to watercolor equipment, you'll find lots of "extras"—from brush quivers to nickeled brass water bottles. If you have the spare change, collecting such accoutrements can become a life-time passion. But, like most artists, you'll probably settle on an empty soda bottle and some pickle jars.

WORKING TIPS

Before you get started with the specific exercises, I have a few general recommendations about practical working methods as well as ways to increase your openness to experimentation. It's important to try different approaches and techniques to discover what works best for you.

Stretching Paper. Whether to stretch paper or not sometimes seems to be a whim of fashion. I can remember a few years back most experts recommended stretching every piece of paper that came into the studio. Now it seems to be more or less an option.

In the classroom studio situation, students tend not to want to stretch paper before class or carry around Masonite boards. Despite what I recommend, most either use blocks, leaving the sheet they're working on attached, or tape dry paper directly to the drawing table with drafting tape. These are not bad methods, but they do not take into account the reasons for stretching paper—which are to lessen the tendency of the

Three methods of stretching paper: at the top, wet paper is stapled to soft Homosote board; in the center, the paper is thumbtacked to a wooden canvas stretcher; on the bottom, the paper is taped with postal tape to a piece of Masonite.

Use a scrap of paper to test your colors before you put them in a painting. Notice how lively the brushstrokes are on this "throwaway."

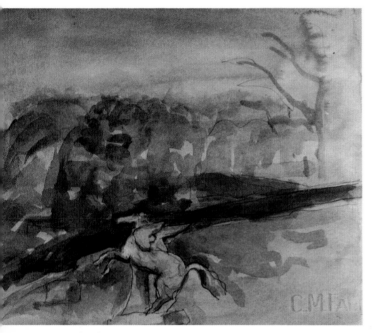

Michael Crespo, *Pegasus*, 11" × 14¹/₂" (28 × 37 cm)

This painting could never have been made solely from a photograph. I painted it one afternoon in Florence, as the clouds moved rapidly in front of the sun, making the light change drastically at erratic intervals. After laying in a light blue wash, I drew the statue and painted it, marking the shadows during moments when the sun peeked through the clouds. Next I sketched in the trees and foliage behind the sculpture. Soon, however, I realized that it was almost impossible to specify these forms, which the light was constantly altering. After mixing some puddles of grayed blues and greens, I let my brush move across the paper, erratically spotting forms in much the same way nature did that afternoon. Such a disorderly cadence would never occur with a camera, which records a very specific second in time.

paper to wrinkle when wet and to remove excess sizing from the paper, through soaking, so it is more absorbent. One solution to the dilemma is to use 300-pound paper, which is heavy enough to remain flat when wet. A lighter paper really should be stretched, although some people work quite comfortably on 140-pound loose sheets lying on the table. I suggest that you stretch some and not stretch others, and compare the experiences.

To stretch paper, you'll first need a board to mount the paper on. I recommend one-quarter-inch untreated Masonite, cut larger than the piece of paper you're going to stretch. Soak the paper in cool, clean water for about ten minutes. A bathtub is perfect for this. Lay the wet paper on the Masonite and tape down all four sides with brown paper tape (sometimes called postal tape)—the kind with glue you have to lick, or, rather, sponge. You can let the paper dry, work on it wet, or rewet it after it's dry. When the painting is complete, cut it off the board with a mat knife.

Another method of stretching is to mount the paper on wooden stretcher bars, commonly used for stretching canvas. Use thumbtacks to secure it to the wood. I sometimes staple the wet paper to Homosote, a porous building material.

Testing Color. Save scraps of your watercolor paper and use them to test every color you plan to put in a painting. By testing first, you'll save time lifting paint later. You may be surprised to find that these test strips sometimes exhibit better technique than the painting itself. On a test strip you may slap down color with a daring and spontaneity difficult to achieve in the one that "counts."

Lifting and Correcting Color. Although it's best to get your color right the first time, there is a way to change it once you've put it down. Always have tissue in hand; then immediately blot out anything you consider an error. If the paint has dried, apply clean water with a clean brush, using a slight scrubbing action. Then dab it dry with tissue. Depending on the color, you may have to repeat the process a number of times. Be sure to let the paper dry before painting into the "lifted" area. To lift an entire painting, try soaking it in a bathtub and then scrubbing.

Once I came upon a friend of mine hosing down a painting in the driveway. The pressure of the hose made an excellent eraser.

Keeping a Journal. Among your basic supplies, I've asked you to purchase a small sketchbook. Use this as a journal. Make small sketches of subjects you want to paint. Also record, in paint and words, colors that you mix and may need down the road (you'll be surprised at how fast you forget a beautiful color). Put down bits of wisdom your teacher or fellow students impart, as well as bits of your own wisdom. As the years pass, a well-kept personal journal will surpass any book ever written on watercolor.

Using Photographs. Most of the time I can go through a student's portfolio and with a glance pick out the paintings made solely from photographs. If you don't want the "look" of a photograph, try to observe your subject directly. With direct observation, you're inevitably engaged in movement. Your eyes and body shift as you go back and forth from the subject to your painting. Natural light is also in constant movement, and even the subject may move at times. All this provides options—options not offered by the static photographic image.

Photographs, like paintings, are the result of an editing process. It makes no sense to edit what has already been edited. I recommend that you paint from the full detail of nature itself and use photographs only as recall aids.

Experimenting with Size. Try to vary the size of your paintings. Experiment with a very small painting—say, 3 × 4 inches (8 × 10 cm)—and a large, full-sheet painting measuring 22 × 30 inches (56 × 76 cm). Many times size will be dictated by the setup. Ask yourself: What size seems appropriate for the subject? What size do you feel comfortable with? Also consider the format. Explore deviations from the norm: nearly square shapes or exaggerated horizontal or vertical formats can be exciting alternatives.

Finding a Personal Expression. Unfortunately, watercolor has become plagued with superficial techniques and "winning ways." We lose sight of the fact that, like any artistic medium, it is meant to be stroked and coddled into each practitioner's distinctive voice. Of course, as a medium, watercolor has its own potentials and limits. But my point is that we *choose* to work in this medium because we think it can express our most individual vision.

Do not substitute flashy, mechanical techniques for your own personal touch, which indicates your will and desires. Learn the basics and revel in what you can bring to the medium. Be taught by everyone, but discover how to make your own paintings. Too many times students and artists wander off track, trying to second-guess teachers or judges, dishonestly posturing to capture that good grade or ribbon. I promise that a judge or teacher is more likely to reward your honest attempts. Watercolors are the poems of art, and poets should speak the truth.

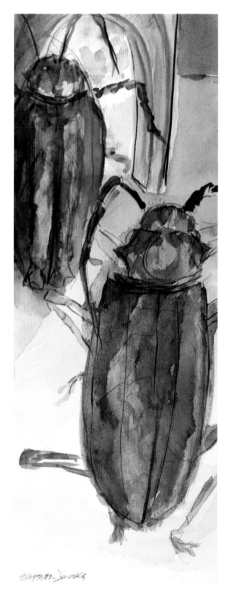

Elizabeth Jenks, student work, 16" × 6" (41 × 15 cm)

The vertical posture of the two beetles, seeming to walk upright, is reinforced by this painting's unusual vertical format. Elizabeth Jenks has accentuated this upward thrust with emphatic black lines. Our expectations of scale are also disturbed by the background architecture, which gives the marching insects an almost human size.

PART 1

FIRST SEMESTER

DAY 1
Brush Movement and Marks

In essence, painting a watercolor is simply making marks with a brush. Let's begin, then, with a look at how your brush does its brushing. I do not believe that there is one way to hold a brush. If you always held your brush in the same way, as you might hold a pencil, the marks would be very limited.

A brush can be moved with the fingers, the wrist, the lower arm, the whole arm, or the upper body. However ridiculous you think you might look twisting at the waist to produce a mark on the paper, it is a possibility. Experiment with different grips to discover what specific movements each allows or enhances. Variation in technique will produce variation in the marks you make, expanding your vocabulary and thus expanding your ability to express your ideas.

The exercises here will get you started. Use each of the different brushes you own to do each exercise. Work on inexpensive newsprint or other drawing paper to economize, but bear in mind different textures and weights of watercolor paper will give your marks a different look. Try to use all of your colors, including some two-color mixes. In other words, use this lesson as a chance to explore color possibilities as well as brushmarks. Also investigate the effect of transparent overlays by painting over your marks when they're dry.

Add a Stroke. Begin with a stamp, but this time leave your brush on the paper. Roll or stroke it in another direction to add another mark to the stamp. Vary the direction and manner of making the stroke, as well as the pressure you apply to the brush.

Compound Stroke. Stroke the paper in one direction (not a stamp, but a stroke). Quickly change your movement, then again. This exercise may seem similar to the previous one, but here you are concentrating on stroking, with more active, flowing movements of the brush. Do not make more than three strokes in a series, and try to form as many different configurations as possible.

Stampings. Load a brush with a color, not diluted with too much water. Make its imprint, or stamp, on the paper. As you do these stampings, vary the angle of the brush handle to the paper.

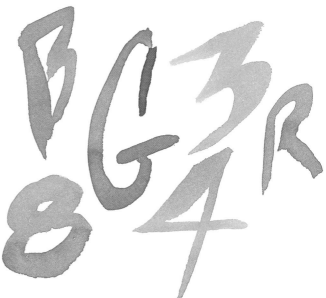

Tip and Heel. First practice painting lines with the tip of your round brush. Use an inklike consistency of paint to facilitate flow. Vary the thickness of the line by changing the pressure you exert as you move the line around the page. Next press the brush hard against the paper and drag it. Now you are utilizing the heel of the brush, which is next to the ferrule (the metal band joining the handle and the hair). As the pigment is used up, the brush will splay, leaving a trail of small, scratchy lines.

Numbers and Letters. Spontaneously paint numbers and letters as they come to mind. Vary the marks used to construct them. Repeat some of them, varying their construction.

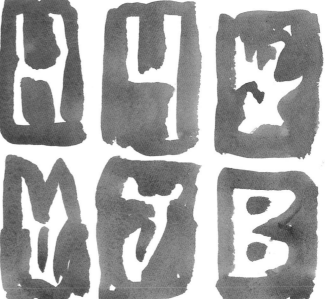

Wet and Dry. This exercise simply involves the amount of water you use to activate your pigment. More water obviously makes the paint flow more, producing a more homogeneous mark. The "drier" the mixture, the more erratic the mark, due to the splaying of the brush. Later, we'll look more specifically at the drybrush technique (Day 13). For now, explore wet and dry modes by repeating all the previous exercises using various consistencies of paint.

Shape and Field. Again, use numbers and letters, but this time paint the space *around* the figure, leaving the number or letter paper-white. When you have had enough of numbers and letters, design some free-form shapes, making them as complicated as possible. Practice this exercise until you are fluent at painting the "negative" shape. This technique will prove very useful in days to come, for when you want white in a watercolor, it is best to leave the area white from the start.

Wet Stampings Wet Stroke Stampings Compound Stroke Dry Stroke

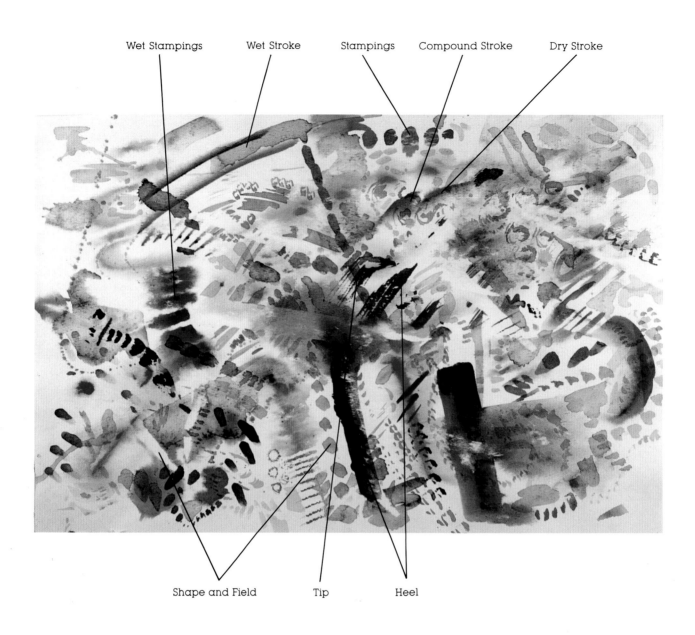

Shape and Field Tip Heel

You may be surprised at the "pictures" you get when you combine different marks. This exercise by Royce Leonard has a liveliness and freshness often missing in more considered painting. The challenge is to carry over this energy into all your work.

The transparency of watercolor pigment is probably its most notable quality. You can create intriguing veiled effects by layering one color over another. As a start, simply overlap your brushmarks. Here stampings of two colors produce a third color of darker value in between.

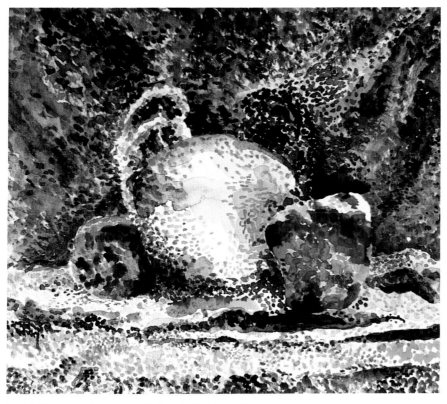

Lori J. Hahn, student work, 8¾" × 7¾" (22 × 20 cm)

Usually artists try to be as versatile as possible with their brushstrokes within a painting, but sometimes it can be constructive to limit your marks. Lori Hahn restrained herself to the point of obsession in this "pointillist" painting. She used the stamping mark of one brush to construct this glittering space. Of course the value and color had to be accurate to yield such a credible representation of light and volume.

Notice Lori's dazzling array of colors. It's the broken nature of the strokes, however, that gives the painting its texture and consequent shimmer. There are a few broader washes, especially on the vase, that help to soften the volume and lend a contrast to the dots. It seems almost impossible to keep jabbing your brush at the paper without at least making one other kind of mark!

On this sheet you can see the diverse marks produced by propelling the brush first with the fingers, then the wrist, then the arm. Royce Leonard may even have gyrated at the waist to produce the long, sweeping strokes from corner to corner. Remember, to travel across the page in a single stroke, your brush must be amply loaded with paint.

Another technique Royce has used is to lay down a stroke with dense pigment and then pass his brush, now saturated with clear water, over it. This creates the "ghost" effect around some of the dark strokes in this picture.

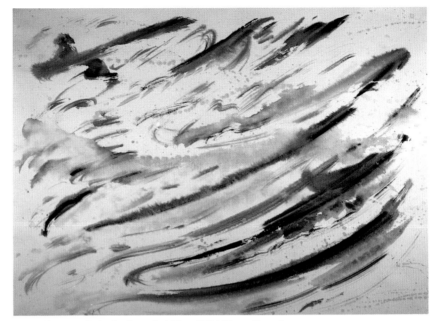

Royce Leonard, student work, 18″ × 24″ (46 × 61 cm)

The "shape and field" exercise is brought into play at the start of this painting. The banana plant—the figure—is left as white paper while the surrounding "field" is painted blue. The dark blue palm tree and green scrub foliage are then sketched in as shapes—additional figures on the field. Using this concept sets up the dynamics of this composition.

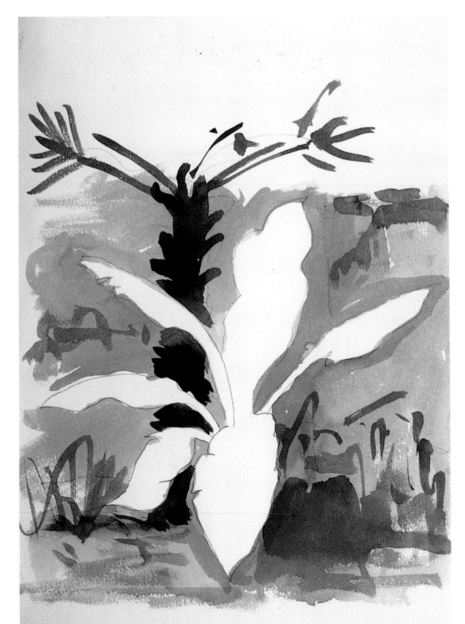

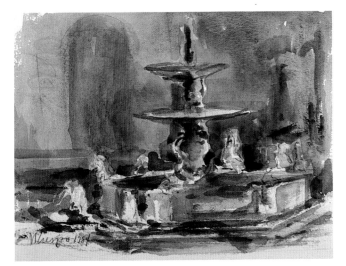

Michael Crespo, *The Fountain*, 11″ × 14″ (28 × 36 cm)

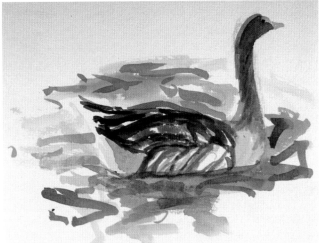

Libby Johnson Crespo, *French Goose on the Pond*, 9″ × 12″ (23 × 30 cm)

A lively, direct response with my brush freed this fountain from its architectural limitations. I began with a burnt orange wash to indicate the field, leaving the fountain and its sculpture white. Next I applied some quick, blue strokes to suggest the contrasting light. By brushing in dark, irregular shapes of brown madder and green earth, I began to realize the drama of the afternoon light. The "left-over" white shapes are just as important as any of the shapes I labored over. I feel that this painting expresses the essence of what I was looking at, while celebrating the exuberance of my brush and its tracks.

This sketch by my wife Libby was begun with a few broad markings to silhouette the goose's shape. Then compound strokes were quickly built into the feathery body and surface of the water.

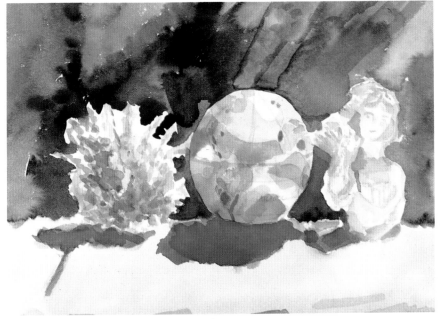

Leslie Wagner, student work, 11″ × 14″ (28 × 36 cm)

Leslie Wagner's foremost compositional concern was to indicate the contrasting edges of the three objects. To achieve this, she first laid in an irregular blue wash, forming the white shapes of the objects. She then painted a subtle rose wash on the ground plane, followed by staccato gray shadows, overlaid with dark red. Returning to the background, she mingled another blue with black, further emphasizing the chiaroscuro, or strong light-dark contrast. To complete the painting, she overlaid a myriad of stampings and compound strokes on the white object shapes, describing their volume and explaining their nature. The transparent buildup of color is clearly noticeable.

DAY 2
A Movement of Grays

It is important to experiment with mixing as many grays as you can. They are a vital aspect of color theory—all too often overlooked by students who, like most of us, are tantalized by purer hues. Working with the more neutral grays at first will make it easier for you to perceive changes in value—the lightness or darkness of an area. It can be much more difficult to sense value changes in lurid reds and bright yellows, because intensity is sometimes mistaken for value.

An important role of grays is their use as transitional color in a composition that also contains purer hues. The eye tends to move more slowly across grays than across pure hues. You can thus slow or speed the visual pace of a painting, depending on the amount of gray you use and how you position your grays. Moreover, grays serve as an excellent foil for pure hues, making the pure colors seem richer and more intense by contrast.

It should be clear that we are speaking here of gray as a color. If you think of gray only as a "black and white" mixture, it's time to expand your view. There are countless mixtures of gray. Just adding a spot of any color in your box to black will give you a diverse variety. You can also create varied grays by mixing the three primary colors: red, blue, and yellow (see page 28). Or combine complementary colors—red and green, blue and orange, yellow and violet—to produce gray.

As you explore these mixtures, you'll find that grays are not always neutral in the strict sense of the word; they can be warm, cool, bluish, greenish, or reddish. Occasionally, when your color mixing is at peak performance, you may achieve a perfectly neutral gray, which doesn't lean toward any particular hue. Don't be too excited about this. Remember, color is always *relative*. Your "neutral" gray will undergo drastic changes the minute you place it next to other colors.

To investigate the movement of grays in a picture, set up a still life with two or three white objects. Place them on a white ground, such as a white tablecloth against a white background. Direct a strong light on the objects, emanating from above right or left. In painting this still life, you'll be building a sequence of grays by applying one over the other in progressively darker values.

This chart displays the colors used to mix triad grays and the grays themselves. The bottom three bands show the value modulation caused by progressively overlapping the grays.

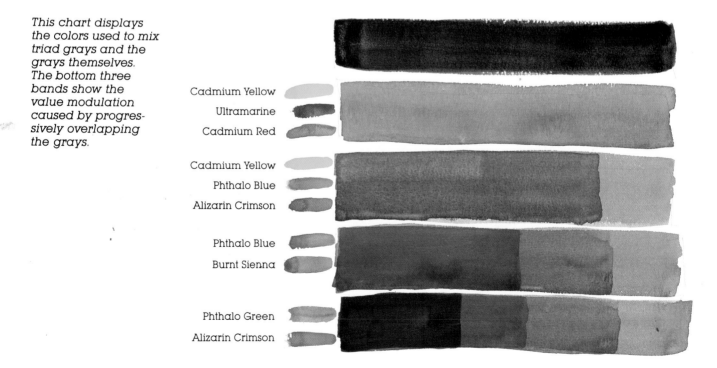

Cadmium Yellow
Ultramarine
Cadmium Red

Cadmium Yellow
Phthalo Blue
Alizarin Crimson

Phthalo Blue
Burnt Sienna

Phthalo Green
Alizarin Crimson

Step 1. Do quick compositional drawings in your sketchbook. Make value sketches to determine what the light is doing. Remember, just because you see a dark on an object, it doesn't mean that it will augment the feeling of volume in your drawing or painting. Look for the major value areas first. And don't clutter your drawing with dispersed, inconsequential darks.

Step 2. Scribble a light sketch on your watercolor paper. Move around on the page. Think of the relationship of forms. Don't worry about making mistakes, and absolutely do not erase anything. Erasures can produce unwanted textural effects. If you make an error, just correct it with a slightly darker line. Relax—this drawing is only a rough guide. As you add color and value, they'll soon visually consume the pencil marks.

Step 3. Mix a puddle of black. Don't economize on pigment—you want enough to cover the background with a truly dark value. Paint only the background. Leave the objects and the ground plane white. Then observe the sense of light established by the contrast of black and white.

Be sure to let the painting dry thoroughly. Problems often arise when you try to paint a transparent overlay over an area that is wet or even almost dry. For this exercise, make sure each step is completely dry—bone dry—before continuing. Use an electric hairdryer if you get impatient. Take a coffee break, or catch up on a novel. Or, better yet, work on another painting.

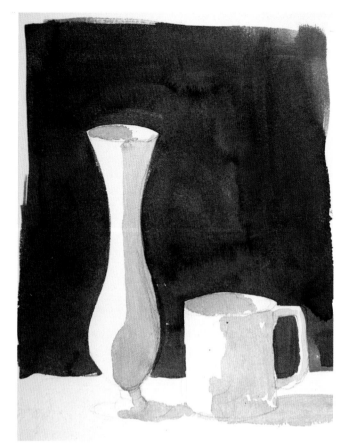

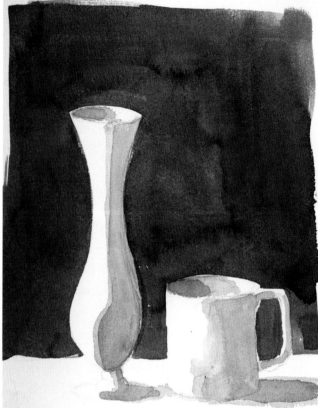

Step 4. On your palette, mix cadmium red, cadmium yellow, and ultramarine blue. Juggle the proportions until you get a gray as close to neutral as possible. Test your mixture periodically on a scrap of paper. It's neutral when it does not resemble any of its components. Overall, this color will be a brownish gray, rather than the traditional black-and-white version.

When you get a satisfactory neutral, add clean water to create a light value. The idea in this exercise is to get progressively darker with each mixed gray and to overlay color to aid in this progression. Now load your brush and paint quickly over the areas that you know will be darker than paper-white. Leave the ground plane white, except for the areas marked by shadow. Let everything dry.

Step 5. Mix your next gray from alizarin crimson, phthalo blue, and cadmium yellow—using hue variations of the primary triad. To make this gray darker than the last, add a little less water to it. Use it to enhance the sense of light in your painting. Also begin to establish transitional values by leaving some of the first gray wash visible. With each step, as you go darker, cover less area, leaving a trace of the previous color. Be quick and emphatic with your application. If something goes wrong, blot it out with a tissue. Again, let everything dry.

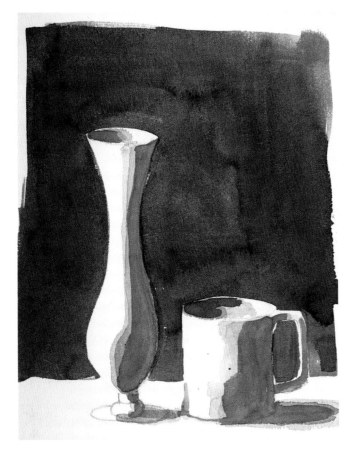 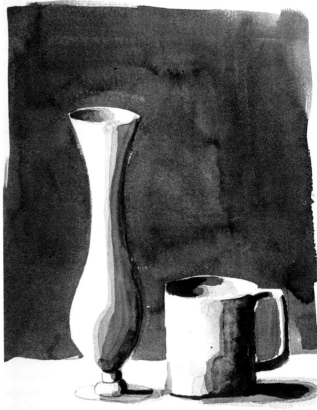

Step 6. Now mix a gray using phthalo blue and burnt sienna. This is a wonderful gray, much seen in watercolors. Essentially it's still a gray from the basic triad, as the sienna functions as a version of orange (red + yellow). Again, this color should be a little darker than the last. Use it to further carve out the volumes of your objects; then let everything dry.

Step 7. Now make a wonderful dark using phthalo green and alizarin crimson. At full strength this luxurious dark, with its hint of either red or green, appears blacker than black. Use it to emphasize the extreme darks in your setup. There—you should have a dramatic, volumetric depiction. Stand back and see if it doesn't work even better at a distance.

Here are some alternative grays you can make with an expanded palette. Note that manganese and cerulean blue tend to be very grainy pigments and produce a beautiful leathery texture found only in watercolor.

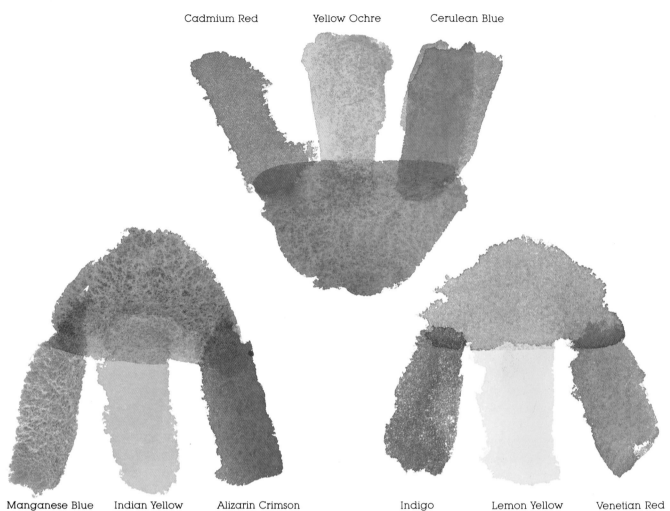

Cadmium Red Yellow Ochre Cerulean Blue

Manganese Blue Indian Yellow Alizarin Crimson Indigo Lemon Yellow Venetian Red

Gloria Jalil's stabbing brushmarks cause correspondingly abrupt value transitions. It is intriguing that despite the strict, recipe-like structure of this exercise, she has kept a sense of her own voice in this painting. I hold this virtue high in your responses—whether the problem is successfully solved or not.

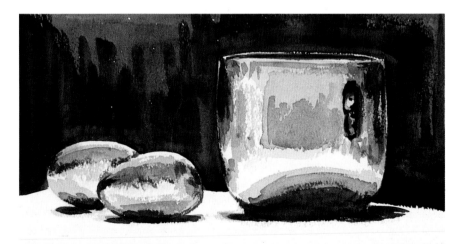

Gloria Jalil, student work, 7" × 11" (18 × 28 cm)

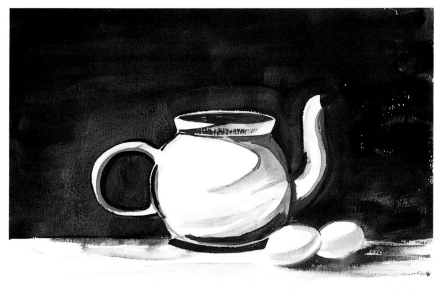

This painting by Deana Houston exhibits economical brushwork in the few bold marks used to describe the internal planes of the objects. But Deana has expanded her brush repertoire in the surrounding space. A drybrush stroke accents the dark in the top rim of the teapot, while characteristic blooms from wet paint on wet paint suggest shadows on the ground plane.

Deana Houston, student work, 12″ × 16″ (30 × 41 cm)

Carrie Alexander's grays move off neutral, giving the painting a slightly richer color sense. Notice that the black Carrie chose appears slightly blue. Blacks usually have a color base, which may be more obvious when the pigment is diluted. Also notice that one of the grays in the coffee pot has a greenish tint. This is probably the phthalo blue and burnt sienna mixture, which can be difficult to lure away from green.

Now look at the whites that run down the center of the pot, which do much to give the form volume. Keep in mind that whites generally project from the picture plane. In this painting they are located on the part of the pot closest to the viewer, so the rest of the pot seems to recede, away from them.

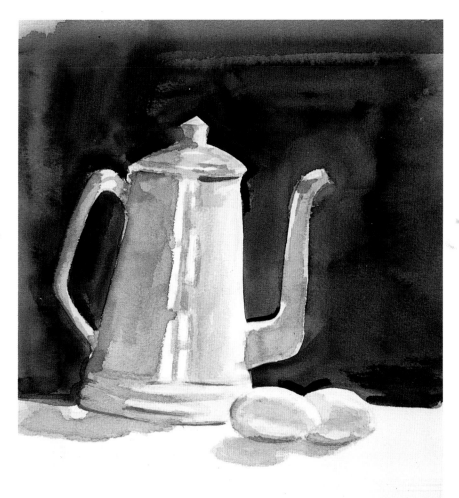

Carrie Alexander, student work, 11″ × 12″ (28 × 30 cm)

DAY 3
The World of Shape

There are two kinds of shapes: geometric and amorphous. Geometric shapes are just that—geometric. Squares, circles, rectangles, spheres, triangles, and tetrahedrans in part make up this category of named, recognized shapes. In contrast, amorphous shapes do not have a recognizable identity. These free-form shapes are often expressive and lyrical.

Shapes can also be defined by their role in a composition. The objects—trees, people, cups, whatever—are all considered *positive* shapes. *Negative* shapes are formed by the spaces between positive shapes or by a positive shape's relationship to the edge of the paper. These two shape types are also referred to as figure/field, yin/yang, or figure/ground. Most people tend to recognize only positive shapes, so it's a good idea to practice shifting your vision to the often neglected negative shapes. Remember, in the flat, two-dimensional world of painting, all is equal.

I would like to inject a third compositional shape, which I call an *immigrant* shape. This shape crosses the boundaries of the positive-negative relationship and borrows its existence from both. An example is a shadow shape on the dark side of an object and the ground plane.

An important concept to consider in compositional shape-making is scale. It's a simple idea. Make some big shapes, then some small shapes. A large shape is not large until you compare it to a small one or vice versa. Scale can also be a factor in suggesting space. Study the cartoon shown here.

Also think of shapes as part of a compositional pattern. By repeating or echoing shapes throughout a picture, you can introduce rhythms and arabesques, carrying the viewer from point to point.

Basic Types of Shape

Geometric

Amorphous

Positive

Negative

Immigrant

IS THIS MAN BIG OR SMALL?

SMALL!

BIG!

OR

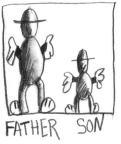

FATHER SON

SON FATHER
HOW SO?

In art, opposing concepts can exist simultaneously. You surely figured out that the tiny father is farther from the viewer. Ah, perspective! This is the beginning of the irony of working in two dimensions but trying to create the illusion of three dimensions.

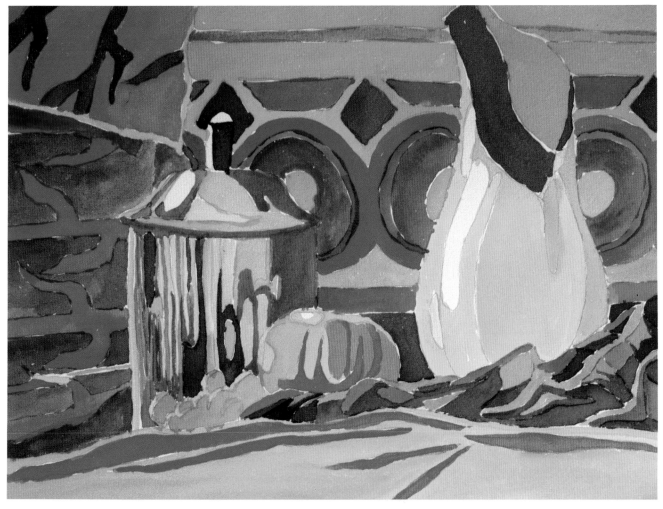

Joe Holmes, student work, 9½″ × 12½″ (24 × 32 cm)

For today's exercise, set up a well-lit still life containing at least fifteen objects and as many draperies as you can pile on. Or use a crowded interior space. With your pencil, begin drawing shapes directly on the watercolor paper. Try to approach this with reckless abandon, freely interpreting the setup. If you can envision the still life as a huge, flat field, it may help you reestimate what you are looking at. As you make each shape, ask yourself, "Is this shape interesting? Or is it dumb and dull?" Fill the page.

Now take colors, many colors, and start filling in the shapes. You do not have to adhere to the local color of your subject. Indeed, you might dismantle your still life, so as not to be intimidated by the color before you. Employ a great variety of intense colors and a full value range (from paper-white to dark). Also "pattern" some of your colors. By repeating a bright red in different places, you can make the eye follow its path.

At first, just randomly place your colors. Soon you will "sense" your next move. Follow these sensations to completion. Remember, you can always modify a color by overlaying another.

Joe Holmes took a realistic approach to the still life, while constructing it with a great range of shapes and colors. Compare the geometric shapes in the background with the amorphous shape of the blue and purple drapery, as well as the positive and negative relationships in the vase. Also notice how Joe has used shape and color variations to depict the reflective qualities of the copper pot on the left. Here we see pockets of smaller shapes within larger ones. To the eye, a bunch of small shapes, or a bunch of large shapes, mass together as a single shape—another compositional weapon to consider.

Bryan Murphy, student work, 12″ × 16″ (30 × 41 cm)

By assigning so many large shapes the color orange, Bryan Murphy has established a field, with all the other shapes floating in it. Geometric shapes dominate, but there are also plant and bird shapes, repeated throughout, which take on a narrative role. These images were not blatantly evident in the setup; Bryan made the transformations.

Christy Brandenberg, 12″ × 16″ (30 × 41 cm)

Christy Brandenberg has a gift for inventive shape-making. Her shapes have been highly abstracted, yet the three-dimensional integrity of the still life remains evident. Amorphous and immigrant shapes dominate the composition, color is widely varied and well placed, but the most striking aspect is the manipulation of scale. The center of the painting is tightly congested with small shapes, while the surrounding edges are more relaxed, as the larger shapes seem to drift in the space. This is not only a juxtaposition of scale, but also a contrast of shape character.

Christy also makes fine use of the yin/yang principle. In the zone with the large shapes, she has included small accents and vice versa. Finally, notice how the color blue weaves a pattern through the space, carrying the eye from foreground to background.

DAY 4
Color Plans

Although we may clothe objects in color, color is essentially abstract, with properties of its own that have nothing to do with the object. In painting, color is remarkably spatial: red advances, blue recedes. It is also emotional: red agitates, blue soothes. Color can be dark or light, bright or dull. It can seem large or small. Most important: color is always relative. Just how dark, how red, or how soothing a color is depends on the relation of that color to others around it.

Color theory will give you insights into color, but there is no substitute for working knowledge. Experiment as much as you can with color. Explore how the same color changes in ap-pearance not only when you place it next to different colors, but also when you apply it on various papers, or perhaps when you change its shape.

It's a good idea to have a very general color plan before you start to paint. Don't make your goals too specific, however—you should feel free to explore many possibilities. Consider adopting one of four basic schemes for color composition that I have found particularly useful:

- varied color shapes on a gray field
- gray shapes on a single-color field
- varied color shapes on a single-color field
- gray shapes on a gray field

Color Wheel. *The colors on the left are warm; those on the right, cool. Red and green are the transitional zones: warm yellow-green meets cool blue-green, and warm red-orange meets cool red-violet.*

Look at the examples below and on the next three pages. In all these plans, there is a dominant color or color group. Wander through a museum or peruse an art book and observe how often a particular color dominates a composition.

Within your basic plan, you must consider various properties of color. Already you've gained some sense of the importance of value in creating a feeling of space and volume. Now we'll look at the effect of color temperature.

Just like your soup, color runs from hot to cold and every designation in between. To understand this, look at the simple color wheel shown here. The primary colors red, yellow, and blue combine to form the secondary colors orange, green, and violet. Yellow, orange, and red are considered warm colors, while blue, violet, and green are cool. Red, however, can enter the cool domain as it approaches violet, and green can warm up as it approaches yellow.

Bear in mind that everything about color is relative. In a painting filled with "warm" colors, it's possible for an orange to appear cool. Similarly, you might find a warm blue in a field of cold colors. Mixed grays take on the temperature of the dominant hue. A blue-gray will be cool, a yellow-gray warm. In practice even "neutral" grays lean toward one temperature or another, sometimes taking on the characteristics of surrounding color and sometimes opposing them. To learn more, turn to the exercise on page 41.

Plan 1: Color on a Gray Field.
Small shapes of various colors are situated in a gray field. It is not necessary for the field to be a solid gray; it could contain many variations of gray.

Alice Verberne's painting exemplifies the color-on-gray plan. The grays dominate the background and also move through the sculpture fragment, the shell, the vase, and down onto the ground plane. Blues, reds, and oranges are the subordinate colors in this gray field. Another strong compositional element to note here is the dramatic placement of the extreme darks.

Alice Verberne, student work, 19″ × 15″ (48 × 38 cm)

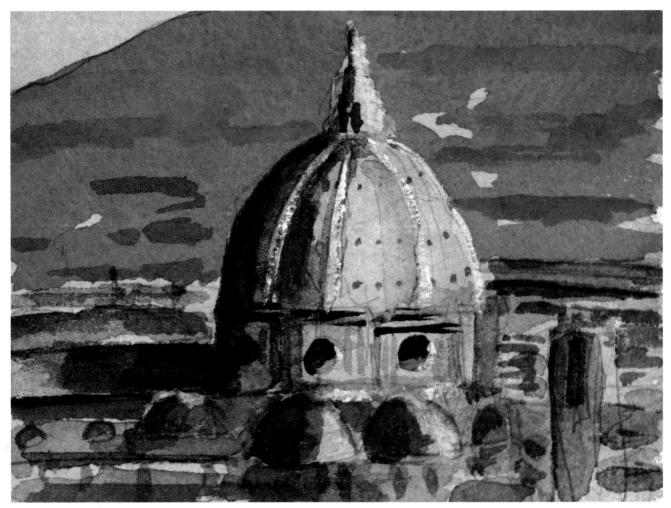

Michael Crespo, *Il Duomo*, 5½" × 8" (14 × 20 cm)

Plan 2: Gray on a Color Field. *Here varied, small gray shapes are engulfed in the blue hue. The blue field need not be homogeneous—it could be an assortment of many different blues. And, of course, the field doesn't have to be blue; it could be any other color in the spectrum.*

In my painting the blue-greens link with the major blue to form the dominant color field. Because the rest of the colors in the painting are decidedly gray, the blue-greens are "forced" to join their blue relatives as a mass. The grays, however, are varied, moving from the cool gray lights to warm gray shadows.

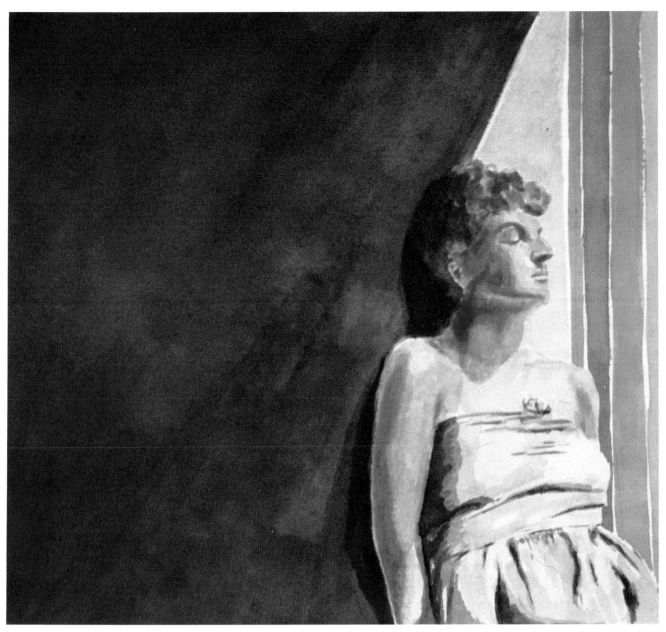

Bryan Murphy, student work, 12" × 11" (30 × 28 cm)

Plan 3: Color on a Color Field. *Now the scale is established by a number of smaller color shapes on a dominant red field. Again, this field need not be a solid red: it could be any spectrum color or a variety of reds.*

Bryan Murphy's poignant figure study offers variation of the color-on-color plan. Here the small color shapes are locked into the field as a unit, rather than dispersed across it. The field is the dark blue wall that the woman is leaning against, her even darker shadow, and her dress, with which the shadow connects. Although the dress is warmer than the wall, it is nonetheless a blue-green, and, since the only other colors are fiery warms, it joins its analogous neighbor (the color adjacent to it on the color wheel). The smaller colors "on the color field" include the yellow, orange, and red stripes on the right and the woman's skin tones and hair color. The two masses connect, like a handshake, at the point where the arm moves into the blue and the dress moves into the warms.

This painting also reveals how temperature can work. The dominant cool colors make the subordinate warms seem much hotter, and vice versa.

Plan 4: Gray on a Gray Field. *This plan is similar to the third one, but now grays constitute both the shapes and the field. Note how in an entirely gray situation, the various grays appear as different colors. The same grays placed in a composition with some pure colors would quickly be reduced to more neutral grays.*

Ellen Ellis has defined a dominant field of grayed red drapery. Within the skull you can find some green-grays, blue-grays, and neutral grays. The touches of grayed violet within the reddish-gray field tend to connect visually with the grays in the skull, setting up some opposition to the field. In a painting of so much grayed color, however, there is far less opposition between the colors and the field than in the other plans.

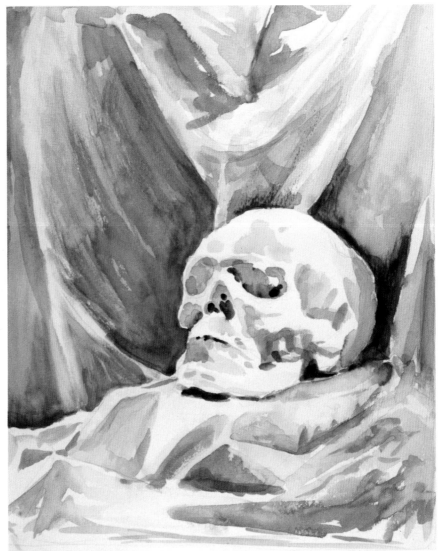

Ellen Ellis, student work, 13″ × 10″ (33 × 25 cm)

TEMPERATURE WARM/ TEMPERATURE COOL

For this assignment, set up two still lifes. Keep them simple. I recommend two objects on a drape. A piece of fruit and a small pitcher or a seashell would be ideal. In one setup, use only warm colors and light the arrangement with an incandescent lamp. For the other, choose cool colors and, if possible, restrict the light to cool fluorescent. You might also try painting the cool subject in early morning sunlight and the warm one in the hot afternoon. Be sure to light your still life dramatically, with the light clearly explaining the objects and making strong, shapely shadows.

Essentially, the task is to paint from your setups, one cool and one warm. I do, however, want you to depart somewhat from the local color. In the warm painting, use as many warm colors as you have in your box or you can mix. Even if you don't observe all these colors in your still life, try them. Aim for an overload of color within the dominant warm temperature. Do the same for the cool painting.

You may use cool colors in the warm painting and warm in the cool, but keep them to a minimum so they don't confuse the dominant temperature. A few cool notes within a warm scene, however, can provide an important scale reference; spots of blue among sizzling warms, for instance, can make the warms hotter by contrast.

One potential trouble spot is the painting of shadows in the warm scene. Shadows generally appear cool, whatever the color of the plane they are on or the light. Everyday remarks, such as "Let's get out of the warm sun into the cool of the shade," confirm this. In a painting, however, anything is possible. You could create cool, purple shadows in your warm painting to provide a temperature contrast, or you could make deep red-orange shadows, which would be slightly more unusual. For the experience, try to find as many warm darks as cool darks.

As you paint, don't worry too much about technique. Use what you've learned so far about working directly and building transparent overlays, not to mention varying your brushmarks. At this point, let technique be born of necessity. Mistakes are inevitable, but also invaluable in discovering how to make the medium speak your language.

There is no doubt of the heat in Marcy Blanchard's painting. She exaggerated the colors appropriately to explore the range of the warm spectrum. Her casual brushwork gives the painting a spontaneity that complements the sunny color.

Marcy Blanchard, student work, 10¼″ × 14½″ (26 × 37 cm)

Jonathan Drury has made very thoughtful color choices in his warm painting. He has kept the heat somewhat subdued and tamed the yellow field by introducing some warm grays. Notice the visual pull of the isolated red area on the large apple. This is but one of three quietly dramatic moments Jonathan has created within the row of apples. Also notice the bold, green contour around the apple on the left and the almost black shadow cast on the apple on the right. These last two are quirky marks, but very effective compositionally. They remind us that this is really a painting, not a rendering, filled with the instinct and daring of its maker.

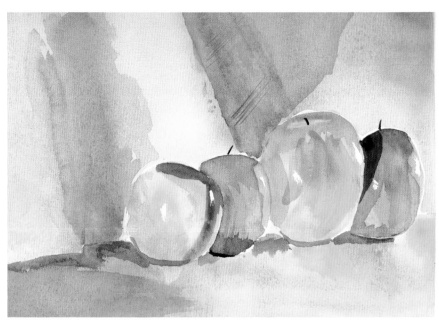

Jonathan Drury, student work, 10″ × 14″ (25 × 36 cm)

Elizabeth Jenks has utilized only cool colors in her painting. Blue-greens, blue-violets, and blue-grays are densely layered in active, transparent strokes, giving volume not only to the pitcher, but also to the background drapery. With all these cool colors, the paper-white conveys a warm light.

Elizabeth Jenks, student work, 15″ × 10″ (38 × 25 cm)

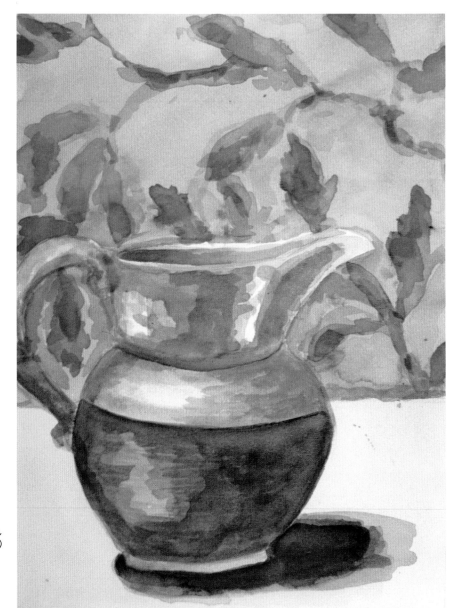

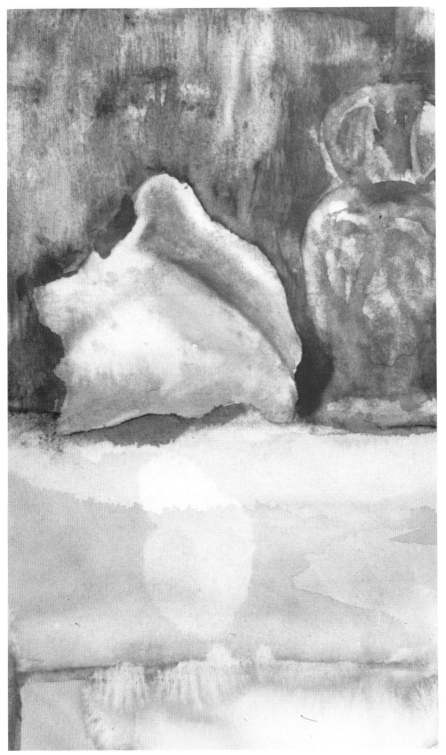

Alice Verberne has patterned a warm yellow into a field of beautifully textured, delicately cool colors. The largest yellow area leads the eye into the cool space, while the smaller yellow areas move the eye up the painting. Although the temperature extremes are great—blue to yellow—there is still a quiet subtlety in the overall color, due to the textural way Alice has applied her paint. At times she let very wet paint bloom at the edges; she also blotted wet paint with tissue. Notice how the color assumes a different personality with different applications.

Alice Verberne, student work, 13½″ × 8″ (34 × 20 cm)

43

DAY 5
From Value to Color to Light

A strong value organization increases the impact of a painting. One way of achieving this is by observing some basic value systems found in nature. Although the emphasis here is on value, you'll soon discover that the use of color is implicit. And by considering color as an equal partner to value, you'll arrive at an effective representation of light.

Every color, of course, has a value: it is light or dark. Yet color also has a light of its own, which is not the result of value. This light is connected to the color's chroma, or saturation of hue—its intensity. The aim is to merge chroma with the power of value to re-create the light of nature in paint on paper.

To understand all this, we'll work with three basic value systems.

Normal Value Range. In this system the values range from the white of the paper as the lightest value, through the middle values, to the darkest dark you can make. Most of the values are clustered around the middle, with extreme lights and darks used primarily as accents.

High-Key Value Range. In this system the range is restricted. The white paper is still the lightest light, but the darkest dark is now the middle value of the normal range.

Low-Key Value Range. Here the middle value of the normal range is the lightest light. All the other values are darker, moving toward the darkest dark you can make.

To explore these systems, assemble a simple still life with two or three objects. Light it strongly from the right or left. You may want to add a piece of crumpled drapery for interest.

Make three small paintings of the setup. Begin with the normal value range; then do a high-key and a low-key painting based on this. When you're finished, compare all three paintings. Does each painting define a distinct value system?

Because the values are restricted in the high- and low-key systems, there's less resolution of form. Dramatic contrasts are also greatly reduced. The temptation is to add some values outside the system to create excitement. Although you may do this occasionally, don't introduce too many other values. Instead, vary your color as much as possible, within the narrow value range, to enliven your painting.

A final tip: I'm sure you've observed that watercolor dries lighter than it appears when wet. Keep this in mind when painting your darks. Also remember that the darkest dark does not have to be mixed on the palette. You can build your darks with several transparent layers.

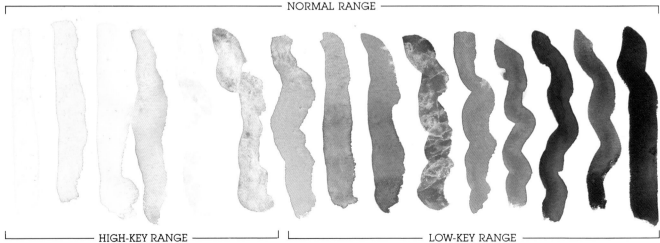

NORMAL RANGE

HIGH-KEY RANGE — LOW-KEY RANGE

Taken as a whole, these strips of color represent the normal value range in the still life I used for my paintings here. You can also see the high- and low-key ranges. It's a good idea to quickly make a similar chart yourself to get a feel for controlling the values of various colors before you render objects with them.

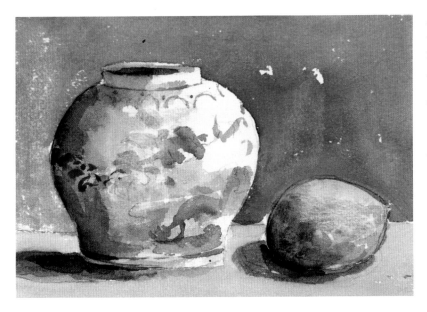

Normal Value Range. *The lightest lights—formed by the white paper—appear as highlights on the vase and as random flecks of light in the background. The darkest darks suggest areas of little or no light—the inner rim of the vase and the point where the objects sit on the ground plane. In between these extremes, there are various light, dark, and middle values.*

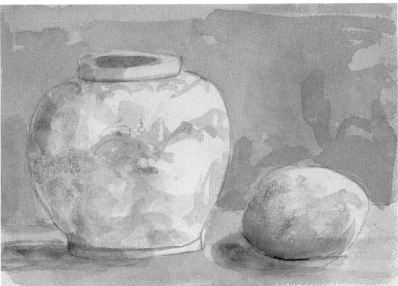

High-Key Value Range. *Here the values are restricted to the light to middle range of the normal value system. Because subtlety reigns in this system, I've expanded the color in certain areas like the shadows under the objects and on the side of the vase to clarify the forms.*

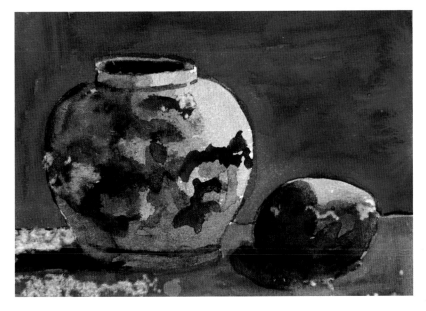

Low-Key Value Range. *This example has been pushed down into the lower value register, from the middle to dark end of the normal range. Notice how I've accentuated the contrast between the reds, greens, and blues to help define the forms. Also notice how, even within this narrow range, there's a feeling of drama to the lights and darks. Experiment on your own with different mixtures and with applying layers of color to improve your skills in creating clear, expressive darks. All too often students don't go dark enough.*

This splendid little painting by Lori Hahn exhibits the normal value range. The intervals between values are remarkably even as they move from the darks to the paper-white, reinforcing the clarity of space and form.

Lori's low-key painting is almost too subtle. While the light is un-mistakably low-key, I don't feel that the values are dark enough, and I definitely think that the color could be varied more. Drama and light can still exist in the low register. This is the most difficult part of the problem for most, so follow the instructions to the letter, and push a little further with color and value.

In this high-key version, Lori has again clearly articulated the space with well-placed planes. The bleached light of the high-key system is quite evident.

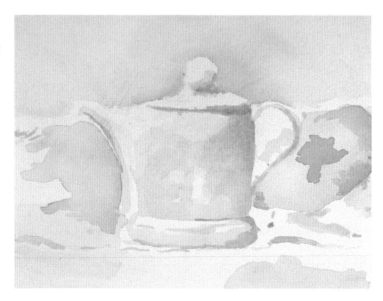

All examples by Lori J. Hahn, student work, 6″ × 7″ (15 × 18 cm)

46

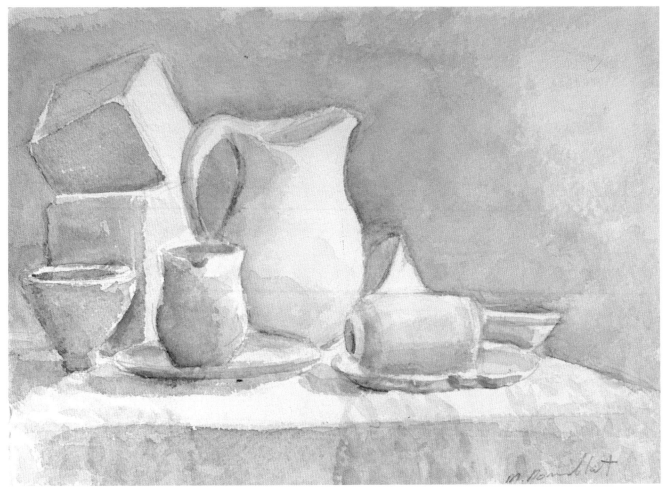

Marcy Rosenblat, *Still Life*, 9½" × 13" (24 × 33 cm)

Marcy Rosenblat is an expert in using the sometimes elusive high-key system, and her work beautifully illustrates the quiet, parched light of this system. In this still life, constructed of an array of the geometric solids, she relies on subtle variations of grayed blues, greens, and reds. The red dominates the painting, but the blues and greens gain some emphasis from their isolation. Marcy manages, with well-placed whites, to transform a very close range of values into a seemingly broad one. Remember that bright whites make adjacent values seem darker than they are—allowing you to dredge a lot of mileage out of a limited system.

Regina Tuzzolino excels in working in the high-key range, a system I personally find the most difficult. In part, her success in this landscape stems from the prolific brushwork, which brings an additional visual element to the limited system. Regina has also varied the color, with the sky moving from blue to purple and the ground from green to yellow. Notice how the triangular cloud is turned over and repeated down into the landscape. This strong compositional device forms yet another loud voice in the relatively quiet domain of high-key color.

Regina Tuzzolino, student work, 15″ × 10″ (38 × 25 cm)

Colleen Tully, student work, 14″ × 19″ (36 × 48 cm)

Colleen Tully's abstract painting beautifully illustrates a low-key range of color. Although the colors are dark, the relationships and contrasts are intense. Are the two glowing verticals in the dark field or behind the dark field? When a painting promotes this kind of interrogation, some form or idea is operating on more than one level, playing more than one role. There is a sense of mystery and intriguing ambiguity. Here the dark, warm smears of yellow and orange speak to me of a ritual fire burning in some distant night or of the evening's sun igniting the doors of a darkened room.

DAY 6
Washes

Most of the time I use the word "wash" to describe a lot of water and a little pigment sloshed onto the painting in the early stages, usually loosely defining large shapes. That's essentially what a wash is, but today we'll look more closely at four basic washes: flat, graded, wet-in-wet, and irregular. These washes can have specific uses—you might, for example, use a graded wash to indicate the sky plane, making it lighter as it approaches the horizon. Or you can use a wash as an unpremeditated underpainting.

I find that painting into color other than white offers alternative ways of constructing light through color, as well as new color variations. Remember that watercolor is a transparent medium. Painting on an orange, a blue, or a gray ground will drastically alter the colors you apply, but it can also unify them with a common constituent color.

How do you apply a wash? To prepare, take a wash cup, saucer, or similar container. Mix pigment with enough water to cover your paper. Go ahead and mix too much. Finding yourself short is a disaster. If you're not using a block, attach your paper to a board or another rigid surface. Now try each kind of wash.

Flat Wash. The goal is to produce a flat surface of color. You have probably already tried to achieve this and more than likely failed. Continuous brushing over an area will flatten oil or acrylic paint, but watercolor behaves differently. The more you pass over an area, the more unwanted blurs, spots, and runs occur. The proper technique, however, is simple; it's based on gravity. Follow the directions carefully and you'll have no problems.

In a well, mix what you feel is enough color and water to cover the sheet you're working on. Be careful not to make too dark a value. This wash will serve as an underpainting. Although you want the color to infiltrate, you don't want the painting to become too nocturnal. A medium-light value will suffice. Test it to be sure.

Set your board or block on a slant. I raise the top edge about one-and-one-half to two inches off the top of the table. Load your one-inch flat brush with paint and make a pass horizontally across the top of the paper. The paint will move downward, with a bead forming at the bottom of the stroke. Load the brush again, and make the next pass a little down the page, in the opposite direction, slightly overlapping the first. It's important to pick up the bead on each pass. Don't waste time; a line can form. It's also important to reverse the direction of the stroke with each pass. This will prevent a buildup of darker pigment on one side of the page. Repeat the process until the paper is covered. Squeeze your brush dry and use it like a sponge to collect the excess wash that has collected at the bottom of your paper.

Fine papers contain rabbit-skin glue as a binding medium. This glue may affect your wash by resisting the pigment, resulting in little spots of white randomly dispersed over the paper. Do not go back in to remove them. I'm always thrilled to have these sparkling "errors" in my wash. They are yet another example of the many unexpected happenings in watercolor that foil attempts at "perfect" technique. (Thank heaven!) You can, however, soak and stretch the paper for fifteen minutes to remove the size, facilitate flow, and prevent the flecks of white.

Graded Wash. This wash should be graded from dark to light. Mix a darker value than in the flat wash. You'll need only enough for one pass. Make the pass across the top of the sheet, clean the brush, and continue the process, as in the flat wash technique, but use clean water for each pass instead of color. You'll be dragging down decreasing amounts of color each time, thus grading the value. Handle the brush just as you did in the flat wash, slightly overlapping each pass, picking up the bead.

Wet-in-Wet Wash. This wash takes advantage of some of the indeterminable qualities of watercolor. Wet the paper thoroughly with a sponge dipped in clean water. Proceed with the technique for the basic flat wash; then immediately go back in with random strokes of darker color, and let the pigment run wherever it wants. Do not wait too long after applying the basic wash, as hard, sharp shapes will form.

Flat Wash

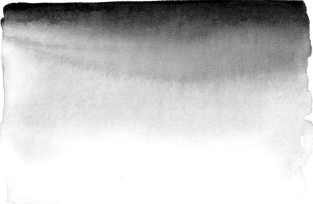

Graded Wash

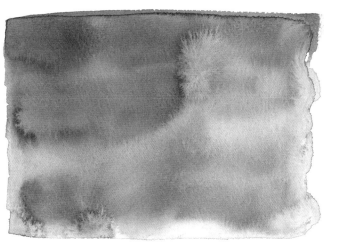

Wet-in-Wet Wash

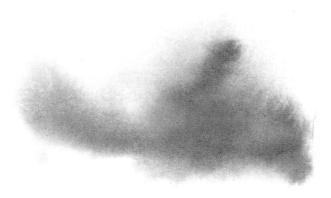

Irregular Wash

Irregular Wash. This is my favorite, as it produces very irregular and often stunning effects. Flow clear water over the entire paper surface. While the paper is very wet, drop in dark pigment on top. Pick up one corner of the sheet and let the color flow as much as you wish, in any direction. Lay the paper down flat to stop the action. Should you want to blend some, or all, of the streaks together, change the angle of the paper.

Painting Ideas. With all of these washes, you can lift out shapes with tissue while the wash is still wet or scrub lighter values out of the dry wash with a hard bristle brush or eraser. After the wash is completely dry, you can superimpose another color using the same or a different technique. You might, for example, paint a flat blue wash over a graded pink wash or a graded yellow over a wet-in-wet blue wash.

Use each of the four wash types as a random beginning for a painting. Do not worry if the color or texture does not seem to fit the subject. It's usually better if it doesn't. Vary your subject matter from painting to painting. Remember that the paper-white has been completely removed or at least significantly diminished. The lightest light is now the underpainting, so push your values to prevent too close a range. Observe carefully the effects of the dominant underpainting color, as well as of texture and gradation.

For my painting outings in Italy, I am always prepared not only with an assortment of pre-cut sheets of paper, but also with several pre-painted washes. I make these ahead of time in my room, so they're dry and ready to paint on. I vary the colors and kinds of washes at random, with no specific plan in mind.

Here I chose a flat, pink wash to paint the dome of a cathedral in Florence. It was a fiery, hot afternoon, so the warm underpainting seemed appropriate. I was pleased with the way the pink enhanced the light on the dome itself and warmed up the blue sky and blue-green hill in the background.

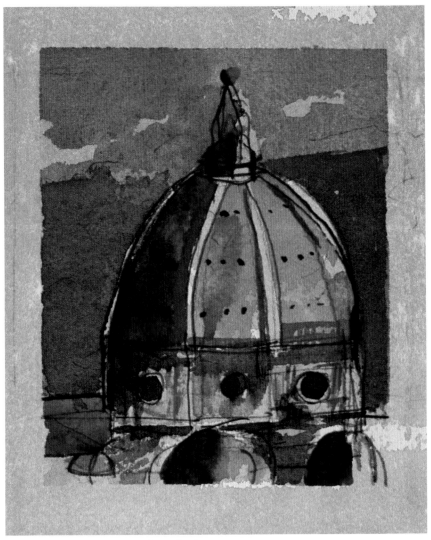

Michael Crespo, *Il Duomo*, 5" × 4" (13 × 10 cm)

In this painting Julyn Duke successfully overcomes an extremely dominant underpainting. A graded red-orange wash was painted over a flat, yellow one, resulting in a fiery tone, more likely to suggest an abstraction than a still life. Overpainting can never quell such a pervasive ground, especially in transparent media. But Julyn doesn't attempt to neutralize it; instead, she enhances it. She has forcefully modeled the space with gray values. A cool gray seems to surface at the top of the painting, where the color is not as strong due to the gradation of the wash. Julyn has reinforced the orange fruit with an even more brilliant orange, pulling it ahead of the pack a little. Overall, this painting works on value modulations permeated by the paramount breath of heat—a still life ablaze.

Julyn Duke, student work, 7" × 11" (18 × 28 cm)

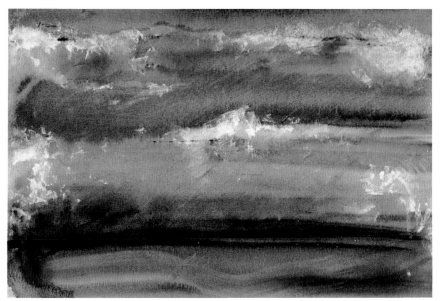

Joel West, student work, 9" × 13" (23 × 33 cm)

Joel West set out to make a routine wet-in-wet wash. As he worked, he began to see images of a nocturnal sea in the wet meanderings of the wash. With a crumpled tissue, he pulled shapes of breaking waves out, and the painting was finished. A simple technique produced a complicated mass of values, which, with slight modification, became a lovely, effortless, evocative statement. Of course Joel had to be paying attention. The lesson to learn—always be looking for a painting.

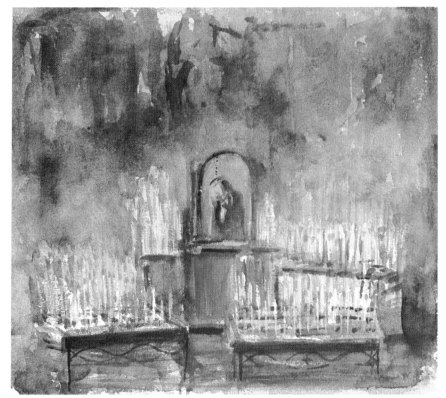

Michael Crespo, *Altar to the Virgin*, 11½" × 15" (29 × 38 cm)

Two irregular washes were the basis for this smoke-filled painting. In Florence one morning, my wife and I were caught in a sudden, violent storm while across the river Arno. We sought refuge in the church of Santo Spirito, where the only light was from an occasional spark of lightning and hundreds of candles burning in praise of the Virgin Mary. Later that afternoon, in my room, I sought to paint the indelible impression the morning had left in my eyes. First, I made a rough sketch and applied some masking solution to keep the candles paper-white. Next I laid in a light pink, irregular wash, agitating the paper furiously while the pigment flowed on the wet surface. I allowed this to dry thoroughly before wetting the paper again and repeating the gyrations, this time with Payne's gray. When this was dry, I removed the masking solution and painted the altar into the billowing atmosphere the washes had established.

After doing an initial drawing, Cheryl Trask laid in the wet-in-wet background wash. She controlled the wash, ending it along the top edge of the pitcher and drapery, and blotting any overruns with a tissue. When the wash dried, she painted the rest of the still life. In the finished work, the streaked, undulating wash serves as a fine rendering of drapery folds, as well as a delightful counterpoint to the strictly articulated objects.

Cheryl Trask, student work, 11" × 15" (30 × 38 cm)

This painting involved an elaborate series of washes. First I painted the bird, the water he's walking in, and the leaves on the bank. Then, after everything had dried completely, I added a flat, brown madder wash, which I altered with some blotting. This wash was painted over the bird, plants, and other areas. Next I applied a flat wash of cerulean blue, which I varied by using a mixture with a little more pigment for some of the strokes. I also allowed some of the strokes to set a bit before continuing. This resulted in the streaks in the sky. Finally, I dragged down a graded wash of indigo, which is particularly heavy at the top.

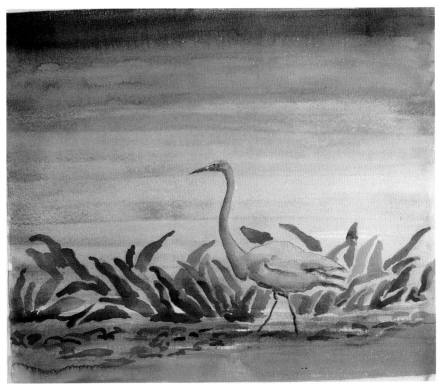

Michael Crespo, *Great Egret*, 14" × 16" (36 × 41 cm)

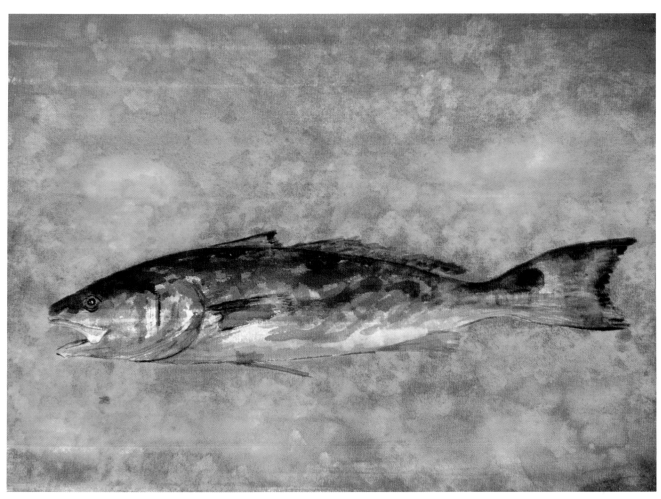

Michael Crespo, *Redfish Feeding*, 21″ × 29″ (53 × 74 cm)

The image of the redfish is sandwiched between two washes in this full-sheet painting. First I laid in a standard wet-in-wet wash of light yellow-green, which produced large, horizontal irregularities. I then painted the fish. When he was dry, I quickly, with a large utility wash brush, laid in a dark blue-green wash over everything, including the fish. While this was still wet, but drying fast, I stippled, using wads of tissue paper with blinding speed and both hands. I began with the fish, so as not to lose the warm and light tones, and worked out to the edges. The result is a heavily mottled surface, which I love to look at (and love even more to paint).

DAY 7
Wet-in-Wet

Beginners often encounter problems when working on wet paper. But you can turn this liability into an asset and use the wet-in-wet technique to obtain some stunning effects.

One of the most exciting aspects of watercolor is the way the paint flows on the paper. When you work wet-in-wet and let the water follow its own course, you can enhance the ephemeral and fleeting quality of watercolor. This technique will also encourage you to think differently about composition. You can't rely on the usual defining brushstrokes or hard edges. Instead, you must compensate for the soft edges and slightly blurred focus with stronger value and hue contrasts. You have to apply the paint boldly to get interesting results.

For today's exercise, assemble any objects of your choosing, but don't let the setup become too simple. I suggest a vase of flowers with an assortment of fruit at its base and a brightly patterned drape behind.

From this setup, make three paintings, using slightly different techniques:

Direct Wet-in-Wet Painting. For this approach, wet your paper thoroughly in a sink. Shake off the excess water and set the paper down on a board. Don't do any preliminary drawing; just start blocking in the composition with paint. Remember to use strong color. And pay attention to what's happening as you paint. Working wet-in-wet implies a certain freedom from control, but you must learn how to use what happens to your advantage.

If the paper begins to dry, either drop more water on it or wet the board beneath the paper. A nonporous surface helps to maintain wetness. I use Masonite covered with formica—the kind used in bathroom construction—which is available from any building supplier. In any event, work fast.

For this exercise, if you want some linear structuring, use the handle of your brush or some similar point to etch into the wet paper. The pigment will then accumulate in the scratches, forming dark lines of color.

Wet-in-Wet with Line. Now take a different approach. First make a pencil drawing of your setup—before you wet the paper. Then proceed as before, only this time base your flow of paint on the structural line drawing. Don't, however, let the line restrict your paint flow. See if you can be just as free when you use line as when you paint directly.

Wet-in-Wet within Shapes. On dry paper, paint intricate shapes with clean water only. Immediately drop in a variety of colors. The edges you have defined will hold, but the colors will run rampant within the wet shape. This is a very useful technique, which you can use either for a whole painting or part of it. The shape is controlled, but within its edges, the pigment flows freely and spontaneously.

Direct Wet-in-Wet Painting

Ellen Ellis, student work, 12″ × 11″ (30 × 28 cm)

Wet-in-Wet with Line

Elizabeth Jenks, student work, 15″ × 10″ (38 × 25 cm)

Now let's apply these three different wet-in-wet approaches to some of the problems we've encountered in earlier lessons. You may wish to change setups for this part of the exercise. Indeed, at one point you'll have to, because I'm going to ask you to attack a landscape.

Variation 1. Review what you learned on Days 4 and 5 about color temperature and value. Then, using the first technique—working wet-in-wet directly—do two paintings. In one make warm, high-key colors dominant; in the other use cool colors in a low key. With all the water saturating the paper, it should be easy to keep your colors light in value for the high-key painting. For the low-key painting, however, you'll need more potent mixtures to get dark, brooding values.

Variation 2. On Day 2 you mixed various grays from the primaries and then used these grays to create dramatic lighting in a painting. Repeat that exercise, working with the second wet-in-wet technique, the one incorporating line. On Day 2 it was imperative to let each stage of your practice painting dry before going on to the next stage. Now, however, you must keep the painting wet at all times. I recommend that you mix all the grays before you begin painting. Don't try too hard to achieve neutral colors; let traces of the primaries tinge your grays to give the painting more color.

Variation 3. The third technique—painting wet-in-wet within shapes—is a natural to use to review the lesson on shape and color composition (Day 3). Choose a landscape setting and fill your paper with shapes based on what you see. Draw these shapes in pencil—in this way slightly varying the third technique. Now return to your studio to do the actual painting, working wet-in-wet within the shapes you've drawn. Use a lot of color, but do not let the shapes run together. Instead, leave little lines of paper-white between them, or allow one shape to dry before painting an adjacent one.

Wet-in-Wet within Shapes

Regina Tuzzolino, student work, 10″ × 7½″ (25 × 19 cm)

Variation 1 (Hot). *This high-key warm painting, based on a setup of summer squash and a green apple, was done by working wet-in-wet directly.*

Variation 1 (Cool). *The same technique—working wet-in-wet directly—was used for a low-key, cool painting of three plums on a blue-green drape.*

Variation 2. *The exercise on the "movement of grays" (Day 2) was repeated using wet-in-wet technique with line. Although the wet-in-wet process allowed the grays to merge more, the dramatic effect of light was still achieved. I'm actually more partial to the muddled, less defined forms.*

Variation 3. *Following the third technique, a variety of colors were dropped into the same wet shape. The mingling of these colors gave this painting an undulating space. You might try repeating the process in the same shape, letting the initial mingling dry and then applying the clear water and pigments a second time.*

Elizabeth Jenks, student work, 15″ × 10″ (38 × 25 cm)

In Elizabeth Jenks's explosive version of the standard wet-in-wet technique, any semblance of the still life is drowned in the deep puddles of water that produced the wild dispersal of color and form. Working with such uncontrollable amounts of water and waiting in anxious glee for the unpremeditated results may seem almost too much fun, reminiscent of making "spin-art" paintings at a carnival. Don't feel guilty, indulge yourself once in a while. Run out to the limits and back. Elizabeth did!

Christy Brandenberg, student work, 12″ × 8″ (31 × 20 cm)

Alice Verberne, student work, 20″ × 15″ (51 × 38 cm)

How wet to make the paper is up to you. Here Christy Brandenberg worked wet-in-wet into defined shapes, but with a slightly drier surface than in the other examples. Consequently the paint does not mingle as drastically. The wetness varies in her painting— obviously, the blue ground plane was wetter than the two flowers. In a few places, Christy has gone into dry paper to establish a focus—a practice you should always consider at the end of a wet-in-wet painting. Never substitute attempts to remain a "wet purist" for a necessary solution to the painting. The same applies to any other technique. Vision brings technique. Rarely does technique bring vision.

Also notice Christy's effective use of white. The large mass at the top cascades down in rivulets, defining the edges of everything.

Alice Verberne has successfully combined two techniques in this floral study. First, she wet a large area of the paper, from the bottom left up and across to the top right. Following standard wet-in-wet practice, she dropped in color. When this was dry, she developed the right side, working wet-in-wet within shapes. In the painting these appear as relatively sharp-edged flower shapes and stems. (You can also see a few in the top left area of the bouquet.) This technique proved an excellent way of establishing focal points.

Alice's color choices are also effective. She has based the painting on the complementary colors red and green, with the reds ranging from red-violet through red and orange to yellow and the greens going from blue-green to yellow-green. The result is an affable blend of warm and cool temperatures—a perfect day, you might say.

Deana Houston first laid in the warm, brownish orange over the entire ground plane and apple shapes. In this instance the paper was not soaked first; rather, the initial wash served as the base on which to proceed. Into the wet wash Deana maneuvered a cool, blue-green gray, which became the shadow color. She was careful to leave some white shapes on the apples as highlights. Next she added darker blue-greens and oranges to give the apples volume. Finally, when everything was nearly completely dry, she painted the dark stems and shapes at their bases.

Keep in mind that, unless you continue to dampen a wet-in-wet painting, the drying process continues, making your brushstrokes progressively more defined, from early blurs to sharp accents. This technique can be very desirable as it layers different focuses in the composition, and any layering creates a sense of space. Deana has made subtle use of this effect here.

Deana Houston, student work, 12" × 16 (30 × 41 cm)

I have sat across the river from Florence a hundred times and questioned, with my brush, the color, form, and magic of the skyline that marks this most exquisite of cities. I began this particular painting with a flat gray wash. After it dried, I sketched what interested me out of the thousand possibilities the panorama offered. I then painted the broad, blue plane that denotes the mountain range behind the city. When this dried, I carefully soaked the entire painting in clear water, shook it off a bit, and quickly painted the rest. When finished, and when the paper was almost dry, I spotted the small dark windows here and there.

Michael Crespo, *View of Florence*, 11" × 14½" (28 × 37 cm)

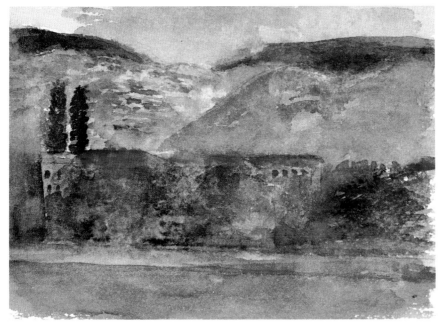

Michael Crespo, *Villa Downriver*, 5½" × 7½" (14 × 19 cm)

This painting illustrates the enigmatic air that the wet-in-wet techniques can impart. I worked this painting a long time, letting it almost dry, then wetting it again, and smearing the edges of almost everything that was in focus. Finally I stopped, disappointed with what seemed altogether vague, nothing but a fuzzy, red roof line and two dark poplars. I stuffed the painting in my bag and sought out a favorite cafe.

Days later the picture surfaced out of a stack of sketches, and I was beside myself with the joy of accomplishment. My little, senseless blur had become a wonderfully faint disclosure of the mystery that permeates the Tuscan landscape. The simple passage of time can be a great studio assistant. If you can't solve a painting, put it out of view for a few days. When you confront it again, your eye will be more objective, quickly discerning its success or failure.

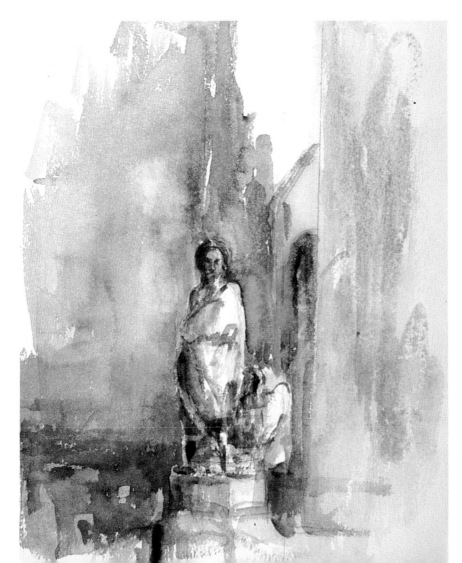

I don't particularly care for this statue itself, but I painted it in homage to the great poet. I started this painting on a very saturated piece of paper, which I allowed to dry in its own time while I painted. With this technique, the later marks tend to speak with more assurance than the early ones. The statue was surrounded by busy architecture, automobiles, motorcycles, bicycles, and people. To suggest all that, I simply slopped in some wet paint. Similarly, I tried to make Dante appear without laboring the entire afternoon on the tedious sculptural ornaments that surrounded his legs. After settling on some sketchy details, I finished the painting by trying to vary the color as much and as subtly as I could.

Michael Crespo, *Monument to Dante, Piazza Santa Croce*, 15" × 11" (38 × 28 cm)

DAY 8
Two-Day Glaze

A well-known oil painting technique is to make a drawing and then develop the forms and light in one color—usually black—with white. The painting is completed in every detail except color. After this underpainting, or *grisaille*, is dry, colors mixed with a transparent medium are glazed over it. The value changes and linear detail are all in the underpainting and are seen through the transparent overlays. Sometimes many colors are glazed over a single form to produce a deep luminosity.

Since watercolor pigments are naturally transparent, you can employ a similar technique.

Work from a relatively busy still life, or choose an interior view. Whatever you decide, make sure that there are a number of color changes. I don't recommend a landscape for this exercise because the tendency is to make everything green, and I want you to use a range of color.

This painting will be made in two days, or with a reasonable amount to drying time between the two stages. I suggest that you take the two days to do it. The first stage will probably take some time. If you work fast, do two paintings.

Begin with a light pencil drawing. Mix a neutral gray from alizarin crimson and phthalo

Monochromatic Underpainting. *The spotted drapery, the ornate pitcher, and the repetitive chilies in the jar gave a decorative emphasis to this subject. I modeled both vases and the pitcher, however, to suggest their volume. At this point I did not really know what to do with the chili jar, so I left it flat, marking the peppers a little. I laid in a slightly wet wash in the background, left ample paper-white on the objects and ground plane to signal the strong light from the right, and punctuated the entire composition with some very opaque darks.*

green. These two colors have great staining power, which is desirable in an underpainting. Other good colors to use in an underpainting are burnt sienna, phthalo blue, lemon yellow, viridian, cobalt blue, rose madder, Winsor red, and violet. The more opaque colors—such as ultramarine blue, cadmium red, cadmium yellow, cadmium orange, and yellow ochre—tend to mix into the overlays. I would avoid them in an underpainting. If you have to use one, don't apply it too thickly and use a light touch for the overpainting to avoid agitating the pigments underneath.

Develop this painting with an eye to value and light. Don't hesitate to employ what you have learned about wet-in-wet and other techniques. Complete the painting to the final details. You want a strong value range, so leave some white paper (if in doubt, leave a lot of white). Also make sure you find some full-strength darks. I cannot stress the importance of this enough. In the next stage you will be glazing over color,

which will lessen the crispness of the value, so it must be overstated.

When finished, allow the underpainting to dry until the next day. Time away from a painting sometimes brings a fresher, more open-minded approach. The next day begin by painting color over the value painting. Traditionally this overpainting was flat, but it can be exciting to vary your technique. Choose a value slightly lighter than middle. If you are hesitant, start with pale values and build them up as you gain confidence. If you established a strong value range in the underpainting, then you will have a dominant structure to build upon. If you did not, add some dark colors as you near completion. Vary your color by using different mixtures. Also try mixing with transparent overlays—painting yellow over a dry blue to make green, for example. Some artists like to leave some of the white paper throughout. It is not necessary to cover all of the underpainting.

Final Version. *After much deliberation, I decided to preserve the lively, airy underpainting by keeping the color light, definitely not overworking it. I played on complementary colors, blue and orange; then dusted in a faint green on the chilies. Although I ended up covering most of the whites, I did leave some small shapes here and there for articulation. As for technique, I kept this one straight and flat, with little invention or variation. I was very pleased with the energy of the grisaille and didn't want to tamper with it too much.*

Monochromatic Underpainting. *This underpainting is less decorative and more atmospheric than the first. I employed a variety of wet-in-wet techniques, seeking a softer, more mysterious rendering. There was as much blotting out with tissue as painting in with brushes. Notice the drips and splatters in the ground plane. On the shells I flicked a script brush to create the broken contour lines. All in all, this underpainting was done more as a continuum than as a description from part to part.*

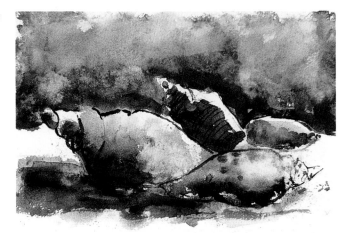

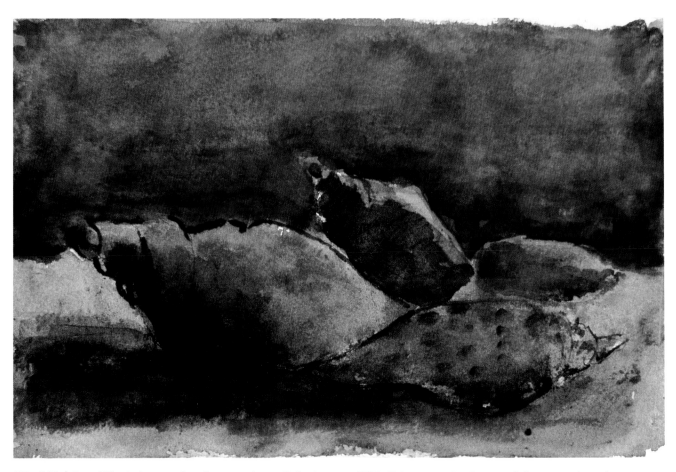

Final Version. *What do you do when you're satisfied with the underpainting and see no reason to go on? I often confront this dilemma, but even then I wonder: what would a little color (or a lot) do? Usually I just can't stand wondering anymore, so I do something. That's what I'd recommend: always do a little something, even if it's just adding some extremely light washes. Try to lead the gray underpainting into slight color variations, perhaps giving some temperature readings. If the underpainting "works," it will be next to impossible to destroy it; if, however, the underpainting is shaky, it's a toss up whether you'll be able to salvage it or not. In any case it's definitely worth the gamble.*

With this example, I was a bit unsure how to proceed with color. I decided that the shadows of the shells should be cool, with warmth surrounding them. To disturb the symmetry of this notion a little, I laid in cool washes on the foreground shell, including it in the shadow temperature. After developing the cool bluish areas, I began to lay in the background, using five or six different warm washes, letting them dry between coats. I also deposited each background wash somewhere in the bottom of the painting, either on the shells or on the ground plane. I simply continued building these washes until I felt that the color saturation and the value modulation were "right."

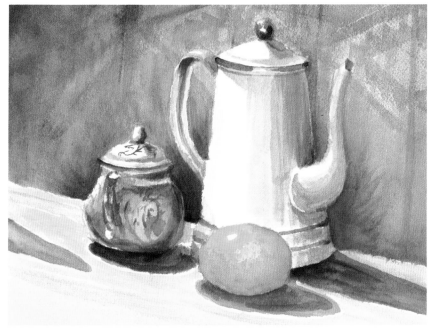

Joe Holmes, student work, 9½″ × 12½″ (24 × 32 cm)

Joe Holmes's color changes subtly with the value, moving in and out of the shadows. To achieve these delicate nuances, he carefully detailed the underpainting. Look closely at the methodical vertical striping in the coffee pot, which suggests its volume; the gentle stippling in the tangerine; and the decorative handling of the sugar bowl and the wall. Also notice the powerful diagonal design. If you're not careful, diagonal lines can be very fast, moving the eye too quickly across the objects along them. Here, however, the tangerine has enormous strength, both in color and central placement; the whites of the coffee pot glow against the dark surroundings; and the sugar bowl has a complex form. All these devices stop the eye in its race across the diagonal and make it linger on the objects for a time. So there are two opposing concepts, the fast diagonal line and the slow triangle of volumes, both in the same painting, adding an exciting tension to the space.

Also intriguing is the shadow cast into the painting from the left, from an object outside the painting. This shadow serves two important roles. It evokes mystery, making the viewer inquisitive about the unseen object. It also echoes the shape of the coffee pot's shadow, joining in its rhythm.

Madeline Terrell's underpainting was very detailed, especially with regard to textures. In the finished version here, she explains with her brush how the shell, ground plane, background, and vase would all feel different in our hands. There is also a forceful value range, with deep darks and key white-paper highlights. Remember that the value usually diminishes somewhat when you glaze over it.

Madeline's color is limited, but effective. She has used the "color on a gray field" system: the pinks and blues at the top and dark blue and red in the center are all contained in a field of warm grays. Also effective is the placement of the commanding red in the compositional center.

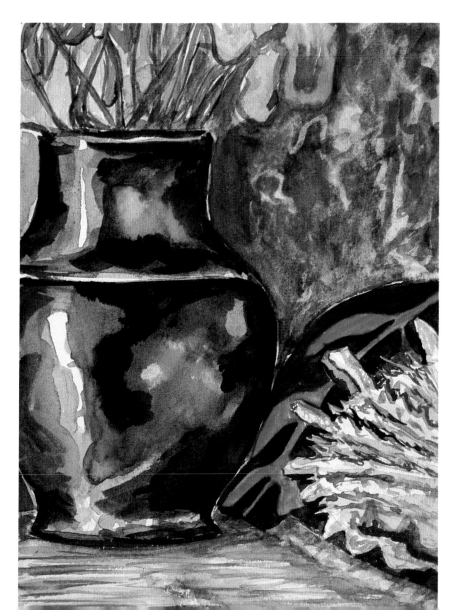

Madeline Terrell, student work, 9½″ × 6½″ (24 × 17 cm)

DAY 9
Within and Without

A volume can be constructed from within its boundaries, or it can exist because of its surroundings. Look at the drawings of Michelangelo to learn about this. There are drawings of single figures on blank white fields. Within the defined edges of the figure, he has densely packed rippling waves of musculature. This exaggerated activity, like a wound spring, pushes against the contour lines and the picture plane, rendering the illusion of mass and volume. The energy of the form is within. There are other works where the figures are only lightly, if at all, touched with drawing, but the space surrounding them is teeming with activity. These figures seem to buckle out of the paper, much in the way a volume is formed if you press your hands into wet clay, forcing a shape to emerge between them. The energy is without.

Also look at the still life drawings of Giorgio Morandi, which are distinguished by obsessive crosshatchings of ink lines. In some, the crosshatchings are concentrated on the objects. In others, they comprise the field surrounding the objects. Then study the watercolors of Paul Cézanne. I recall a skull almost entirely void of markings, but around its perimeter is a maze of multicolored brushmarks. In another work there is

a bottle heavy and dark from layers of transparent planes.

Working within or without is not just a technique—it can play an important role in composition. When you use both methods in the same painting, a dichotomy is produced, forcing a spatial irony. Use this as a compositional cornerstone on which to build.

To set up a dichotomy, choose two objects: one that will promote internal painting (for example, an object with a lot of texture or multiple facets) and one that is simpler, perhaps with a smooth, expansive surface. The challenge is to paint one object from within and one from without, and yet keep the painting as a whole coherent. For one object, then, devote the majority of your marks to its interior. For the other, keep as much of your work as possible in its surrounding environment. But don't make this an absolute; you need transitions from one method to the other. While constructing the object from without, make some definitions within as well, and vice versa.

I suggested that you use two objects of different textures. It's probably easiest to begin by painting the obvious. But it can be interesting to reverse this and to paint the heavily textured object from without.

This drawing bluntly shows the basic concept discussed here. The circle on the left is transformed into a sphere by the markings inside its contour, while the one on the right gains volume through the activity outside its contour. There is some light modeling within the right form, but the predominant force is the surrounding crosshatching. Similarly, there is a trace of subordinate activity surrounding the left sphere. Note the disjunction in space from the contradicting techniques as they lie side by side.

This still life consisted of a preserved crab and a white ceramic sugar bowl. Mylene Amar chose the obvious route: painting the crab from within and the bowl from without. She has described the intricate lines of the crab's armor in fair detail, while marking the internal shape of the bowl with only faint planes of barely perceptible color. Behind the bowl, the colors and markings are intense, but notice how they gradually fade as they move away, toward the crab. To develop this rear plane, Mylene first applied faint colors wet-in-wet to stage the atmospheric lack of focus. As this dried, she built up the area surrounding the bowl in both focus and color.

Mylene Amar, student work, 10″ × 14″ (25 × 36 cm)

In another approach to the same problem, made from the same still life, the concept is treated in much subtler fashion. Marcy Blanchard has painted the floral background in broad, lilting shapes, unlike Mylene's textural treatment. The impact of the background on the softly bulging bowl is of a different nature. Instead of forming an explosive edge, the broad red and green shapes gently nudge the volume into existence. There is some linear description of the crab, but Marcy has concentrated her efforts on modeling the planes of the claws and shell in delicate grays and oranges. Although this painting may be less dramatic than Mylene's, I consider it a successful solution to the problem.

Marcy Blanchard, student work, 9″ × 11″ (23 × 28 cm)

Michael Crespo, *Still Life with Orange and Cabbage*, 6″ × 11″ (15 × 28 cm)

I have always loved to play with two objects in a painting—the conversational potential between two voices is simpler and thus more easily observed. Here I reversed the obvious ploy in rendering the relatively smooth orange and the striated cabbage wedge. For the orange, I invented a multilayered surface of abbreviated brushstrokes, while I reduced the cabbage to a simple white rock, faintly described. In line with this, I intensified the striped background around the cabbage shape, but let it fade as it moved behind the orange. I also made the ground plane more agitated under the cabbage. As a final embellishment, I inscribed some pencil lines in the pale background behind the orange so as not to lose the effect of the stripes completely and to make the transition across the back less abrupt. Remember that transitional zones in the background and ground planes are key to successfully combining these two contrasting techniques within a single painting.

Michael Crespo, *The Black Vase*, 10½" × 14" (27 × 36 cm)

I must confess that I did not begin this painting with the idea of within and without, but later rescued the failing painting with the concept. Initially my intention was to show off the stark black vase and yellow pears against an intricately decorated background. All went according to plan, except the painting never did gel. I simply overworked it.

A month later, as I went through a stack of paintings deciding which to toss and which to attempt to save, this one flashed a message in giant red letters: "Practice what you preach—within/without!" There's never anything to lose, so I began the transformation by scrubbing out the busy background surrounding the pears (which I had chosen as the likely candidates for inside painting). I then scattered small planes across the pears to substantiate their volume. I also flattened the vase some by scrubbing in an additional wash of indigo, which is the base color of its blackness. The background here remained the same, as it was already quite active. The concept of within and without may have come in the "back door," but it saved this piece of paper from the trashcan.

DAY 10
Texture

So far your paintings have been based on perception. You began by looking at something. But during the painting process you had to work with concepts to translate three-dimensional objects into a two-dimensional composition. To suggest volume, for example, you modeled light to dark. Or recall your work with shapes and color from Day 3.

Now let's make a totally conceptual painting, one based on the act of painting itself rather than direct observation of a subject. As a motif, we'll explore different ways of producing texture in watercolor:

- *Tissue, paper towels, or napkins*. Use these materials to lift paint. Each leaves a distinct pattern, varying infinitely with crumpling.
- *Stampings*. Press anything that you can apply paint to onto watercolor paper: leaves, wine corks, and sticks, for example.
- *Sponges and brushes*. Lift wet paint off the paper with a sponge or a brush to create soft patterns of light. Also use the sponge as a paint applicator.
- *Brayer*. Apply paint, perhaps in several colors, to a brayer (the inking roller used in printmaking). Then roll it on wet or dry paper.
- *Squeegees*. Using matboard scraps or credit cards, drag pigment from one area of a wet painting to another, leaving interesting tracks, which vary with the paper texture.
- *Brush handle*. With the handle of your brush, scar or distress the paper surface, either just before painting or while the area is still wet, producing dark lines and marks.
- *Palette knife*. With a palette knife, dab or drag pure pigment on wet or dry paper. Use the edge to create very thin lines.
- *Toothbrush splatters*. This is classic technique! Scrub a damp toothbrush into pigment; then, with your thumb, pull the bristles back and splatter color on the painting. You can mask areas with torn or cut paper to control shapes.
- *Crayon resist*. First draw with white or colored crayons on the paper. The wax will resist any watercolor painted over it, leaving the crayon exposed.
- *Masking solutions*. Use these solutions, available from art-supply stores, to mask areas and build mazes of intricate pattern. Paint the solution directly on white paper or on previously applied color. Usually there's a dye to indicate where the solution is, and it can be easily removed with a rubber-cement pickup.
- *Blooms and water effects*. Touch water into barely damp areas of color. As the paper dries, these waterspots will form patterns. Also explore sprinkling, spraying, dropping, or brushing clean water into already dry color.
- *Salt*. Sprinkle coarse table salt on a moist area of color. Pigment will be absorbed by each grain, leaving texture variations. Dust off the salt with your hand when the painting is dry.
- *Wirebrush and sandpaper*. Try modifying the texture of the paper itself. Before painting, stroke a wire brush in one direction over the surface of the paper. Or lightly rub sandpaper over the surface, so it accepts more paint and becomes darker. Do not use coarse sandpaper unless you want scratches. But, if you want a rough surface, try scratching the paper with a knife or a razor blade; the pigment will then settle into these abrasions.

A word of caution, however: don't get addicted to these textures. In moderation they can be very constructive, but when used in abundance they can make a painting tricky-looking. Today—for this lesson—indulge yourself and see what can be done. But in general, be judicious.

As a way to begin, choose one of the following titles for your painting: "Ocean Grayness," "Red Crush," "Moonlight Sonata," "Dark Winds," or "Sun Scheme." Let the title set the mood, but keep away from recognizable subject matter. Instead, make a painting about texture using a few, many, or all of the textural effects just described. You might even invent some of your own. In addition to texture, play with color, line, shape, and value as the "subject" of your painting.

Lifting out with tissues, paper towels, and napkins.

Colors rolled with a brayer.

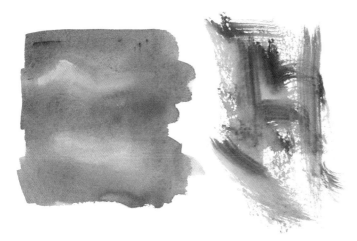

Left: shape pulled out with a brush (top) and a natural sponge (bottom). Right: paint applied with a cellulose sponge.

Left to right: stampings with leaves, wine cork, stick, orange peel, crumpled plastic bag, and packing foam.

Paper etched with a brush handle before and after the paint was applied.

Left to right: paint dabbed with a palette knife; paint dragged with a knife; knife worked into wet paint.

Paint pulled across the paper with a credit card.

Toothbrush splatters over torn-paper shape.

Crayon resists.

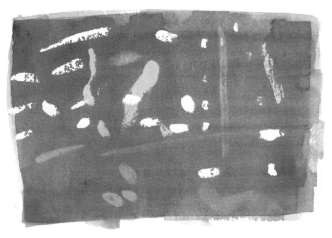

Masking solution applied and sometimes removed between washes.

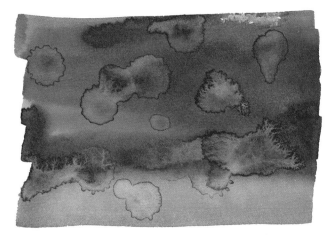

Waterspots.

Salt sprinkled in wet black wash over green.

Paper sanded with a horizontal motion before painting.

Paper scraped with a wire brush before painting.

Gloria Jalil, "Sun Scheme" (student work), 9″ × 13″ (23 × 33 cm)

Gloria Jalil's marks take on the look of bugs, flowers, and butterflies. She set up the background space with wet-in-wet blooms. When these were dry, she made stampings with leaves and a sponge. She has used this dry-on-wet technique very effectively, as there is a great spatial lunge from the hard marks on top to the soft billowing in the distance. I also applaud the wonderful sweep of movement here—up from the bottom left with the sponge marks, across, and down to the bottom right with the leaves.

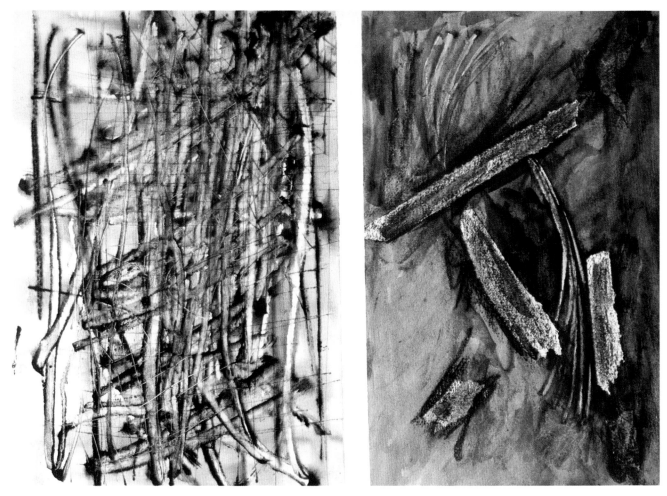

Colleen Tully, "Ocean Grayness" (student work), 30" × 20" (76 × 51 cm)

By laying a piece of masking tape across the center of the sheet before working, Colleen Tully has created a diptych—two separate paintings intended to be viewed as one. Although there are no flamboyant relationships uniting the two, some connections exist. Both contain depressed color, abundance of texture, and, most important, the marks of Colleen's ever-moving, slashing hand.

In the left painting she began with a series of sharply incised lines, cut in the dry paper with a knife. She then wet the paper and laid in the gray, yellow, and green colors. With a stick, she rubbed violently into the wet paint, making the fatter lines, which became more defined as the paint dried. When everything was completely dry, she sliced again with the point of a knife, which tore through to the paper and created thin white lines.

In the right painting Colleen tore masking tape, twisted it, and stuck it on the dry white paper to form the basis for the large white-edged shapes. Next she painted masking solution on, creating the feathery shapes. After laying on wet washes with squeegees, she removed the masking solution in stages so the feather shapes became multicolored. When everything had dried, she removed the tape and scraped black randomly across the paper, quieting all the shapes and pushing them into a murky abyss.

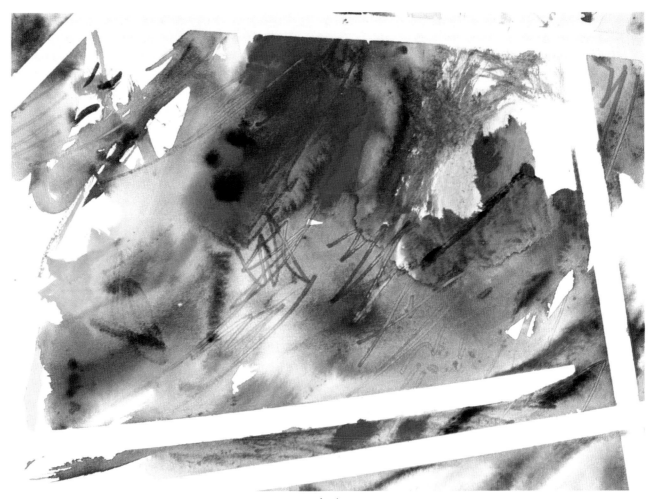

Royce Leonard, "Dark Winds" (student work), 10" × 13" (25 × 33 cm)

Royce Leonard has used masking tape to establish an out-of-kilter frame, roughly surrounding his various exploits within. Before dropping in paint, he sanded the bottom and used a wire brush at the top right, where the hairy green shape lies. He then worked with diverse techniques: wet-in-wet, salt, and scribbling with various instruments.

The mood of this painting is very different from that in Colleen's work. The purer colors here suggest a lighter tone, but the mark of Royce's hand is also distinctive. Where Colleen created a violent repetition of stabbing strokes, Royce has given us big, soft, amorphous shapes, and his calligraphy strikes a note of playfulness. This is not, by the way, a comment on the personalities of the two artists, just on their painterly intentions that day.

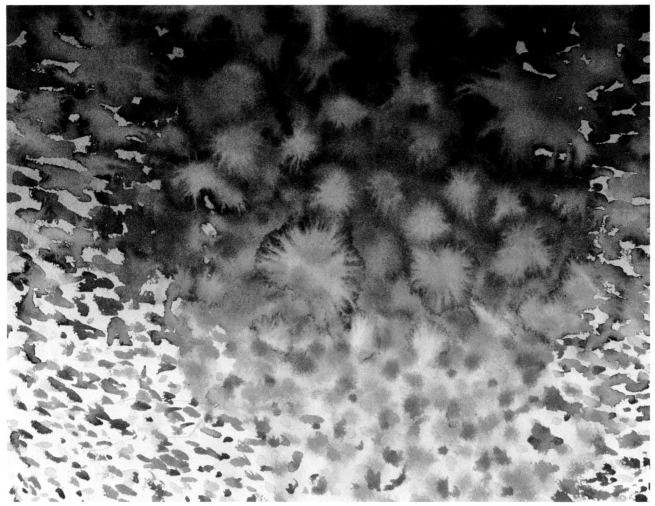

Julyn Duke, "Moonlight Sonata" (student work), 12″ × 14¾″ (31 × 37 cm)

Julyn Duke's painting suggests fireworks: small, dry shapes originate at the bottom edges, dissipate as they move up, and then culminate as exploding blooms of wet paint, cascading back to the bottom. To achieve this effect, Julyn first laid in the drier shapes and then added water in progressive amounts, until she reached the center zone, where she dropped in large amounts of water and more pigment. When you're working with such big puddles, be sure your paper is in a stationary, flat location, so it can dry undisturbed for hours. A hairdryer is useless with this much water, and may even be destructive.

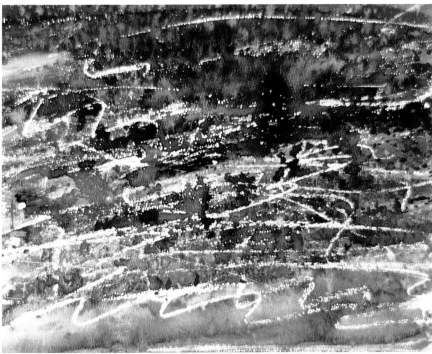

Deana Houston began this rendition of "Dark Winds" by making the scrambling lines with a white crayon. These lines remained as she dropped different colors into wash areas, varying in wetness, to form the horizontal bands across the composition. Close scrutiny reveals a myriad of small blooms and spots in this galaxy of blurs.

George Chow has projected a gentle, sweeping movement in this wispy texture painting. After laying in the blues and reds in a wet field, he dragged a credit card in a curving motion. He then punctuated this by using the same motion with the end of his brush. Overall I think there is a gentle balance of the soft, friendly colors and the swirling, muted textures.

Deana Houston, "Dark Winds" (student work), 11" × 13¾" (28 × 33 cm)

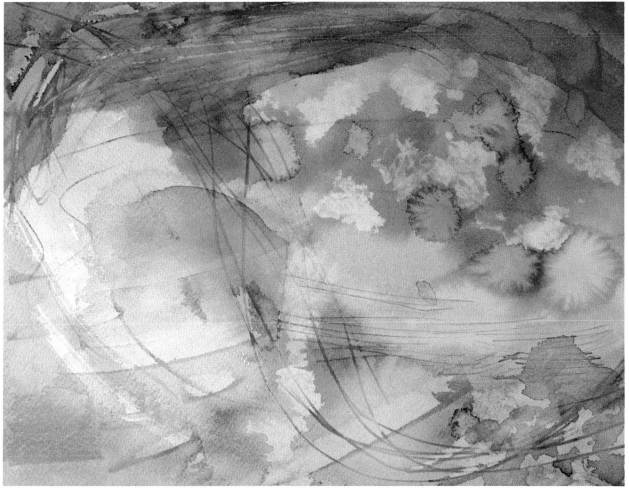

George Chow, "Dark Winds" (student work), 7½" × 10" (19 × 25 cm)

DAY 11
Linear and Other Beginnings

For all practical purposes there are three ways to start a watercolor. You are versed in two of them already: making a light pencil drawing and directly dropping in paint with a brush. It's time to look more closely at drawing with your brush and paint.

Day 1 included an exercise on the brush as a line-maker. You have probably used this technique in some of your paintings—to emphasize an edge, render a pattern, or just make lines for their own sake. What is the potential of line made with paint and a brush?

A line can have width. As you vary the brush pressure on the paper, the line thickens and thins accordingly. A spatial illusion is created, with the broader line usually appearing closer to the viewer and moving into space as it thins. Of course, this is not an absolute—it depends on the other elements in the painting.

A line can have value. As a line changes in value, its apparent position in space will change. Usually a dark line appears closest to the viewer, while paler lines diminish in the distance.

A line can have color. Red lines are aggressive and usually come forward in a painting. Blue lines are recessive. This is stating it bluntly; remember, the relativity of color can produce endless spatial surprises.

A line can emote. Short, staccato lines speak differently from long, undulating ones. Similarly, lines suggest different speeds as they move across the paper. The patterning, or rhythm, of lines can also invoke speed or emotion. By "emotion," I don't exactly mean happy or sad, love or hate, but more the way we individually sense and respond to the abstraction in all art.

To explore the potential of line, set up a still life with at least five objects of varying shapes and surfaces—the more unusual, the better. Try to include some plants or cut flowers, or similar "linear" material. The idea is to suggest as many kinds of line as possible with this setup.

With your no. 3 script brush, begin to draw from the still life directly onto the paper. Do not begin with a pencil drawing. Pay close attention to all the aspects of line discussed here. Experiment with very wet, as well as dry, mixtures of paint. Do not feel limited by the local color of the setup—

instead, change color frequently, at random. Also, remember that line does not just indicate edge—it can also move across objects, conveying their volume.

Use as much line as possible, moving all over the paper, even drawing over previous lines from time to time. Continue until you have virtually completed your painting. Then step back and take a look. You could be finished at this point, or you may want to indicate some planes with strokes of a broader brush. Just be careful to keep line dominant in the finished painting.

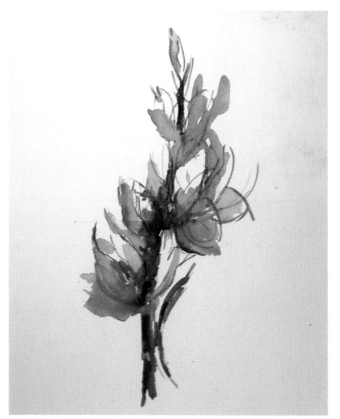

Juanita Cacioppo, *Gladiolus*, 12" × 5" (30 × 13 cm)

Juanita Cacioppo's lines began as a quick, gestural notation of the planes of the blooms, but in the end they became a dominant element, imparting a lively tempo, literally uplifting. Instead of cautiously rendering the clustered blossoms of a gladiolus, the lines serve as a dynamic abstraction, perhaps exalting the soul of natural beauty. And that is what art is supposed to do, isn't it?

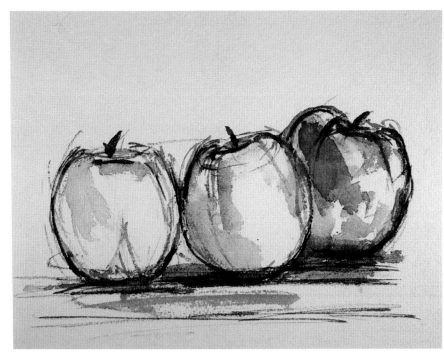

In this little "bare bones" painting, a type I often like to make, the idea of today's exercise is clearly indicated. I begin with very quick linear responses to what I'm looking at, changing color at random as I move along. I try to keep the paint very liquid, yet potent with pigment, so my marks are bold and visible. When I feel the line has satisfactorily depicted the forms, I lay in some secondary color planes to reinforce the volumes. I like to leave a lot of white, as this gives the illusion of a strong light source in a mostly linear treatment.

Michael Crespo, *Three Apples*, 8″ × 12″ (20 × 30 cm)

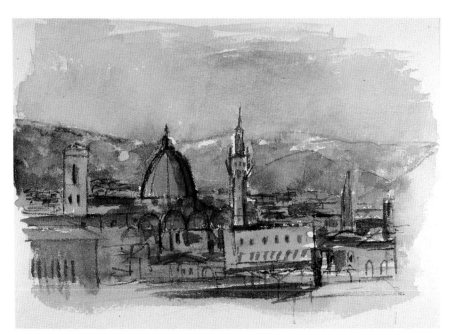

This view of Florence displays a different approach to a primarily linear treatment. I first laid in a gray wash and, while it was wet, began to describe some of the major plans of the composition: the mountains in the distance, the sky, and the darker gray band underlying the architecture. I let this "atmospheric" underpainting dry and then set about describing the city with a maze of lines. When the lines were dry, I went back in with some color planes to accentuate the skyline. This way of working results in a contrast of soft, generalized masses and hard, specific contour lines.

Michael Crespo, *View of Florence*, 10″ × 15″ (25 × 38 cm)

Ellen Ellis, student work, 13″ × 13½″ (33 × 34 cm)

Ellen Ellis presents a fine example of qualitative line, which varies in thickness and thus appears to be at different distances from the viewer. Notice the range from small flicks strewn across the composition to broad strokes in the plant, its pot, and the foreground. The widest strokes never depart from the realm of the line, with the possible exception of the green on the parrot's head. That stroke could be considered a mass. But it's really a philosophical argument as to when a stroke ceases to be a line. My point is that this painting is a celebration of linearity.

To grasp how line can explain the space occupied by an object, look at the leaves of the plant and the pot. The smaller lines provide different information from the broader ones. When you gaze across the entire painting, however, you realize that there is no set system—thin and fat lines appear both in the foreground and the back. Yet the eye translates these differences into space. It may not be an ordered perspective space, but it is a highly active visual situation. The thick and thin lines move us in and out, perhaps not in reference to the objects, but definitely in reference to the picture plane. Also note the variations in the color and value of these lines, which again lead in and out. Surprisingly, a relatively static still life is energized into a pulsing space by the quality of the lines.

Gloria Jalil, student work, 9½" × 13½" (24 × 34 cm)

I find the rhythm of line the most important aspect of this painting by Gloria Jalil. Notice how the lines of the intricate tablecloth act almost as quotation marks surrounding the basket of fruit. The lines on the right pulsate in unison to the right, while those on the left pulsate to the left. Within the fruit, the lines do not have any obvious cadence; they move in many directions. Yet they are contained by the most static of line structures—a grid—in the basket. The contradictions and repetitions all bring out the rhythmic potential of line.

Bryan Murphy, student work, 9" × 12½" (23 × 32 cm)

Bryan Murphy has used line to impart a slightly distinctive quality to each object. His line might be described as nervous, possessing a wound-spring tension. As a contrast to this taut feeling, he applied flowing planes of color, after establishing the linear structure.

I am always impressed at how line-making seems to disclose the individuality of the painter, sometimes even more than color choices. This exercise always results in distinctive expressions by the different students in my class. I am not proposing specific meanings, nor is such scrutiny really relevant; my point is just that decidedly individual stances are evident. Lines were probably the first artistic utterances by man, so why shouldn't they have power?

Elizabeth Jenks, student work, 9" × 14" (23 × 36 cm)

Elizabeth Jenks has painted an abundance of lines, forcefully contained within the contours of the various objects. No line is allowed to escape its designated object. These lines then take on a more obsessive, decorative role than lines that transgress and describe the entire space. The objects, which exist only within their own boundaries, seem to reinforce the static truth of inanimate objects.

DAY 12
Three Zones of Landscape

For the past few days, for the most part you have been painting objects that you carefully chose, positioned, and lit. With a landscape, however, you are faced with 360 degrees of subject matter, including every color, shape, value, and texture imaginable. To compound the misery, all of these change character constantly in the ever-moving light. Where do you begin?

You could just start painting at some point and work out to the edges of the paper. Although this is not always a bad idea, often the composition is left too much to fate. It is always better to have a structure, something to fall back on, something to give meaning to intuitive marks and techniques, something to allow freedom in response.

Let's consider the most common structuring of space: foreground, middle ground, and background. Obviously these zones are not specifically reserved for the landscape, but can be applied to still lifes, interiors, figures, and abstract works. Essentially, they are a way of categorizing what we see, of organizing it.

Look at the first drawing on the facing page, where the landscape is divided into three clearly distinguished spatial zones. Here the bright middle-ground water is isolated from the other two zones; it is fronted and backed by darker and more textured grass and trees. Working with basic pictorial elements, consider how you might juggle contrasts and similarities in developing this composition:

- *Light*—place darker values in the foreground and background, and saturate the ground with lights. Or make the middle ground dark and let lighter values dominate the foreground and background.
- *Color*—make greens dominate the foreground and background, with blues, yellows, and grays in the middle ground.
- *Focus*—keep a sharp focus in the middle ground, but avoid sharp edges in the foreground and background.

If you decide on three clear divisions of space, it's easy to organize the various pictorial elements.

I've mentioned only one possibility—isolating the middle ground. Any combination is possible. The focus could occur in the background with the foreground and middle ground left unfocused and fused together. Just be careful not to follow any structure too stringently. Let some similar elements exist in all three zones. If these areas are not related in some way, your picture will flatten into stripes.

While we are examining compositional zones, let's take a look at what is called a *repoussoir*. This compositional device can be found in landscape paintings over many generations—see, for example, the paintings of Claude Lorrain, Salvator Rosa, and Jean Baptiste Camille Corot. What is involved is a kind of spatial contrast. There might, for example, be a dark frame running down either the left or right side of a painting and across the bottom—composed perhaps of a tree and its shadow. Immediately behind this repoussoir would be an area of bright, contrasting light. Some of the more inventive landscape painters incorporated a few lights into the repoussoir itself to echo the light behind. In this way they kept the "frame" from appearing too flat. They might, for instance, include a shepherd asleep at the base of the tree, with his shirt and features faintly lit.

To understand these ideas, venture outside and find a motif that generally fits into the three-zone scheme. Make a number of thumbnail sketches, trying out various configurations of the zones and what occurs in them. When you feel you have an idea of how to proceed, sketch in a light pencil drawing and begin painting with your compositional concept in mind. Paint as directly as you can in this painting—don't get bogged down in technical considerations. Also don't worry if you've never painted a tree. We'll study the parts in the next lesson. For now, do the best you can. Simplify your forms. Keep your value range intense and your colors varied. As I stated before, remember not to overstate the system. In general subtle transitions will draw the eye across the space most easily, although sometimes an abrupt transition may be desirable.

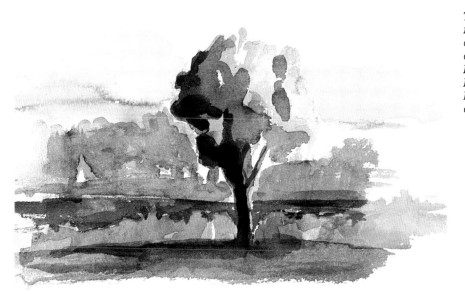

This drawing defines three zones, differentiated by value. The isolated middle ground is contained by a dark foreground and background. The eye moves into the space from the foreground, across the middle ground, to the background because of the strong relationship. Or the eye may situate itself in the sequestered middle, well aware of the two related zones swaddling it.

In this drawing the value plan has been reversed, with the foreground and background in light to middle values and the middle ground distinctly dark. The highlights on the water help to make the transition from front to rear. Focus also plays a part in this scheme. The foreground and background are for the most part out of focus, in contrast to the hard-edged middle ground with its sharp highlights.

This is the same landscape, but now color is used as an agent of contrast. Sandwiched between the dominant green foreground and background is a blue lake. The brief highlights of yellow along the banks join with the blue to wedge apart the two zones of green.

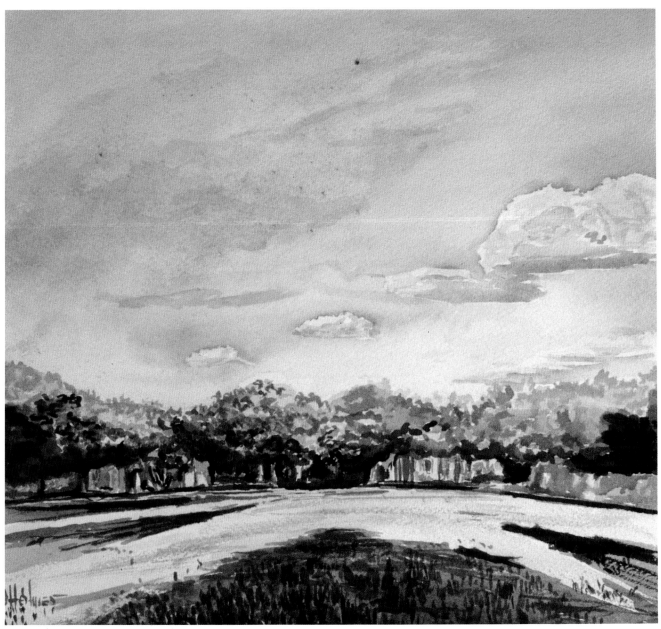

Joe Holmes, student work, 9" × 10" (23 × 25 cm)

The concept of three zones may be crystal clear, or it may venture into spatial irony, as in this painting. Joe Holmes envisioned the bright, X-shaped yellow path as the middle ground, held in place by the textured, dark green foreground and background. The irony, which makes for a wonderful spatial transition, is that this yellow plane intrudes on both the other planes and yet still maintains its integrity as the middle ground. It arises from the right and left corners of the foreground, and its yellow hue permeates the tops of the background trees.

There is another question raised by this painting that flaws the "perfect" theory of today's lesson. What zone does the sky belong to? You might say that the sky is above all three zones and therefore shared by all. But skies can easily be grouped with the background, or they may remain aloof from the system, with the spatial zones occurring solely on the ground. Joe depicts the sky as above all three zones. Notice how he has drawn the clouds in perspective, making the sky move toward the distance, echoing the spatial thrust below, on the ground.

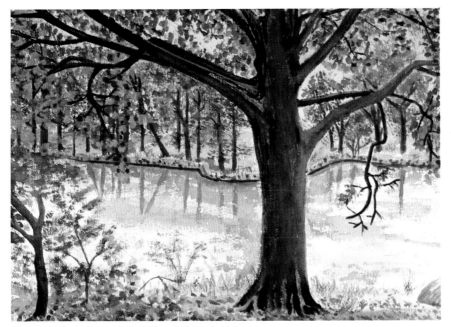

Texture dominates this painting by Gloria Jalil and helps to both distinguish and unite the spatial zones. The foreground and background are both painted with many stamped brushstrokes. Although there is some texture in the middle ground, the values are close, making it seem untextured when compared with the other two zones.

Marcy Blanchard has used color to separate the three zones. The middle-ground green is situated between the related warm grays of the other two grounds. The greens on top might belong to the large tree in the foreground, the trees in the middle ground, or the little trees in the distance—a very clever ploy. At the bottom, the green moves the eye into the foreground through the shrubs and muted scrub grass.

Gloria Jalil, student work, 11″ × 15″ (28 × 38 cm)

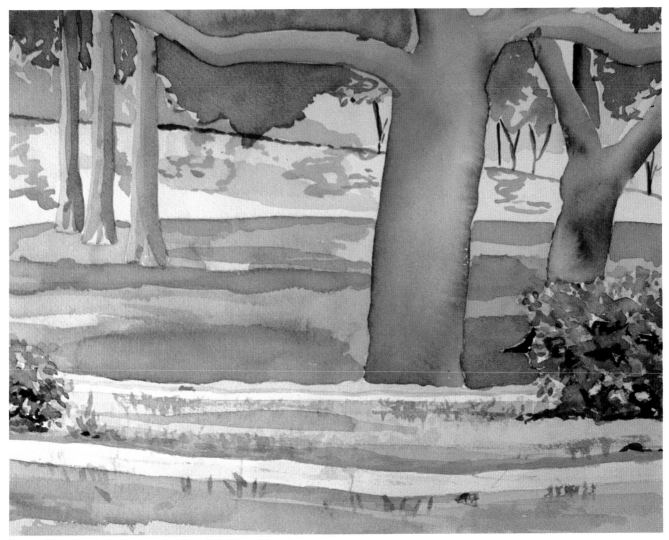

Marcy Blanchard, student work, 11″ × 14″ (28 × 36 cm)

Christy Brandenberg has thrown the proverbial monkey wrench into this one. For the time being, ignore that blue triangle, or swimming pool, on the right. The foreground is marked by a dark tree, with some clumps of shrubs surrounding its base. The middle ground is then the flat green expanse leading to the other trees, the fence, and the house. The trees in the background are dark and also have shrubs at their feet, forming an obvious connection with the foreground and its similar tree. But then we have that blue swimming pool, which blatantly disturbs the tranquility of this order. It does direct us into the space, but it is most eccentric in placement, as well as being a mildly unexpected color. Christy has created a delightful moment that works because of its sheer arrogance, puncturing a spatial system she probably considered too stoic.

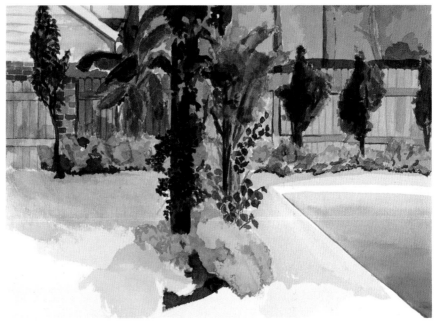

Christy Brandenberg, student work, 12″ × 16″ (30 × 41 cm)

George Chow poses another variation on the theme. All three zones are different. I consider his sky the background zone, the building and trees the middle ground, and the flat, shadowy, yellow-green lawn the foreground. The clarity of the scene allows the eye to make the transition between the zones—from field to architecture to sky. There are also color connections: the white of the clouds moves into the white of the building, and the yellow-green of the field is repeated in the trees on the right. It's simple and effective: one, two, three.

George Chow, student work, 9½″ × 12″ (24 × 30 cm)

This drawing shows the classic repoussoir, in which the dark tree and its shadow frame the rest of the composition and also create an interesting spatial tension.

Joel West has used the classic repoussoir, with a large oak on the left that casts a shadow across the bottom of the picture. This dramatically frames the rest of the space, in which more oaks pierce through the picture plane in a line of perspective. To exaggerate his repoussoir, Joel increased the color temperature as he moved away from the framing device. Also notice the softly modeled tree trunks, which mesh with the multi-layered strokes of the foliage.

Joel West, student work, 10½″ × 14½″ (27 × 37 cm)

DAY 13
Landscape Components

Today let's look at some basic elements of landscape painting. Keep in mind that there are innumerable ways to paint any subject, and feel free to venture beyond the particular techniques presented here. Use this exercise as a starting—not a stopping—point. Take your equipment outside again and try the methods described here; then continue to experiment and to expand your working methods.

handle almost parallel to the paper, rather than at the normal ninety-degree angle.

You can also squeeze the brush dry with your fingers and then splay the bristles by pressing them on your palette. Use dry pigment with this newly formed brush and experiment with stroking, dabbing, and dotting gestures. Remember that the look of your drybrush marks will be greatly influenced by the roughness of your paper.

Basic Tree Study. First sketch a tree with pencil. Lay in the foliage with a light wash and, while this is still wet, lay in a darker value to suggest volume. Since outdoor light generally comes from above, keep the first, light wash visible at the top of the clumps. When your two washes have dried, add a few dark drybrush marks for emphasis and then paint the branches and trunk.

Tree Silhouettes. Familiarize yourself with the underlying forms of as many trees and shrubs as possible. Practice painting flat silhouettes of specific tree shapes. Use sepia, umber, or sienna. Do not make a pencil sketch; instead, start with a loaded brush and define the tree or bush shape as accurately as possible, starting in the center and working out to the contour. Paint single forms first, then mass groups of trees into a large shape.

Drybrush Practice. This is a good time to review drybrush technique. Basically "drybrush" means skimming the surface of the paper with color, depositing that color on the rough-textured "hills" of the paper. As the term implies, your brush should be relatively dry, not loaded with paint. To keep your brush on the dry side, pass it over a tissue or sponge before applying the pigment. Then, to make your strokes, hold your brush

Grass. Paint the overall shape of grass and weeds as a silhouette; then complete the contours by using a variety of drybrush marks. Add darker values and accents to build the form. Before the paint is dry, use your fingernail, a razor, or a knife to scratch in a suggestion of individual blades of grass.

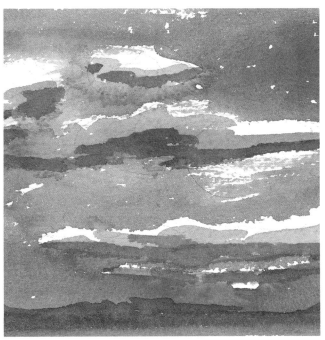

The "Forest." Sit in front of a bush. Choose a small area of the bush at random and loosely record your impressions. Work wet-in-wet over the whole mass, establishing various shapes and values. Let the paint dry a bit and then lift some of the paint to create a light source. Finally, after everything has dried, indicate some of the darker positive and negative shapes.

Next, using the same approach, paint a larger subject, such as a row of hedges or a forest. This exercise will help in situations where there is an abundance of intricate information, but you want only to convey a "sense" of the subject.

Skies. Skies are always a delightful painting experience. John Constable's numerous studies of clouds are testament to his passion for these ever-moving, ever-changing masses. Already, in working with washes (Day 6), you've learned the basis of sky painting. Using this knowledge and experimenting with several different color combinations, explore three basic approaches:

● *Cloudy Sky on Dry Paper.* Sketch in the cloud shapes with a pencil; then rapidly paint in the surrounding blue sky. Soften some of the edges with your brush. Mix a gray for the cloud shadows and paint them in. Let everything dry; then paint in darker grays, as well as darker blues in the sky, to increase the value contrasts.

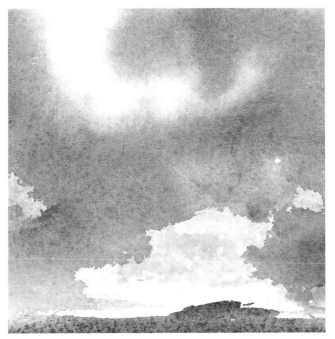

● *Clear Sky.* For this situation, use a simple graded wash, or a flat wash.

● *Cloudy Sky Painted Wet-in-Wet.* First wet the sky area with clear water; then paint in the cloud patterns. Add a second color to the wet surface; also add darks where needed. Work quickly so the paper does not dry and so no hard edges form.

Elizabeth Jenks has produced a page full of very fluid, spontaneous gestures. These simple configurations may be all that is needed to render a tree effectively. Too much deliberation with the brush can lead to stale, awkward renditions of trees. Instead, try composing an entire painting with simple silhouetted markings like these.

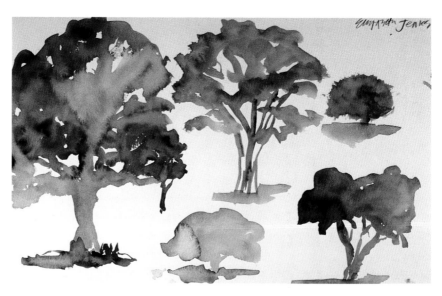

George Chow's stylized, contained approach is evident in these studies. Notice his skillful use of value and delicate mixing of color in each form. Also notice how, on the right, he has combined the tree and grass in a mini-composition.

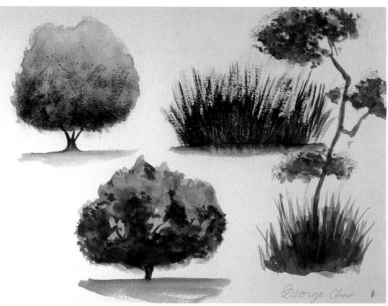

Bryan Murphy crammed this page with a variety of exercises. At the top left is a wet-in-wet cloudy sky; below is a cloudy sky done on dry paper, as well as a grass study. On the right is another cloudy sky sketch, with two examples of the forest exercise below.

I like my students to approach this assignment with a certain nonchalance—as if, after the "serious" paintings they've done, these little exercises didn't really count. This relaxed attitude fosters spontaneity. You might compare this exercise to doodling in a phone book. And you may be surprised at what you learn. I discovered how to model basic forms by filling legal pads with scribbles during faculty meetings.

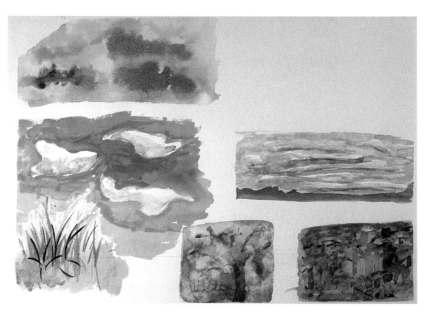

92

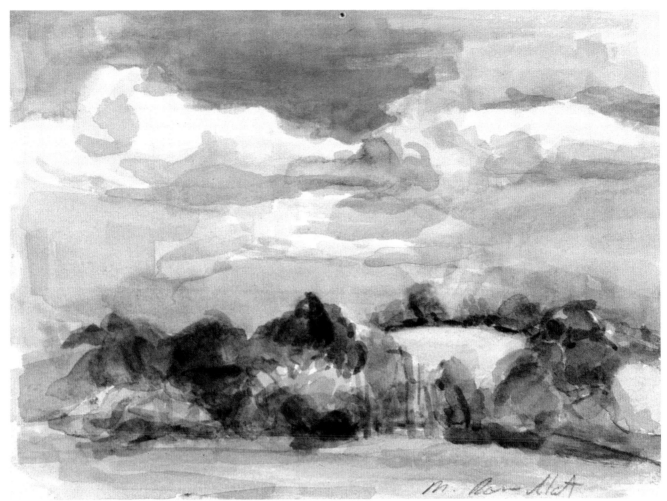

Marcy Rosenblat, *Landscape*, 6″ × 7½″ (15 × 18 cm)

The magical little landscape by Marcy Rosenblat exemplifies two of the exercises you have just practiced. The earth, with its meandering strokes, is a sophisticated version of the nebulous forest exercise, while the sky represents the classic treatment of cloudy sky on dry paper.

In Venice I've encountered almost every kind of sky. On this particular day it was as if the scene instructed me to wallow in wet-in-wet. Color evaporated into misty blue-grays, and the water and the sky became one, demanding the same technique. At times I wondered which was reflecting the other.

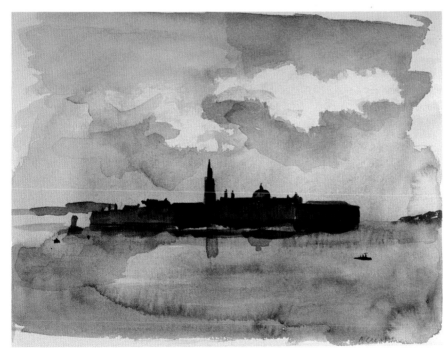

Michael Crespo, *San Giorgio Maggiore*, 9½″ × 12½ (24 × 32 cm)

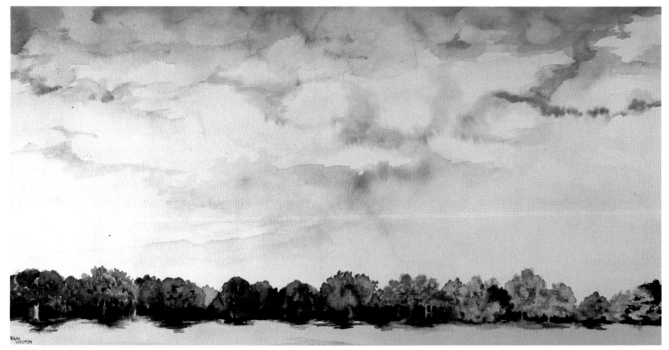

Deana Houston, student work, 9" × 18" (23 × 46 cm)

In her striking horizontal composition, Deana Houston has put the exercises to work. She first silhouetted the line of clumped trees along the horizon, then painted them in the "basic tree" manner. The sky, done wet-in-wet, is what I call a "Sara Lee cheesecake" sky, for the clouds resemble endless squirts from a pastry bag.

Marcy Blanchard mingles warm, brownish-gray clouds in a mottled blue, wet-in-wet sky. She has carefully worked over the wet painting with tissue, pulling out pigment for the dappled effect. Be sure to look at the cloud studies by Constable, which demonstrate the power of painting the sky alone.

Marcy Blanchard, student work, 7" × 11" (18 × 28 cm)

Elizabeth Jenks has combined the basic tree exercise with a wet-in-wet sky to produce this vivacious landscape. The lively coloring comes from her use of an acrid yellow underpainting and the way she has perched the two cool, blue-green trees in the multi-colored field.

Elizabeth Jenks, student work, 10½″ × 14″ (27 × 36 cm)

Marcy Blanchard, student work, 7″ × 11″ (18 × 28 cm)

Marcy Blanchard wove this intricate, spidery web while staring into a bush. The color is analogous and hot; the technique, wet and fused. Practicing this "forest" exercise can help you when you encounter vague, tangled spaces that you want to imply but not describe.

DAY 14
The Painterly Middle Space

Imagine a day in winter. The blue sky has bled to gray, the sun is absent. Color and value are present, but have been washed slightly gray. This is a good example of the middle space in painting. Jack Wilkinson, a great friend and teacher of mine, was a master landscape painter, and his work was laden with lessons in the middle space. He taught me many things, one of the most important being a clear understanding of the quality called *painterliness*. And that is what we'll shoot for today—painterliness. Some of you may have forgotten the lessons of Day 1 on wielding the brush. Today should inject some passion into your stale brush.

When you limit color and value, they are much easier to control, for you are working with much slower transitions. Recall the discussion from Day 2 on the relative slowness of grays compared with purer hues—the same applies to value. Imagine a black-and-white checkerboard and a middle-gray or slightly lighter checkerboard. You can easily sense the contrasting speeds.

So now you have grayed colors (which are closely related in their grayness), as well as values that cluster around the middle of the scale, close and comfortable. Given all this inertia in color and value, you should feel free to wield your brush with more reckless abandon. There are no great color errors to be made—the grays all sit richly together. And if your values do not provide dramatic contrasts—well, that's just how it should be for this exercise. The space—the middle space—of the landscape will be different from what you've encountered in the last two lessons. It will be close, contained, and flatter. But, in this limited arena, you can find a new life in your brush. That muted winter day I asked you to imagine is nature's lesson in limitation, and in painting, limitation is often the threshold to freedom and expression.

It would be simple to paint that bleak winter day, but it's not necessary. You can observe the middle space in any landscape on any given day at any given time. I would suggest that you choose a scene dense with foliage to give your brush motions a little more exuberance. Use a limited palette—alizarin crimson, ultramarine blue, cadmium yellow, and black—and keep your color grayed, except for focal points. Also keep the values very close, clustering them more in the middle than you would in the normal value system. Use lights and darks for punctuation only. Do away with traditional representational focuses, and let brushmarks of accented color and value be the only focal points.

Be certain to let your brush run rampant in this painting. Let it caress forms as your eye does. Let it convey your feelings about yourself, this day, and this landscape. Meditate, and paint within this subconscious. Speak *your* language.

Deana Houston has discovered that "imaginary day in winter" I described. By carefully holding the value and color intensity within a very limited range, she has imbued the scene with a very sober light. The brushwork, however, is anything but restrained. Moreover, Deana has plotted a number of subtle, but enlivening color changes, the most dramatic of which is the dusty red lurking behind all those greens.

Deana Houston, student work, 17″ × 15½″ (43 × 39 cm)

Patricia Burke, student work, 10″ × 15″ (25 × 38 cm)

Patricia Burke's rapid, immediate brush responses enhance the painterly quality of this landscape. She has maintained the close value range of the middle space while leaving small, crackling paper-whites intact to illuminate forms in the chaotic mass. A few rambling darker values lead us from the bottom left across the tree and back into the bushes. Despite the drastic reduction in color intensity, there is a remarkable range of warm and cool tones, which dance around the vigorous shapes.

Observe how the "space" of this middle space works: it is relatively flat, punching into the picture plane occasionally, but there is just enough to give some weight to a form. Also notice that although you can discern the tree and a few shrubs, the focus is not really on the perceived objects, but on the elements of the craft itself: the brushwork, shapes, values, and colors. Finally, consider the importance of the one contradictory color note: when the line of bluish color moves away from the tree to culminate in the pure red spot, which screams its independence in this exemplary middle-space painting.

When I consider Marcy Blanchard's characteristic hard-edged approach, this painting seems explosive and arrogant in its brushwork. It's a good example of how a different problem can expand your repertoire.

Marcy has inched her limited palette into a formidable color scheme. Everything is permeated by an initial grayed-yellow wash. The dominant warm tones are then challenged by the complementary purple that moves across the center zone. In the restricted world of this problem, Marcy has discovered a vibrant sense of light. And it is as if the very restriction made this light peculiarly intense.

Marcy Blanchard, student work, 11″ × 14″ (28 × 36 cm)

There are always a few renegade students who just have to burst through restrictions whenever they can. Scot Guidry is an exuberant person, and I can't imagine him finding any comfort in graying his color too much. The color here may be a bit too strong and the value too wide-ranging, but his brushwork decidedly promotes the middle space. Despite the deep space implied by the high horizon line, the character and energy of his marks stay right up in front, on the picture plane. The soft, but agitated, wet marks at the bottom move on to the more whimsical slashes of the trees and sky. The central focus is on the yellow and red construction equipment, but notice that this machinery is exposed as a series of negative shapes by the green mass of trees.

Scot Guidry, student work, 12″ × 16″ (30 × 41 cm)

DAY 15
Expanding Color

On Day 3 I discussed dominant color and suggested some color schemes. I trust you've been using them, or at least testing them. Today, we'll experiment with another color structure. This one doesn't work because its obvious, it works because it's ironic.

Irony is as natural in painting as color. It exists in much the same way as it exists in anything else—as an expression of the opposite of what one really means, or incongruity between the actual result and the expected result. We've had dealings with it all along. It's hard not to when you're shifting from three dimensions to two. Today, odd as this may sound, we'll make a definitive statement of space by manipulating the scale and chroma of color to contradict perspective.

The theory is simple. A small amount of a color located in the foreground of a painting exists in the background as a large amount. The irony is also simple. We use perspective to get from the foreground to the background, with objects becoming smaller as they move back and colors fading to gray. But when there is a small amount of blue, isolated in the front, or bottom, of the painting, and it expands into a sky in the back, or top, there is reverse perspective, or irony. This is true two-dimensional space-making. A little purple car in the foreground drives down a highway that diminishes, tree by tree, into a big purple mountain. The purple mountain is bound by perspective and logic to the background; but the same perspective also dictates that the large purple shape is closer to us than the small one, entitling the mountain to reverse its position with the car. The cycle repeats itself again and again in our eye. The space is alive and active.

My class always gets a charge out of the setup for this exercise. They refer to it as the "cup in the desert." I use a beautiful, old, hand-painted Mexican coffee cup. The array of bright colors offers many options for a background. I intricately fold and roll a neutral-colored drape and place it between the cup and the wall. This establishes a middle ground to separate the expanded color. As in most of my still lifes, the subject is dramatically lit.

Try to reproduce my setup as closely as possible. This setup may seem overly simple, but after all the landscape painting, you may enjoy the return to basics. Moreover, the decorative passage on the cup and the drapery folds can provide complexity, should you want it.

Paint directly from perception at first, clearly marking the small color passages in the foreground. Then paint the wall, or the space beyond the folded drape, with one of the isolated foreground colors. Once this expanded color is in place, the importance of the simple structure should be manifest. It seldom fails. Apply the principle to other motifs—look for it in nature, or conceptualize it if it doesn't exist. Be certain to tuck it away in your repertoire, for many painting problems can be solved with expanding color.

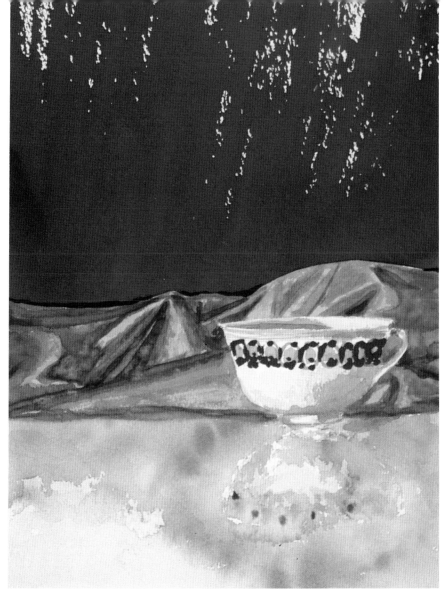

Gloria Jalil has transformed a simple still life into a bundle of visual events. The expansion of blue is direct and powerful. If you enter the painting from the bottom, you first encounter the blue as small, reflective specks on the ground plane. You then move to the source of the reflection in the decorative band of the cup. Finally you move back in the painting to the large mass of brilliant blue. The reflection of the cup on the broad ground plane, the elliptical top of the cup itself, and the folds of the drapery all take you back in space to the brilliant blue wall.

There is an irony in all this. Perspective dictates that things should get smaller and vaguer as they recede. This blue, however, gets larger and more intense, making the wall strive to be first in our eyes—which it is. At the same time the orange drape clearly separates the wall from the related blue dots in front and keeps forcing it to remain in its place behind everything else. The result is a lively visual tension. Also intriguing is the shower of paper-whites that rain in from the top of the painting. What a wonderful effect!

Gloria Jalil, student work, 13½" × 9½" (34 × 24 cm)

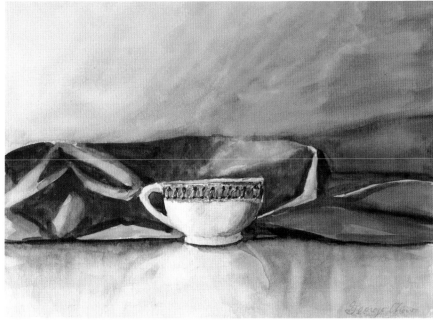

Working with the same still life as Gloria Jalil (above), George Chow has taken a very different approach. Here the dominant hues are warm, with a single, isolated patch of contrasting color in the cup's band. George has taken the small, bright orange from that band and expanded it into the background plane, washing it in like a sky. That windy plane of color then shines down into the rest of the painting, further strengthening the little blues and greens that surround the source color. Within this system there is still a reverse perspective, or irony. Notice especially how the dramatically rendered folds of the cloth move the eye back while the orange "background" drifts forward.

George Chow, student work, 7½" × 10" (19 × 25 cm)

101

By lining the three objects up in a row, Marcy Blanchard established a strong two-dimensional structure, which allowed her to inject two systems of expanding color. In the immediate foreground, a couple of orange blurs are expanded in the drapery, with the objects as the buffer zone. At the same time, the isolated violet band on the center cup expands into a large violet background. Both systems neatly intertwine, giving us a more complicated system and spawning a more comfortable color logic.

Marcy Blanchard, student work, 9½″ × 12½″ (24 × 32 cm)

In Jonathan Drury's painting, the vase and two apples lie on the same line, asserting their place near the front. Behind them lies a band of almost white light, before the wall of spotted fabric. The expanding color is obvious: the circular blue area in the vase expands to the back wall. The variation here is that objects do not form the separating zone; instead, an area of intense light divides the blues.

Jonathan Drury, student work, 9″ × 12″ (23 × 30 cm)

Karen Wright, student work, 12″ × 16″ (30 × 41 cm)

The six diverse objects in Karen Wright's still life help to control the expansion of that most domineering of colors, red. The red is patterned in different sizes and shapes across the foreground and then plastered across the background. The red stripes lead the eye back in perspective to the red wall, which then pushes forward. The complexity of the objects keeps the red from overwhelming the painting and provides an important counternote to the strong back-and-forth movement of perspective and color. Also note the tension created by the lively, decorative pattern on the left. This area pushes forward even more forcefully than the right. I think we have here a strong case for shape affecting the role of color.

DAY 16
Backlighting

So far we have been working primarily with frontal and side lighting, which usually create contrasting lights and darks on objects and are thus conducive to rendering volumes. Backlighting, however, flattens objects into dark, well-defined flat shapes. The space surrounding the forms is usually very flat as well, with an abrupt shift from the dark ground plane to the light-filled background. Backlighting can thus dramatize the space, making for exciting paintings.

A good way to observe backlighting is to position a still life in a window, ideally on a sunny day, at a time when the light outside is at its greatest intensity. You need only use a couple of objects, as the window and view through it will provide more subject matter. Turn off any lights in the room and work only in natural light.

Of course, you can also produce backlighting artificially. Simply position spot or floodlights behind a setup, aimed in a direction that will not interfere with your vision.

The challenge in this exercise is to combine two value systems in the same painting, abutting on a line like weather fronts before a storm. Turn back to Day 5 and review the high- and low-key color and value systems. The foreground and objects are in a low-key system. Because there is very little value modulation, you must suggest volume through color variations. Use rich, dark hues to swell the flat object shapes into subtle volumes. Paint the background in high-key color and value, again varying color to produce movement within the restricted system. Do not understate the contrast of dark and light—intensify it.

Joe Holmes uses a mostly white background to bring out the backlighting. Within it are some very light abstract shapes, which keep the plane active. The objects are characteristically dark, and the cast shadows go forward—another quirk of backlighting.

Keep in mind that backlighting tends to destroy volume. Here the color variations, especially in the shell, and value modulation in the dark range help to create gently swelling forms. There are also some strong lights on the front of the objects, which do much to establish volume. Don't use too many of these frontal lights, however, as they can destroy the effect of the backlighting. Backlighting should be severe; if it's not blatantly obvious in your painting, it doesn't exist.

Joe Holmes, student work,
12½" × 9" (32 × 23 cm)

Lori Hahn's soft-edged brushstrokes provide a minor, but effective, contrast to the sharp, dramatic lighting. She has strongly emphasized the plane of light on the ground just behind the objects by making the dark foreground end abruptly at that point. Also notice the reflection of that ground-plane light in the bottom right of the vase. Always look for these little idiosyncrasies of light in nature, and make the most of them in your work. Light can be a beautifully diverse voice in painting.

Lori J. Hahn, student work, 13″ × 11″ (33 × 28 cm)

In Bryan Murphy's painting, the faint yellow background and dark, opaque shadows, looming in the front, clearly establish the light. Bryan first modeled the objects with dark, somber tones, but then he allowed his instincts to take over and began applying intensely colored strokes in a wild flurry. The backlighting, however, is not lost, and the objects take on new identities, which might never have been found otherwise.

Bryan Murphy, student work, 12″ × 15″ (30 × 38 cm)

This scene, which deviates a bit from normal backlighting, was presented to me late one evening in the Boboli Gardens in Florence. An intense sliver of evening sun slipped in between this sculpture and a dense, dark thicket in the rear. The problem, which excited me, was to paint backlighting without flooding the background with high-key colors surrounding a dark object. On the contrary, the background was the darkest part of the painting. I met this challenge by painting the dark front of the sculpture in middle-value colors and letting the white of the paper, the only indicated source of light, wrap around the statue wherever it could.

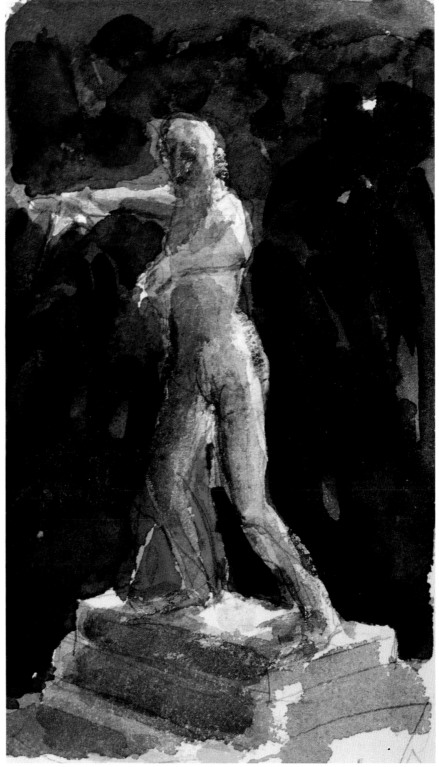

Michael Crespo, *Il Pescatore*, 8″ × 4½″ (20 × 11 cm)

My wife Libby made this painting just before Hurricane Bonnie came ashore, when the landscape was dramatically backlit by a light sky. Notice how she has kept the trees and horizon flat and dark, unlike the still life paintings here. This choice emphasizes the curiously illuminated cloud that hangs over the tree line, defying the backlighting effect below. René Magritte made a surrealist painting of a house and trees in the dead of night, with a sky in the light of the day. The effect of light in Libby's painting, however, is not an invention, but a study of natural light, as presented by Hurricane Bonnie (not to be outdone by Magritte).

Libby Johnson Crespo, *Before the Storm*, 5½″ × 8½″ (14 × 22 cm)

These two bromeliads share my studio with me. One hot, yellow afternoon I set them in a window to get the full effect of the light. The plants looked almost black as I painted, staring into the sun. I used a full-strength chrome yellow to set the pace and then began layering blues, greens, and violets, trying to veil the plants, pots, and windowsill in obscurity and yet maintain some volume and surface texture. I had to somehow render sensations on the paper, for the objects gave me very little information. This kind of predicament is quite common when you're painting from nature. The idea is to welcome it and lunge in to paint that unknown solution that must come from within yourself.

Michael Crespo, *Bromeliads in a Window*, 14″ × 19″ (36 × 48 cm)

DAY 17
Two-Color Limit

Some of Winslow Homer's most breathtaking watercolors are those of boats and fisherman out in the Gulf. The color and the light are rich and accurate. After scrutiny, I have always been impressed with how very few colors he actually employed to produce this rich, though subtle, color field. I have always held that a good colorist is measured more by what he or she can do with a couple of tubes of color, not a boxful.

With the "middle space" exercise, you limited your color to the primary triad and black. Theoretically, all colors can be mixed from the three primaries, although in practice it's almost impossible. Now I'm going to restrict you to only two colors. It may take some struggle and ingenuity, but consider that if you choose two complements, such as blue and orange, you have at your disposal these colors in their pure states, as well as a neutral gray, orange-grays, and blue-grays. This is not as much of a limitation as it would seem. Moreover, there can be just as much implicit color activity with two more analogous

colors, such as green and violet, or even green and blue. It is important to realize that if you present a color in two different values, it can appear to be two different colors. A strong sense of light can thus produce an effect of more color than is actually there.

For today's exercise, use a traditional bouquet of flowers. Although this is not necessary, you might set them in a clear glass vase to increase the activity of the subject and the value complexity. You might also select multicolored flowers to augment your incentive to seek color variation.

Choose two tubes of color from your box. It is not necessary to use the two that give the *most* variation—Homer produced stunning effects with burnt umber and blue. Once you have chosen your colors, for whatever reason, stick with them; a strong commitment is an asset here. As you paint from the still life, surprise yourself—do whatever you have to do to make this painting work. Any possible technique or expression is applicable.

Finding diverse color can be difficult when analogous colors are employed, as in this painting, in which I used violet and green (viridian, to be exact). I quickly discovered I could make a rich black, which became the center of a broken field of frenzied marks. Although I did develop a suitable range of colors, I felt that using an array of techniques, with different textural qualities, would give the illusion of more generous color offerings. I scratched, stamped, overlaid, lifted, wet, and masked— the theory being that more of this may just make more of that.

Michael Crespo, *A Vase of Azalea Blossoms*, 18″ × 20″ (46 × 51 cm)

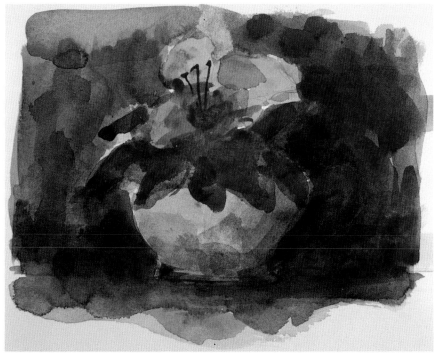

In the painting on the left I used only burnt sienna and ultramarine blue. I played heavily on a light value of the pure sienna, surrounded by mixtures of the two colors in much darker values. I also used a bit of pure blue in the area to the left of the flower. There's obviously a range of colors to be mixed from these particular hues and a lot to gain from exploiting their temperature contrasts. I love this problem because it invokes deception. You have to make wily use of color and everything else: value, texture, mixtures, transparencies, and so on.

In the painting below I used red-violet and cadmium yellow, but I did not use these colors full strength. Instead, I took a less obvious approach and explored the rich variations within the brooding grays. I also used the lighting to create a drama that thrives more on value than hue.

Michael Crespo, *Still Life with Azalea Blossom,* 7" × 8½" (18 × 22 cm)

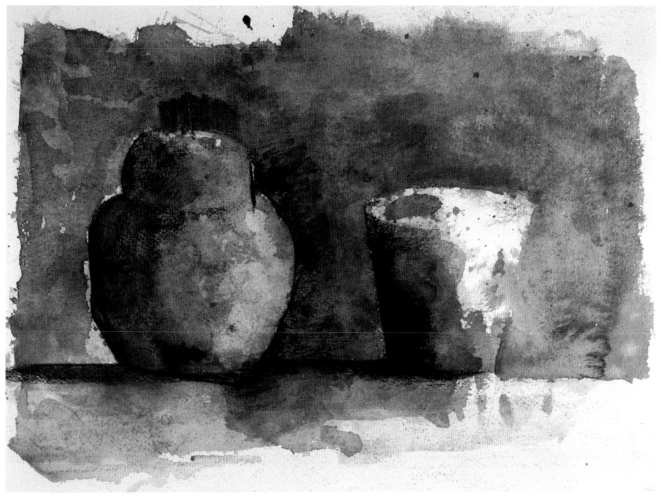

Michael Crespo, *Two Objects,* 9" × 12½" (23 × 32 cm)

109

I did not intend to limit myself to two colors—manganese blue and cadmium red—but in the act of painting this work, I found the two colors adequately explained the subdued light that filtered under the portico. I began by mixing a dark with the two colors and did a monochromatic underpainting, much as on Day 8. I then applied a diluted flat wash of the blue, blotting with a tissue where I wanted a highlight. After this dried, I repeated the light, flat wash with the red, again blotting the highlights. At this point I was shocked to realize that I was finished—one of the most pleasant surprises of painting. The colors had permeated the grays in the wash process and remained intact in the light, blotted areas.

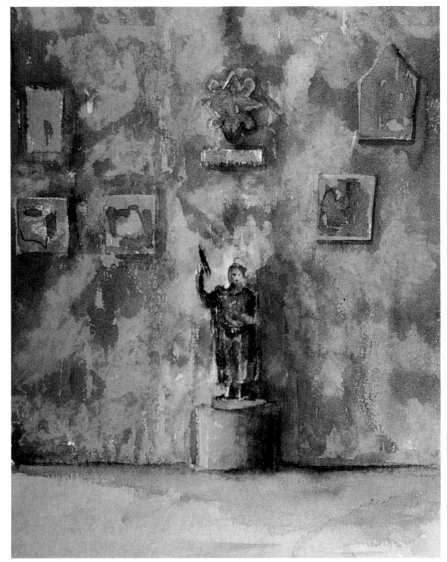

Michael Crespo, *In the Bargello Courtyard, Florence*, 15″ × 11″ (38 × 28 cm)

Joel West chose burnt umber and cerulean blue as his two colors and worked primarily with subtle gray mixtures. The objects he selected to paint warranted such metallic colors. Notice that the grays move back and forth from warm to cool, in this way aiding the very competent modeling. At some point Joel decided not to use the pure burnt umber anywhere, but to lean the color toward blue.

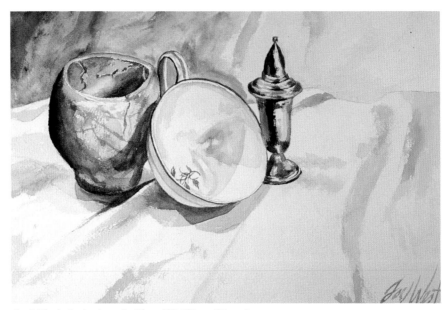

Joel West, student work, 9″ × 13″ (23 × 33 cm)

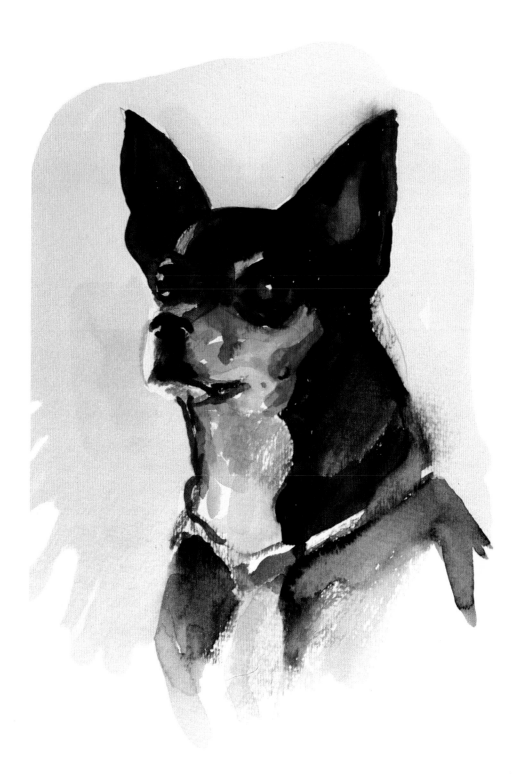

Libby Johnson Crespo, *Portrait of Angel*, 12″ × 10″ (30 × 25 cm)

Amazingly, this dog portrait is made with only two colors: black and burnt sienna. My wife Libby first laid down a diluted wash of sienna. She then laid black in to describe the dark areas of head and nose. For the fawn-colored muzzle and throat, she used sienna, modeled with a trace of black. She made the rest of the middle grays with a mixture of the two colors and left the white paper for highlights on the collar and nose. Despite the restriction, there is more than adequate color.

DAY 18
Plans and Variations

I am sure there has been a time when you labored over a drawing until it came close to perfection. With boundless optimism, you began to paint. Somewhere—through a misjudged color, overworked volume, or unexpected spill—you failed, reducing the paper to garbage, never to retrieve that splendid drawing.

Today we'll look at an alternative practice: the drawing plan, or master drawing. The idea is to make a drawing that is transferred to another piece of paper before it is painted. The drawing remains intact to be reused again and again. A note of caution, however: this way of working can be dangerously stifling. I do not recommend it for everyday use, but it does have its just application. If, for example, your subject is highly detailed, it may be impractical to draw directly on your watercolor sheet, especially more than once. Or there may be a subject you may want to paint in a series, perhaps performing color variations on the same form. I sometimes find myself with one chance to paint a subject—for instance, a freshly caught trout. After making a master drawing, recording color notations and perhaps painting a sketch on the spot, I bring everything back to my studio for deliberation and perhaps a grander attempt.

For the drawing, find a paper opaque enough for you to draw comfortably on, yet transparent enough to let a little light through. (I use index stock.) Use a pencil so you can easily make corrections and modifications. The only other equipment you'll need is a lightbox. If you don't own one, there's always another way. I've been known to tape the drawing and paper to a window for tracing. Of course this only works in the daytime. One night, however, I simply illuminated the room, went outside, and taped the drawing and paper to the other side of the window. The mosquitoes proved the only problem. Even better is a glass-top table with a lamp placed underneath. You may upset the decor of the room, but you'll have a real lightbox.

There's no set subject matter for this exercise—it's time you took on some responsibility! If you're desperately uninspired, go back and find a motif from a past problem that you were comfortable

with. Minor alterations to a still life or a different point of view in a landscape can engineer an entirely different set of concerns. Whatever you decide on, seek out and draw an obsessive amount of detail. Editing can take place during the transferral. Make the drawing work as a drawing—do not just consider it a sketch for a watercolor. It may include value, or it may just be linear. When you're finished, go over it with pen and ink, or a marking pen, to facilitate tracing.

Transfer the drawing to a sheet of watercolor paper, and do a painting in front of your subject, observing it directly. Either today or in the near future, trace another drawing from the master and work on it without the subject. The first painting will be your only reference. In this second variation, do something different: perhaps changing the dominant color or technique, or exaggerating the light, or even utilizing a completely irrational color system. It's also possible to vary the original drawing. This is easily done when tracing, and is sometimes a necessary stimulus to the boredom of copying. Whatever you do, try to maintain a sense of spontaneity. It's all too easy for dullness to slither into this "once-removed" painting.

SPECKLED TROUT
(ERISCION NEBULOSUS)

This is one of many drawings that I keep on file for possible paintings. Usually I use pen and ink for this kind of drawing, but here I used a soft ebony pencil—it just depends on what's at my fingertips. I made this particular drawing from the fish itself, but did the three paintings shown here at different times.

In this, the first painting that I made from the drawing plan, I worked directly from the fish, which I lit in a very even manner. I fully intended for this painting to serve as a reference for paintings to come, which accounts for the rather tight-fisted rendering, done entirely on dry paper.

A year later I pulled out the original drawing and painted two new variations of the same fish (shown below). This time I wanted to show the fish underwater. I figured that with a couple of washes, the static fish would begin to swim.

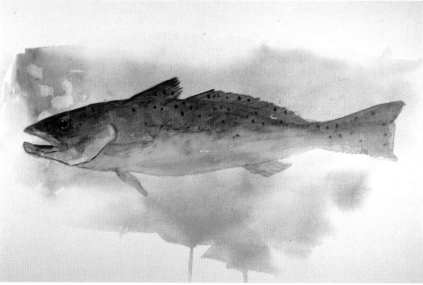

After transferring the drawing, I wet the paper and laid in an irregular viridian wash. I allowed it to dry, carefully wet the paper again, and laid in another irregular wash, this time with ultramarine blue. When it dried, I began to paint the fish over the washes. I used much more color and a greater value range in this painting; I also worked wet-in-wet in the first few stages. Incidentally, I had to work to get the two drips at the bottom. Sometimes I'm more involved with these little maneuvers than I am with the subject.

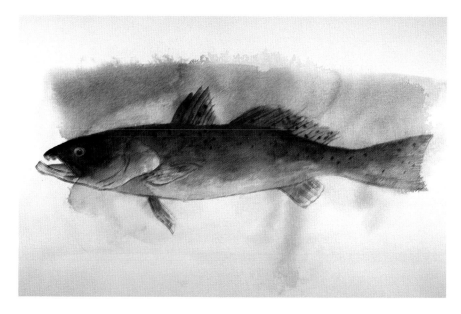

Once again I traced the original drawing, this time manipulating the lines and proportions of the original to establish a more menacing expression. I had already decided that this fish would be dark, red-eyed and red-mouthed, swimming in a gray sea. I painted the fish first with a number of glazes, establishing the dark top in contrast to the warm red-orange underbelly. When this was dry, I carefully brushed in an area of clean water, gently stroking with a large, soft brush so as not to disturb the pigment of the fish. I then brushed a gray of burnt sienna and phthalo blue across the top and, following the irregular wash technique, allowed it to fall down the page, encasing the trout.

This painting was made from a pencil drawing for obvious reasons. It took me a while, with much erasing, to sketch the intricate rigging of the boat. I only intended to make one painting, but with confidence waning, the security of a drawing, in case of failure, seemed appropriate. I grappled with the painting, wash after wash, and was disappointed with the outcome (which is how I usually feel after a struggle). I thought I had overworked it—the most common malady of watercolors. Two days later, I loved it. But I also began another attempt immediately.

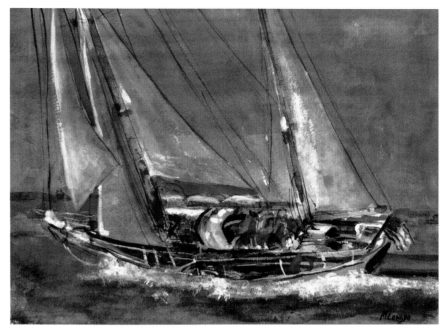

Michael Crespo, *Sailing, Variation 1*, 11″ × 15½″ (28 × 39 cm)

At the time this version sat a little better with me. Sometimes, but definitely not all the time, the second variation flows more easily from the brush—the first endeavor being a learning experience, the second a spontaneous enactment of that knowledge. I did not work this painting as much, and the more decisive marks and color give it a livelier tempo and light. In the end I don't really know or care which is the better version. I'm happy with both, and I only had to labor over a drawing once.

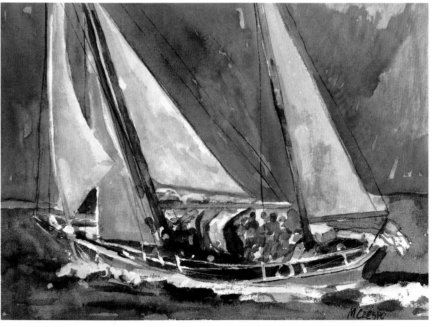

Michael Crespo, *Sailing, Variation 2*, 11″ × 15½″ (28 × 39 cm)

114

Juanita Cacioppo's drawing is a wonderfully alive study of shape and value pattern, as well as line. She used marking pens, whose slippery movement encourages animated work. Notice how the blue and black shapes, as well as the uncolored areas, suggest possibilities for not only a general value scheme, but also figure-ground relationships and perhaps color changes. There is a world of information in this drawing, quite different from the simple line studies that I use. Curiosity led me to lay this drawing on my lightbox and slip a piece of paper over it, just to see how it would work. I found a pool of options.

Juanita Cacioppo, *Drawing Plan for Anemones*, 13½″ × 20″ (34 × 51 cm)

I was at first surprised to see this delicate offspring from Juanita's rambunctious drawing. Yet, in comparing the two, you can see that in most areas the structure is identical, despite the major editing, especially in the background landscape. The space, however, changes drastically because of the color. As the intensity of the reds and greens shifts, there's a back-and-forth spatial movement.

It's clear that Juanita and I work quite differently from drawing plans. She makes ambitious, crammed drawings and selectively composes from them. I make spartan contour sketches and expand on them in the paintings. Both are options to consider.

Juanita Cacioppo, *Anemones*, 13½″ × 20″ (34 × 51 cm)

DAY 19
Gouache

Often my students, despite my warning, can't live without using a tube of Chinese white. It's the conditioning from oil and acrylic painting. I hope that for the most part you hid it in the bottom of your box, so you were able to experience the wonder of light living in the paper, shining up through layers of transparency.

Today we'll examine gouache as a medium in itself and as a slight variation of *aquarelle*, or transparent watercolor. Gouache is the result of introducing Chinese white into the transparent watercolor palette, providing an opportunity for opaque value modulation. There are pigments designated "designers' gouache" or "designers' colors." Like the paints you've been using, these are ground in a gum-arabic vehicle. Gouache colors, however, usually have more pigment ground in and sometimes chalk is added for greater opacity.

In addition to gouache and watercolor, there are some other water media still used today. With *distemper*, the pigments are ground in gelatin or rabbit-skin glue. These colors dry immediately and are very matte, but brilliant. *Egg tempera* uses the yolks of eggs as a vehicle for dry pigments. The painting process involves a tedious layering of crosshatched underpaintings. *Casein* is a milk product used to bind colors. The effects are similar to those of gouache. Gouache, however, tends to be picked up with subsequent layers of paint, while casein is waterproof when dry. Finally, there is acrylic paint—a relatively recent development.

As I mentioned earlier, gouache involves using Chinese white to tint your watercolor pigments. To a certain extent, then, you can paint over mistakes. You can also combine techniques, continuing to utilize the paper as a source of light and creating lights with the white pigment. For a different technique, begin by priming your paper with a coat of Chinese white; then go about making a traditional watercolor painting on this surface. The white paint will lift up into your painting, giving the opacity of gouache.

Use the two techniques for two different paintings. With the first—combining opaque and transparent passages—paint one of the following motifs: a fantastic animal in an ordinary environment, an ordinary animal in a fantastic environment, or a fantastic animal in a fantastic environment. Interpret this in any way you feel suitable and, above all, have fun. For the second technique, when you prime your paper, do a variation on an existing masterpiece, much in the way Picasso painted from Goya, Raphael, Rembrandt, and Chardin. Work with a reproduction, but interpret it freely—you're meant to have fun, not labor over a copy. Just a stab at this problem will teach you about the structure of the masterwork. If you're still unsure how to begin this one, go to the library and study Picasso's variations—he painted hundreds of them.

Joel West, student work, gouache, 9" × 13" (23 × 33 cm)

This is Joel West's rendition of a fantastic animal in an ordinary environment. I think we can agree on the fantastic animal, although some may doubt the ordinary environment. The color is exaggerated, but the landscape is definitely Louisiana marshland. Besides, it's not critical that you translate this problem literally. It's intended for you to experiment with gouache, while extending your imagination.

Joel's use of Chinese white is especially obvious in the sky, where he layered the paint repeatedly, with definite opacity. Notice, too, how the gouache technique adds solidity to the land forms and "monster" in contrast to the water, which is handled more transparently.

Robert Warrens, *A Snake Posing as Uncle Sam*, gouache, 30″ × 22″ (76 × 56 cm)

George Chow has placed an unlikely animal in an extraordinary space. The top half of the painting, with its deep perspective, seems to collide with the enormous fish. The surface of the water then clearly divides two distinct spaces. A nice touch is the fin breaking the spatial barrier.

George has used the gouache heavily in modeling the fish's face and body, where chalky planes mark the volume. The milky cast to the water surrounding the fish indicates a mingling of Chinese white with the various colors, although their transparencies are still quite apparent. Don't feel you have to use the Chinese white in every color you use. It's best to mix various aquarelle techniques with different opacities of gouache.

George Chow, student work, gouache, 14½″ × 12″ (37 × 30 cm)

Robert Warrens is well known for his raucous compositions stuffed with raucous images. He needs an opaque technique like gouache for the massive buildup of marks and feeling of density in his zany visions.

On a compositional note, there's an intriguing ambiguity in this scene. The great red dog dominates the window view, but also breaks the frame on the right, entering our space. I'm especially fond of the quiet, tenderly modeled inkwell that sits in the right corner, in blatant contrast to the eye-ripping landscape.

Michael Crespo, *Study after Goya's "The Forge,"* gouache, 15½″ × 12″ (39 × 30 cm)

I practiced the second technique described on page 116 to make this study of the great Goya painting in the Frick Collection in New York—a painting that mesmerized me in my graduate school days, and still does. To begin, I laid down a fairly watery coat of Chinese white on hot-pressed paper, which does not permit much saturation, keeping the paint mingling on top. It's not necessary to use this kind of paper, but it works well. After this dried, I freely interpreted the Goya with ordinary, transparent colors. They picked up the white and formed a milky opacity.

My study loosely describes the forgers forging metal around a hot, red strip, which denotes a fire in the original. I, like Goya, have used the red as the primary focus amid a mass of dark shapes and men pounding hammers in a smoky room. Goya created the sense of atmosphere with color, while I have used texture. As I mentioned, the point is not to copy the masterpiece. Instead, this should be an exercise in interpretive expression, blasting off in any direction from an established composition.

This painting, also made with the second technique, is a variation on a different kind of masterpiece. It's a painting inspired by Wallace Stevens's masterful poem "Thirteen Ways of Looking at a Blackbird." I did not illustrate any particular lines; I just worked from a general feeling.

Here I used a heavy layer of white on the paper, which came up into the overlaid color and made it even more opaque, particularly in the multicolored underpainting of the birds. When I wanted less opacity, I stroked the paint on with delicate touch, without disturbing the underpainting. I also went back in with pure white in the background to cover some strong colors that I had placed adjacent to the birds. The opaque white is still transparent enough to allow them to be seen, as gentle currents beneath the surface. Finally, I used a thick white to delineate the jagged contours, central to what I wanted to say.

I strongly suggest that you try working from a poem you like. Poetry and painting share the same space.

Michael Crespo, *Two Blackbirds*, gouache, 11" × 30" (28 × 76 cm)

Melody Guichet, *A Woman Snipping Hair*, gouache, 11" × 15" (28 × 38 cm)

Melody Guichet is an expert in this variant medium. While she exploits the opaque buildup and more sustained execution possible with gouache, she does not abandon the translucency of watercolor. Here she has juxtaposed labored, opaque volumes on an equally labored, yet opalescent, mosaic field. The value variations, as well as the clustering of the little squares, gives the grid a rolling feeling.

121

DAY 20
Composition and Beyond

Most of the time we think of composition as simply the placement of shapes and colors in a two-dimensional field. Although this is a very important consideration, it is only a partial definition. I would define composition as *all* that makes up a work of art: the balance, rhythm, domination, harmony, and contrast of line, value, color, texture, shape, and subject. As painters we seek to express our most personal visions by assembling and organizing these elements in different ways. Somewhere in the process of juggling these visual elements, the painter's spirit is imprinted on the whole, creating an energy that distinguishes art from illustration.

To reiterate and expand on the many aspects of composition you've encountered in the preceding lessons, I would like to discuss some of my own paintings, as well as those of other professional artists. These works represent diverse styles and techniques, but even more they reveal the individuality of each artist, with his or her unique comprehension of art-making.

I don't intend to dwell on every element in these paintings; instead, I hope to give you a sense of what I consider the major concerns, not only when I make a painting, but also as I study the works of others. It is important to allow the work of other artists to inspire, if not influence, your own. Approaching other paintings with an open and constructive attitude—and not just as something to copy—can substantiate and brighten your own ideas and images. To get you started in this direction, I've suggested some exercises, derived from the paintings shown here. You might also try to design some problems of your own. My wish is that you will tap the enormous pool of options available every time you touch brush to paper.

This tiny painting depicts one of the many little statues that adorn the major fountain behind the Palazzo Pitti in Florence. I feel that the extreme drama of the blackened green against the paper-white edge of the sculpture sharply contrasts with the lack of focus and close values in the little cupid and the foreground. I am very fond of this and other miniature paintings I made during my stay in Florence, and it discourages me to see the emphasis placed on full-sheet works by jurors of watercolor shows these days. Don't ever fall for such a false standard. Let your instincts and subjects dictate the size of your format. Making symphonies does not necessarily mean you're making music.

Exercise. *Seek a subject that you feel would be comfortably presented in a tiny format. Paint it in a format where the largest dimension is no greater than three inches.*

Michael Crespo, *Putto, Boboli Gardens*, watercolor, 3¾″ × 3½″ (10 × 9 cm)

My wife Libby made this decidedly planar study of a young girl's head for a large oil painting. The articulated planes each play very specific roles in moving the eye around the head and explaining the surface contours. The strong, light blue streak down the girl's right cheek not only is a surprising focal point, but it joins with the blue plane of the nose and the grainy, blue background in line with the expanding color principle of Day 15.

Notice, too, how the hair augments the back-and-forth spatial movement. On the right the orange and sienna tones shove forward, appearing on the same plane as the eyes, while on the left the dark, flat shape is trapped back behind the ear and the graduated planes running from forehead to the cheek. The flat hair plane abuts the dimensional, multiplanar side of the face. The multiplanar hair area presses against a flat facial plane. These contradicting placements intensify the volume of the head by forcing the eye to move back and forth across the form, trying to unite the separated planes with their counterparts.

The light-drenched glimpse of an anxious dachshund is another example of wise plane location. We move into the space on planes of varying color. Look first at the paper-whites, which move from the dog's back to the chair top and on to the horizontal in the left background. Ironically, the other spatial transport is the black, which streaks us back from the bottom left, through the dog, to the chair, and back to the square in the background above the puppy's head. The colors then complete a powerful three-part scheme used by many artists to evoke harsh light and exaggerated contrasts: black, white, and color in close to equal portions.

Exercise. Crumple a piece of white paper and place it under a lamp or another direct light source. From any point on it begin a pencil drawing directly on watercolor paper, carefully delineating and connecting the planes. Fill your page with the planar subject and paint what you see using black, one other color, and the white of the paper.

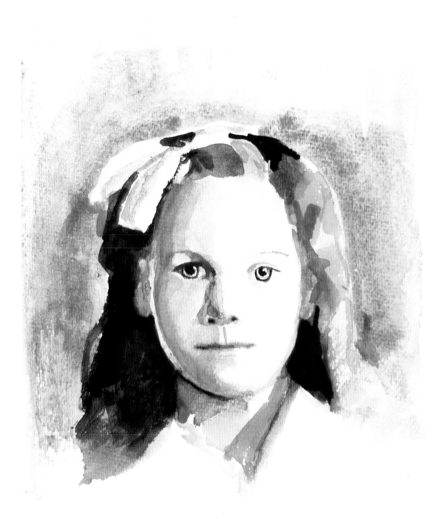

Libby Johnson Crespo, *Study, Leigh Hansbrough*, watercolor, 14″ × 9½″ (36 × 24 cm)

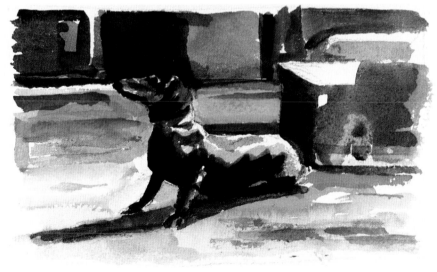

Libby Johnson Crespo, *Chris*, watercolor, 6″ × 9″ (15 × 23 cm)

123

This enthralling little still life is intensified by a rich, grainy surface with an unusual dispersal of pigment. Jean Wetta achieves this effect by first priming the paper with an acrylic medium. This prevents any saturation of the paint into the surface and causes it to move and dry in mysterious ways. She has made ample use of this effect in the tabletop, where the strong, controlled reflection of the vase is flanked by a subtle buildup of illusive geometry, together depicting a convincing highly waxed surface. Additional texture is created when the paint collects in the brushmarks left during the sizing process.

Exercise. Choose a subject suited to a more textural treatment. Before painting, brush a coat of acrylic medium onto your paper and let it dry. You might experiment with various dilutions of the acrylic medium, as these will produce varying surfaces of color.

Jean Wetta, *Kalanchoe in Chinese Pot*, watercolor, 7" × 5" (18 × 13 cm)

I painted this studio companion very directly, with no preliminary drawing. With each new painting I try to discover something new about myself and the medium. In this one I held the brush in my awkward left hand and marked the cat's placid presence with quick, erratic movements. Meditating on the feline more than my painting, scraping and scratching my way to an image, I let some unexpected things happen. No matter how insignificant these things appear now, they were for me a minor triumph.

Exercise. Without making a preliminary sketch, paint any subject holding the brush in the hand you do not ordinarily use. Do not relent, even when painting the most minute detail.

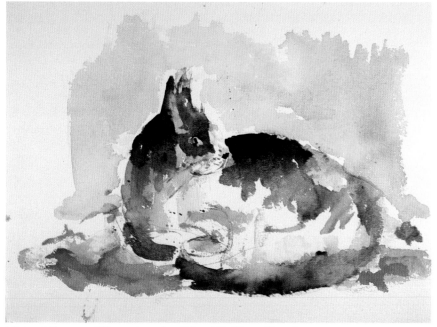

Michael Crespo, *Ollie*, watercolor, 11" × 15" (28 × 38 cm)

124

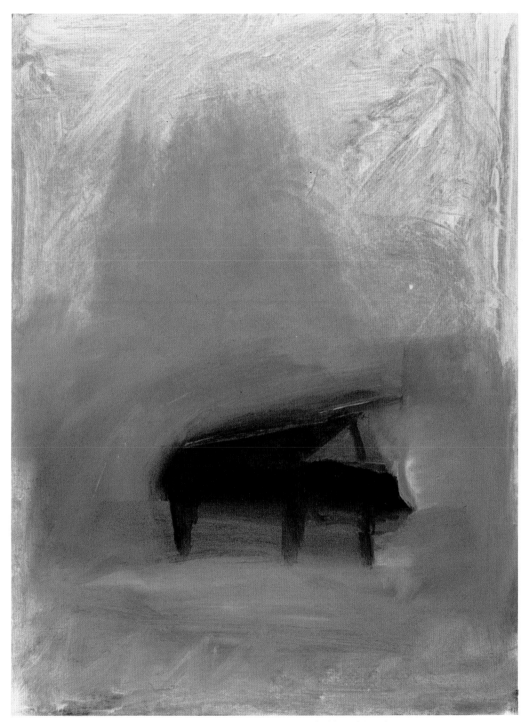

Edward Pramuk, *A Little Mozart Piano*, watercolor, 13″ × 10″ (33 × 25 cm)

This is one of a myriad of paintings Edward Pramuk has made celebrating the grand piano as form and instrument of art. In its shadowy simplicity it establishes itself in my mind as an intimate symbol of that moment when a young Mozart discovered the wonder of the piano. The mood is conveyed by the absorbing cobalt field, with the faint pentimenti of wispy reds and greens tracing beneath the expressively brushed surface. The contour of the piano is kept soft, merging with the background as if it were born of it. A soft, rubbed-out light becomes a curious cloudlike pedestal on which the massive weight rests, not in the concert hall, but in the artist's vision.

Exercise. Make a painting in which a solitary object or shape rests in a large field dominated by one color.

125

My primary intention in this painting was to avoid the usual compositional tactic of containing the entire fish within the edges of the paper. So I began by radically (in my mind) drawing half of the fish entering from the right edge. This set the tone for the rest.

I was always taught that if you cropped an object, the mind's eye would continue the form outside the format. I believe this is true, but one of my major meditations when painting these underwater pictures is that I am painting a complete space, like an aquarium, comfortable and contained on all sides. Cropping violates this drastically. Determined to resolve this, I devised the confrontation of the fish with its prey, the shrimp. This little life-death drama commands the center of the paper, offsetting right-sided placement of the fish.

To enhance this effect, I faded the focus of this fish as it moved closer to the edge, pushing the image more to center. I then dampened the paper and laid in a wash, diminishing it slightly in value as it approached the center. Next I turned the painting upside down and made an emphatic graded wash, also bleeding to light at the center. I might add that to create the scratchy texture of the fish and shrimp, I used a duck's feather I found by a lake.

In the second variation of the theme of the big fish with the little prey, I was content to contain the dominant actor in the center of the composition. Notice that the storyline of the big fish chasing the small one occurs within the basic structure of an orange stripe in a soft, cool field. The larger fish was begun wet-in-wet and then resolved using a stiff bristle brush, of the kind usually used in oil painting. This brush gave a slightly variant mark, freeing the edges of my strokes. The wash was once again graded from bottom to top.

Exercise. Draw a composition in which the majority of objects and shapes are cropped, or situated at the edges of the paper. As you paint, remember that you must keep the viewer's eye moving within the format, so it doesn't escape at the edges.

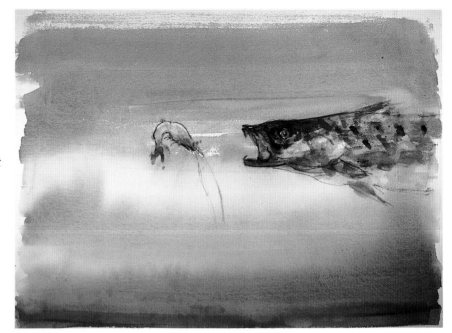

Michael Crespo, *Feeding 1*, watercolor, 22″ × 30″ (56 × 76 cm)

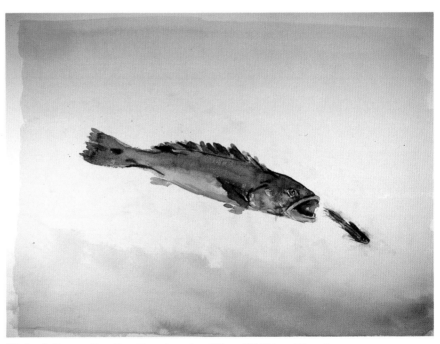

Michael Crespo, *Feeding 2*, watercolor, 22″ × 30″ (56 × 76 cm)

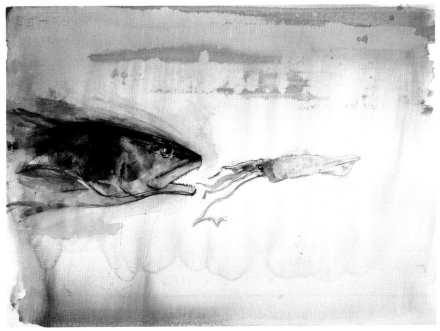

Michael Crespo, *Feeding 3*, watercolor, 22″ × 30″ (56 × 76 cm)

I often work in a series, painting variations on a theme much as musicians compose musical variations. In this way I get to know the subject and inherent problems more intimately; I also force myself to find different solutions and interpretations, if only to avoid the boredom of repetition.

Here I have repeated the basic theme of Feeding 1, but this time I have emphasized the graphic portrayal of the fish and bait by using purer colors and more distinctive line. I was very much influenced by the movement that color produces in Japanese woodcuts. I feel that the colored, gestural lines suggest the movement of a chase more than the rather still confrontation depicted in the first painting.

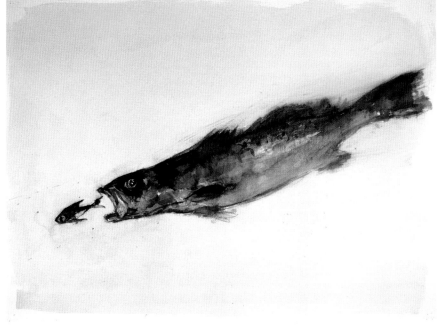

Michael Crespo, Feeding 4, watercolor, 22″ × 30″ (56 × 76 cm)

In this fourth variation I have increased the size of the fish in relation to the format and given it a diagonal pose, again to find more movement. Remember, it's my belief that diagonal lines are faster than horizontal or vertical ones. I have also used a different technique to arrive at a greater sense of volume. I laid down a number of layers of color on the fish until it was very dark and muddled. I then took a stiff, hog-bristle brush loaded with clean water and commenced scratching back through the layers and lifting out with a tissue. In some areas I scratched all the way to the paper. The result is a subtle, convincing volume.

Exercise. Do a series of at least five paintings, exploiting a single theme. You might, for example, work from a still life, keeping the objects in the same position while varying the other elements of the painting. Or you might vary the positions in each painting, or you might do both. The variations may be subtle or drastic.

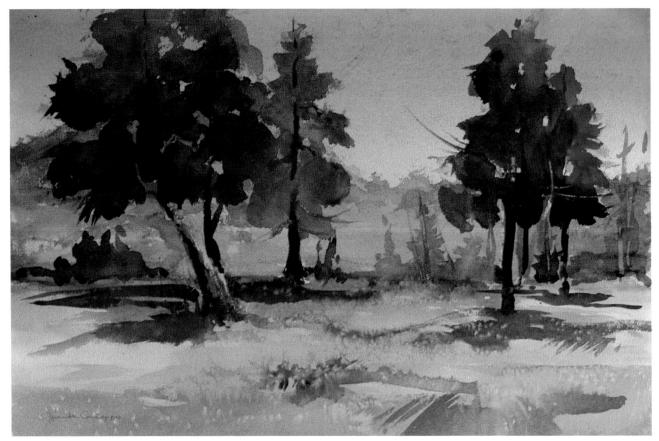

Juanita Cacioppo, *Landscape, Late Afternoon*, watercolor, 14" × 21" (36 × 53 cm)

This fine practitioner of traditional watercolor has taught me much about the medium and inspired me even more. Juanita Cacioppo has been wetting brushes for many years, and I don't think there's any question about the practice of watercolor you can ask her that she can't answer. This landscape is a fine example of how to use temperature contrasts to explain space. The warm foreground plane thrusts cool shadows into the middle ground, which then dissipate into cool, deep, atmospheric space. The edges of forms also dissolve as they move to the rear of the space in what is known as atmospheric, or aerial, perspective.

Exercise. Find a landscape view with a deep space. Begin painting the space farthest away, letting the edges bleed together with little or no definition. When dry, layer the next zone of space on top of this one, painting the edges of forms with a little more delineation. Continue building the space, gradually letting the edges come into focus until they are harshly defined on the forms in the very front of the painting.

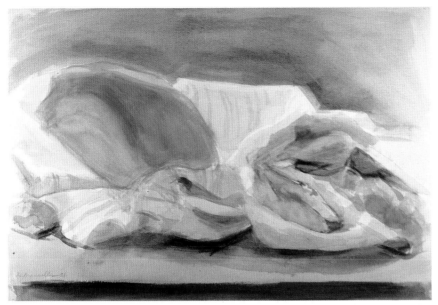

The amorphous objects of this still life lose their identity at the hand of this painter, but a sense of tranquil energy persists, as they seem to crawl across a comparatively distinct table plane. I have always envied Stephanie DeManuelle's gentle markings and colors, and how they extrude a rarefied presence from the carefully chosen objects she owns and confronts. Transparencies are beautifully layered, and warms and cools define the objects and folds, locking together into one large glowing mass. This particular structure results from a very thoughtful control of the edges of forms. These boundaries can be very significant in controlling the flow of space in a painting as they are eroded away or strictly enforced.

Stephanie DeManuelle, *Still Life with Melon Shell*, watercolor,
13″ × 19″ (33 × 48 cm)

The edges are more distinct in this version of the same still life. The smaller, cool grouping on the right defends against the pressure of the larger warm shell with a shield formed by a fold of drapery and its diamond-shaped recess. Observe how Stephanie fades the top edge of the mass into the white, implying its continuation into the space.

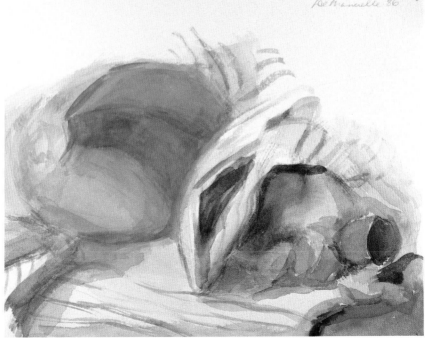

Stephanie DeManuelle, *Still Life with Melon Shell II*, watercolor,
8″ × 10″ (20 × 25 cm)

These curious figures, toiling at mundane chores, seem to be locked in their space and situation by the dazzling grid manifest in so many of Melody Guichet's paintings (see also page 121). The repetitive structure of a grid can be found as a principal motif in the decorative arts, as well as an emblematic framework in contemporary abstract art. Here it establishes a kind of woven atmosphere connecting disparate objects and events. To me, the blatantly distorted cup and saucer suggest that the field may be some uncanny time zone, forcing three disjunctive moments into proximity. In any case, Melody shrewdly juggles the values and colors of the grid to produce an inner light, layers and gaps of space, and nervous optics.

Melody Guichet, *Woman Combing Her Hair*, gouache, 11" × 15" (28 × 38 cm)

Stella Dobbins floods her paintings with repetitive patterns, which form an underlying gridlike structure. She develops the patterns by laying in multitudes of glazes; it takes her well over a month of steady work to complete one of her paintings.

This painting operates on several compositional levels. From one perspective we perceive the illusion of space, marked by the clever color and value changes from the reflective table plane to the hanging drapery. From another, the obsessive patterning of the drape and reflection merges into a continuous, gridlike field, on which the four animal objects are superimposed. And when we scrutinize the beasts, we begin to discern not only their geometric placement, but their visual and literal likenesses and differences, establishing yet another level. All these different compositional readings help to make this painting exciting to look at.

Exercise. Spend some time sketching shapes in your journal. They should be derived solely from your imagination. On your watercolor paper, plot and lightly draw a grid, which is merely a repetition of any type of shape. Situate some or all of the shapes you invent in the grid and commence painting.

Stella Dobbins, *Indian Still Life, or Homage to Mu C'hi*, watercolor, 26" × 40" (66 × 102 cm)

Barbara Lion, *Witches Delight*, gouache, 22″ × 30″ (56 × 76 cm)

Barbara Lion works almost exclusively in water media on paper. Spirited, visceral shapes in tumbling organizations always identify her wonderfully inventive paintings. The background for these frolicking creatures is set by the soft murmur of transparent wash transitions. The shapes of the dreamlike inhabitants then alternate between harsh opacity and modeled transparency, providing the volumes with curious spatial identities. This painting is also a fine example of the "varied color shapes on a gray field" scheme from Day 4.

Orlando Pelliccia, *Pekins Study #2*, watercolor, 9″ × 20″ (23 × 51 cm)

This entertaining painting reflects Orlando Pelliccia's concern for the format as well as the three-dimensional illusion. The intricate edges of the waterplants along the horizon line form the top edge of the paper, for they have actually been cut away with a razor along their contour. It's an odd little surprise and gives the painting a slightly sculptural feel. The technique is well planned, economical, and painterly. Value and color are recorded with notable precision and describe the space with authority.

Exercise. Make a painting of your choice, but break from traditional formats. You may wish to use an extreme version of the rectangle as James Templer does (see page 136). You might also consider a circle or another shape, or you might cut away an irregular format with a mat knife as Orlando Pelliccia does. There is also the possibility of building a three-dimensional structure out of paper and tape, and then painting it. Whatever you do, be daring and keep tongue in cheek.

Orlando Pelliccia, *Untitled*, watercolor, 22″ × 30″ (56 × 76 cm)

Precise colors and values create the illusion of cut-out and pasted-down forms in this wash-day painting, even though it's painted on a standard watercolor sheet. It is, however, a study for a work in which the socks were actually cut out of plywood, painted as they appear here, and hung on real clothesline across the gallery. For a time, Orlando Pelliccia thrived on juggling illusions and realities.

In this painting Jean Wetta builds layers of transparent watercolor to produce a luxurious sky of billowing clouds. She facilely models warm violets to cool, making sensations of heavy volumes. The paper-whites ripple reflections in the sand, form whitecaps in the waves, and speak of sunlight in the sky. Earth, sky, and water attain a majestic scale with the appearance of the two small, brightly clothed waders in the surf. Try to imagine this scene without the figures and you'll understand just how much they contribute.

Not so long ago, while visiting James Templer in his studio, I immediately responded to this exaggerated format containing the vast panorama. The distant shore on the left exposes just enough of the tan color in the diagonal slice off the right corner to engage the two slivers of land in a conversation across miles of the expansive bay. Their scant, warm color is magnified by the luscious blue of everything else. But the prima donna of this painting is the playful, central cloud, which rises up with brattish aplomb, defying the compressed horizontal format and internal lines.

Jean Wetta, *Galveston Beach with Two Women*, watercolor, 7″ × 5″ (18 × 13 cm)

James Templer, *Galveston Bay with Single Cloud*, gouache, 7″ × 22″ (18 × 56 cm)

Michael Crespo, *Three Great Egrets*, watercolor, 14″ × 20″ (36 × 51 cm)

One of the benefits of living in Louisiana is that these magnificent birds occasionally appear in my backyard. A little lake attracts them, and when they arrive I try to paint or draw as much as I can. This painting began with two washes, one blue, one yellow, set side by side. The blue wash remains as the sky, but the yellow one lies beneath the birds and water. Some traces of it are still visible in the left center. The whites of the sky and on the birds were not masked initially, but just carefully worked around. As I painted, my interest seemed to shift from the birds to the surrounding palmetto leaves, which in the end became the dominant subject. Their jagged activity excited me more than the morose egrets.

Exercise. Look over all the paintings you've made so far and find one in which heavily articulated forms are surrounded by a relatively undeveloped background. Remake this painting, reversing the scenario. Let the background become the focus of your labor, the objects its aftermath.

PART 2

SECOND
SEMESTER

DAY 1
Beginning Again

Even if you're extremely dedicated, faithfully painting on a regular schedule, there will be periods of time when the water evaporates from your brush-cleaning bucket and the colors dry up on your palette. For my students, the culprit may be one or all of the semester breaks; my own routine may be interrupted by a vacation, a period of intense work in another medium, or a simple lack of inspiration.

Eventually, however, new ideas and the urge to paint will propel you back to the studio. And then you must face the often daunting prospect of beginning a painting. Fear of failure and all its subsequent tensions inhibit me whenever I approach the vast, empty white sheet of paper that awaits me. But I have learned to overcome this initial apprehension, and you must, too.

Let's take a little time now to analyze what we do when we paint and allow ourselves to drift effortlessly back into the full painting process.

Normally, you would begin with an idea about something you're looking at, or a vision in the mind's eye, or just a phrase begging to be illustrated. Today, the only subject matter will be the colors and marks that illuminate the movement of your hand.

Exercise: Letting Go. Your first task is to clear your mind so you can appreciate the sensations of painting. To facilitate this, I suggest you choose some piece of music to play in the background, something that relaxes, comforts, even inspires you. Music, in its inherent abstraction, is remarkably symbiotic to painting and is the quickest way to lift the mind from its pedestrian preoccupations and let it soar uncluttered and creative.

Place before you a full sheet of clean white paper and a full palette of moist colors. Choose a brush you like and mix a large puddle of your favorite color. Slowly carry the fully loaded brush to your paper.

While your mind loses itself in the music and your eyes focus on the spot where your brush tip releases its colored cargo, allow the hand and brush to move where they will, marking the paper as if responding to a force deep within you. Feel the brush in your hand. Feel the pressure your fingers exert on it. Release any tension you feel in your hand and arm. Relax your grip until the brush almost falls from your fingers. Feel the wet bristles as they trace the surface of the paper. You may even find your brush marking time to the music. Keep the brush loaded, and allow any and every motion and mark to occur.

Celebrate. This is the pure, unobstructed core of any painting process. Continue until this color has wandered from corner to corner of the page.

As the first layer dries, contemplate a new color; perhaps the first color will guide you. You may even wish to change your music, seeking a different structure, a different mood. When you've mixed the second color, proceed as you did with the first. Find your pace. Meditate on the mingling and interacting colors. Continue to let your impulses and intuitions guide you.

Does it bother you that you have no subject matter? Remember that you are making a painting about painting. Color, value, light, rhythm, pattern, emotion are all present. There will be time enough later to think about subject matter.

Build at least four layers of color before you stop, and then do not be too quick to discard this "action" painting. Tack it to a wall somewhere in your work space and observe the freedom, flow, and spontaneity. In the days to come, this lyrical, ephemeral meandering of color may serve as a reminder of the expressive tranquillity and heightened sensitivities that are so essential to successful painting. Remember: relax, love what you're doing, and don't take yourself too seriously. Let your critics do that.

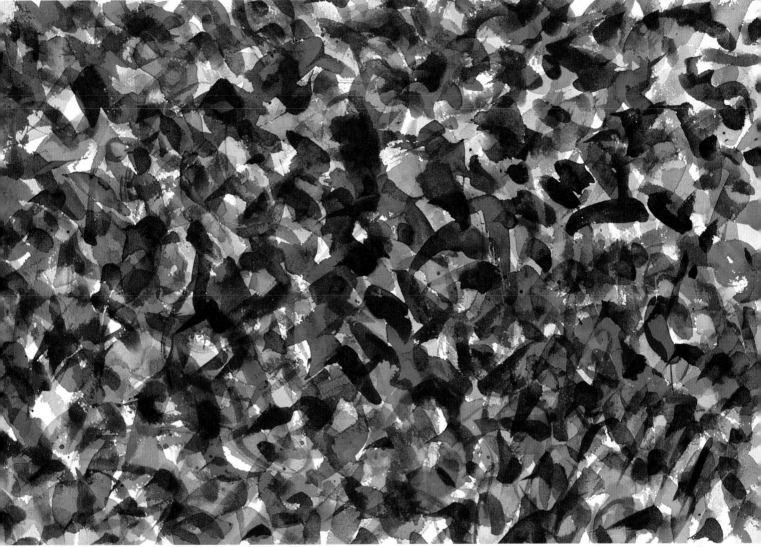

Michael Crespo, MEDITATIONS ON DR. JOHN AND BACH, watercolor, 22″ × 29″ (55.9 cm × 73.8 cm)

I seldom work in my studio without music in the background. It's a friendly studio companion. This exercise, which I practice frequently, clears out the cobwebs and brings me back to a more heightened awareness of the elements of painting, as well as the soothing intelligence of music. I was listening to the jazz piano of Dr. John and some J. S. Bach preludes performed by Glenn Gould as I worked on this painting. I made about ten layers of different colors; the brush motions were translated from the music.

DAY 1: Beginning Again

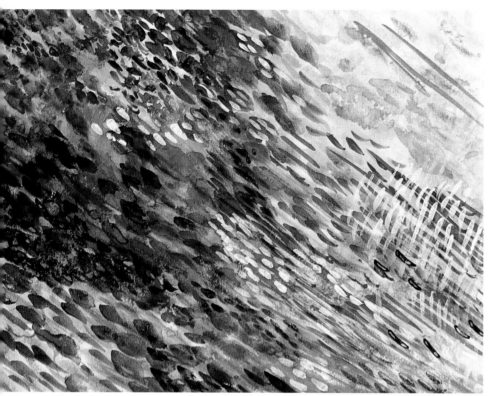

Dierdre Broussard, student work, 9″ × 12″ (22.9 cm × 30.5 cm)

Dierdre Broussard concentrated on maintaining a distinct direction to the flow of countless similar strokes of red, blue, and yellow. She began painting on wet paper, and as it dried, the marks became more focused. This progressive layering of dry over wet is a very logical way to form space; the eye perceives the less-defined strokes as farther away. Dierdre also did not apply each layer uniformly. The top right and bottom left corners are both remnants of earlier layers, while the left center area is densely populated with marks from each pass. Such distinctions further enhance the space in this exercise-turned-painting. Finally, the opaque Chinese white strokes on the right provide an effective counterpoint to the commanding direction of the flow, like a small pack of minnows suddenly darting out of a larger school.

Tanya Ruffin, student work, 9″ × 12″ (22.9 cm × 30.5 cm)

Tanya Ruffin has produced a dreamy, undulating world by keeping the paper wet throughout the process. We can detect some drier contrasting shapes among the prevalent puffy, cloudlike forms. Rather than let the paper dry completely as she painted, she occasionally rewet it, creating a lovely interplay between the soft but animated layers. The color further reflects this very soothing space by systematically moving along the color wheel from blue to purple to red.

Joe Holmes evokes a great sense of motion in his painting with two great elliptical movements that fill the top and bottom halves. Although a long, slashing stroke prevails, setting the rhythm, there are a number of contradictory marks that fly furiously about in this violent space. Obviously, Joe alternated great sweeping movements of his arm with smaller wrist and finger stroking. There are some abrupt changes of direction that also counter the big circular patterns. I can't help seeing imagery in these abstract wanderings, and this one reminds me of the depths of a tornado.

Joe Holmes, student work, 25″ × 18″ (63.5 cm × 45.7 cm)

Charles Brown, student work, 22" × 30" (55.9 cm × 76.2 cm)

Charles Brown volunteered the fact that he painted this while listening to the rock group Genesis. His meditations resulted in some relatively structured geometry housing the random scrapings of color, many of which are drybrush technique. He allowed a lot of paper to remain white during the process; this imparts a wonderful sense of light to the painting. Verticals, horizontals, and diagonals are clearly rendered and loosely woven together. Five mysterious yellow verticals dance in a well-orchestrated field of complementary colors.

Celeste Schexnaydre began with some very faint movements on very wet paper. Then she applied more color in big, splashing gestures that became more defined as the paper dried. She also made smaller notations within some of these large movements. Everything seems to be gently spilling from the right edge of the painting. Her final marks, the flora-like stems and lozenges at the top, seem almost recognizable, perhaps indicating that Celeste may have been thinking of some literal subject matter. Nonetheless, they add a little mystery and top the composition nicely.

Celeste Schexnaydre, student work, 16″ × 11″ (40.6 cm × 27.9 cm)

DAY 2
Edges

Honoré de Balzac's short story "The Hidden Master-piece" contains many insights into painting and the creative process; I consider it required reading for any artist or art student. At one point in the story, the master painter Frenhofer lectures to the young Nicolas Poussin on the virtues of eliminating edges from forms, making it almost impossible to distinguish where an outline ends and the background begins. He contends that light alone gives appearance to form. The old painter concludes his inspired lesson by comparing this technique to that of the sun, which he names the divine painter of the universe.

Although the fictional Frenhofer could be satisfied with a single technique for handling edges, artists in the real world should explore all the possibilities. Variety in edge can produce different voices within a painting, changing the look of the space, controlling the tempo of the eye as it moves over the painted surface. You may choose to employ only one type of edge, as did Balzac's painter, or you may use many.

The painted statement will be different with each decision you make.

We will examine four different ways of handling edges. The hard edge gives absolute distinction to a form, while a soft, mingled edge suggests a more atmospheric look and lessens the focus. The overlapped transparent edge produces a third color that serves as the transitional element, and the linear edge marks a boundary that can vary as much as a line can be varied.

Exercise: Variety in Edges. Set up a still life of at least four objects. Make one painting from it that illustrates all four of the edge variations discussed. It is not necessary that you actually see the different edges in the setup, although varying surfaces and creative lighting can produce them. It is necessary that you paint them, either letting each object represent a different edge type or randomly weaving the different types throughout the painting.

Hard edges are produced by painting a shape, letting it dry, and carefully following its contour with the adjacent shapes or background. To save drying time and produce an even harder, sharper edge, you can leave a trace of unpainted white paper separating the edges. This will allow you to paint both edges at once without two shapes mingling.

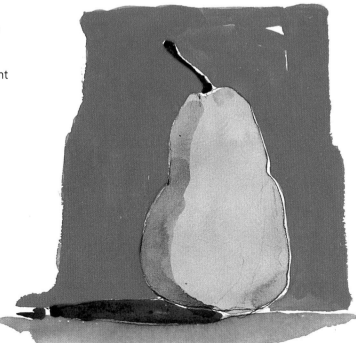

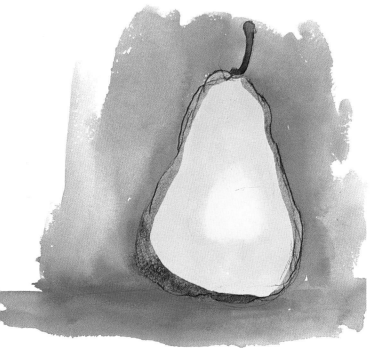

The overlapped transparent edge, a variation of the hard edge, is produced by painting a shape, letting it dry, and painting the background over it. In this illustration, the blue background has combined with the yellow of the pear to produce a green transitional edge.

Simple wet-in-wet technique will result in the soft, mingled edges that wed form to background. Color and value changes are used to distinguish the two.

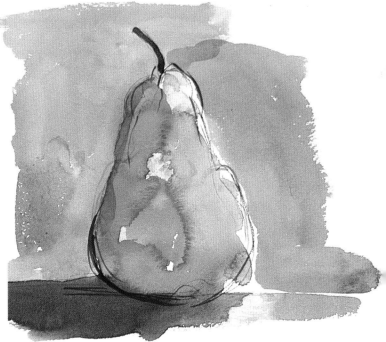

Here are a few of the many possible types of linear edges. The pear's shape was first constructed with line, followed by the broad planes of color. The character and function of the edges are determined by the type of line painted. In this example, they are thin and frilly in the light, heavy and morose in the shadows.

All four types of edges—the hard edge, the overlapped transparent edge, the mingled edge, and the linear edge— were used to define the perimeter of this pear's form.

DAY 2: Edges

Steve Erickson has succeeded in producing a very cohesive space despite his scattering of the various techniques here and there. He finds linear edges in the metallic coffeepot and the piece of drapery entering the foreground. Soft edges dominate the two objects in the left background, contrasting with the hard edges of the three foreground objects—a fine example of how varying the edges helps promote spatial illusion. The orange and the large blue vase both contain overlapped transparent edges. An ambiguous brown plane connects the coffeepot to the big blue vase, overlapping the edges of both. This idiosyncratic mark provides yet another beautiful surprise in a painting chock full of them.

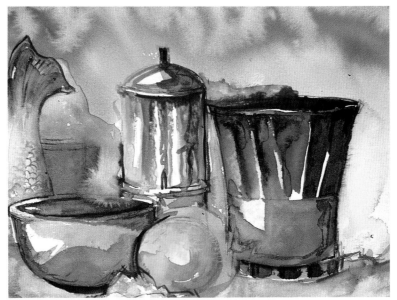

Steve Erickson, student work, 9½" × 13" (24.1 cm × 33.0 cm)

Ann Mouser accents a predominantly soft space with hard and linear edges. She has casually shifted edge techniques in each object, so the various types are evenly dispersed, except in the espresso pot. There, the hard stripes and assertive line make it the center of attention. Note the exceptional molding of shadows in the rich green ground plane and the wet-in-wet mingling of the complements blue and orange in the background. Drenching color and value produce the pleasant light, but Ann's preoccupation with the edges imparts the vitality that I feel is this painting's strongest asset.

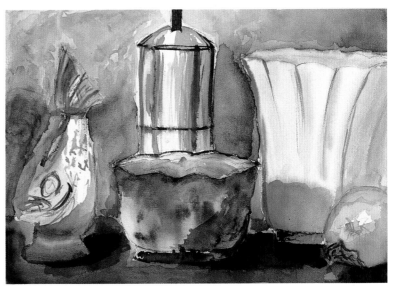

Ann Mouser, student work, 11" × 15" (27.9 cm × 38.1 cm)

Robin Viallon achieves a heightened sense of space, suitable to his personal style of draftsmanship, by using a different edge type for each object of this still life. The fish vase is constructed with linear edges, the coffeepot with hard and linear, the bowl with soft, the big vase with overlapped and soft. The orange flaunts all four edge types; its varying contour, the warmth and intensity of its color, and its front-and-center placement all assert its dominance in the composition.

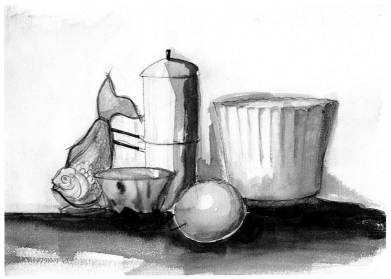

Robin Viallon, student work, 12" × 16" (30.5 cm × 40.6 cm)

146

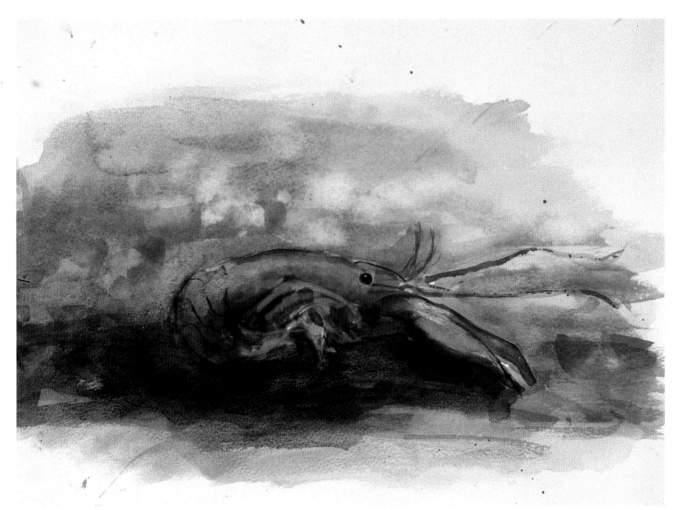

Michael Crespo, MUDBUG, watercolor, 11″ × 15″ (27.9 cm × 38.1 cm)

I suppose that painting and eating crawfish could be vocation enough in one person's life. This book was being formed while the delectable crustaceans were in full bloom, which accounts for their appearance in a couple of my paintings. I intended that this specimen be painted in a submerged environment, a bayou of course. I accomplished this by using all four edge types to construct the creature. There are hard edges in his legs and on his back; overlapped transparent edges under his tail and in the background; linear edges distinguishing parts of the anatomy, especially the segmented tail; and soft, mingled edges scattered throughout. This dispersal of edges causes focus to move in and out, which definitely enhances the illusion that he is underwater.

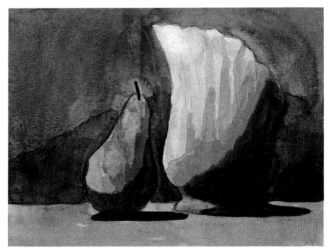

Maureen Barnes, student work, 9″ × 12″ (22.9 cm × 30.5 cm)

Maureen Barnes surrounds areas of soft, damp brushwork with hard edges that bring a lively feeling to a quietly glowing still life. When painting edges, you might consider their relationship to the planes that they border. For example, the dark, elliptical shadows cast on the ground plane are hard, flat planes with hard edges; the other shapes are painted in various degrees of wet-in-wet but still have hard edges. A single type of edge can play numerous roles in combination with various techniques.

DAY 2: Edges

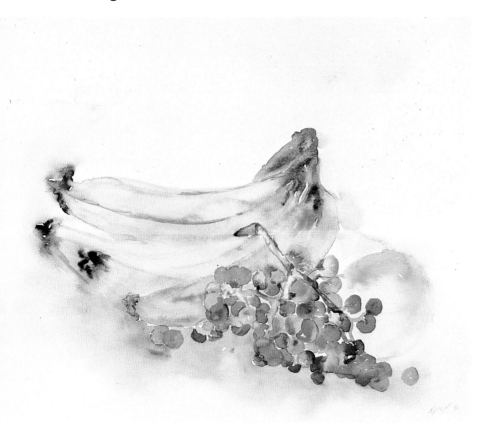

Patricia Burke, student work, 15″ × 20″ (38.1 cm × 50.8 cm)

Patricia Burke has fused three of the edge types to produce the sinuous surface of this study of bananas and grapes. The grapes are formed with hard and soft edges that seem to pop in and out of the paper. The bananas are dominated by soft edges occasionally marked with line, a line that further articulates the space by its cadence from sharp and dark to dull and flat. Remember that linear edges can be manipulated with all the qualities attributed to line: width, value, color, and emotion.

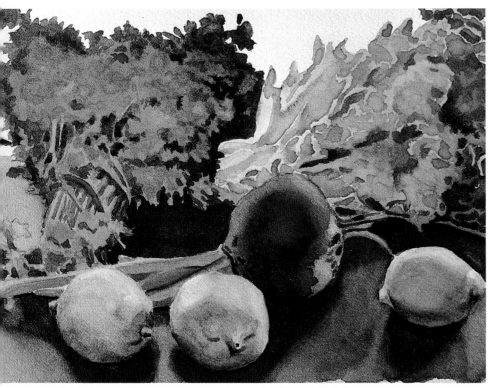

Robert Hausey, STILL LIFE WITH LEMONS, PARSLEY, AND TURNIP, watercolor, 8½″ × 11″ (21.6 cm × 27.9 cm)

Robert Hausey relies heavily on contrasting edges to construct the space of his vegetarian still life; he uses hard edges in the background and soft edges in the foreground. Thus, he describes the volumes of the turnip and lemons with soft-edged transitions of light that are echoed in the play of light on the tabletop. In the background, he describes the bunches of parsley with clear contours and many small, discrete, hard-edged planes.

Robert does vary this scheme somewhat for the sake of unity and balance. There are some soft edges in the background parsley, and the contours of the lemons and turnip are sharply defined. He is keenly aware of the potential of edges within a composition, and he paints them with dazzling skill.

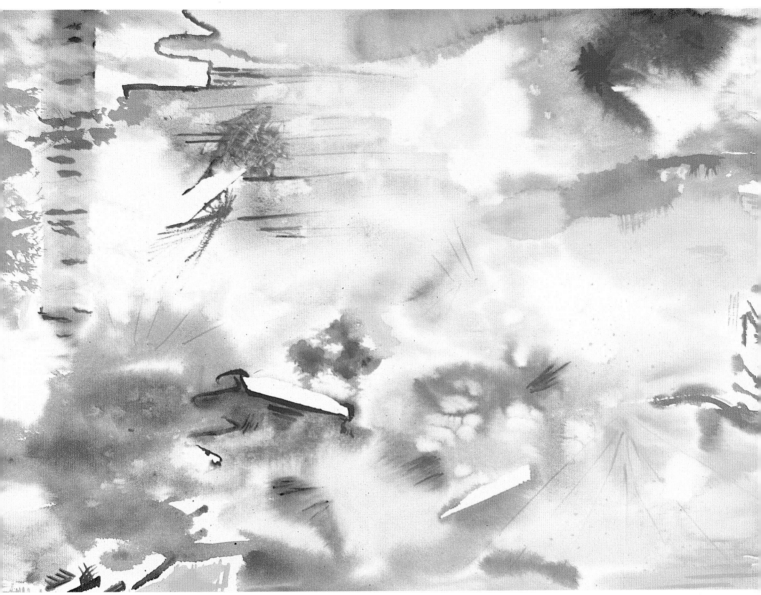

Laure Henry, student work, 16″ × 22″ (40.6 cm × 55.9 cm)

Laure Henry has paid attention to edges in this abstraction from a landscape. The subject's identity is lost in the wet, mingled edges and the bright primary colors. Contrasting sharp, linear edges move the eye around the space and vaguely describe trees, foliage, and architectural forms. The side of the blue tree trunk on the left displays alternating mingled and hard-edge techniques. Other edges in this painting have been formed by overlaying wet edges over hard edges, forming another variation on the overlapped transparent technique.

DAY 3
Multiple Viewpoints

One of the most basic problems painters must wrestle with is describing a three-dimensional world in a two-dimensional medium. From the Renaissance through the early part of this century, most artists relied on one- and two-point perspective. Then Pablo Picasso, Georges Braque, and the other artists we now call the cubists started exploring alternatives; one technique they used was to paint a subject from several different angles at the same time, using multiple points of view in the same painting.

Picasso argued that his work was more realistic than that of the academic painters because their subjects were all painted from a single point of view, while he drew his from above, below, right, and left, displaying all these facets simultaneously. He supplied the viewer with more information about the subject. His argument, however cheeky, was essentially correct, and although his paintings distorted nature, they resulted from intense analysis and perception. Picasso and the cubists completely restructured the space of the "real world" on which they gazed so fiercely.

Today I would like you to generate a new vision of nature, not by whim of the imagination, but by a methodical examination of the subject. You will also make a painting using multiple viewpoints to produce more credible volumes.

Exercise: Shifting the Viewpoint. For the first painting, set up a still life with five or more objects. Place them out in the middle of the room rather than against a wall. There should be plenty of activity in your field of vision. With a pencil, or with a small brush and paint, lightly sketch the entire still life, including what you see behind it. Now shift your point of view, right or left, up or down, and draw the setup again, right over the first sketch. Notice how the shapes and dimensions of the objects change as you move. Continue to move and draw in this manner three more times, making a total of five points of view overlaid on the paper. By now the references to objects will be greatly distorted, so be aware as you paint that new shapes and new rhythms have been created. You may choose to work with a new color system, or you may work in local color. Combine some of the shapes into new, larger ones to vary the scale. You may wish to paint with a natural light in mind, perhaps, illuminating the scene from the right and leaving darker values on the left of the "new" objects. Experiment with technique. Transparent overlays are effective in rendering the new space. Whatever you do, do not get tongue-tied trying to follow the still life too closely. You have discovered a new world; keep experimenting and innovating until the painting is finished.

Exercise: Increasing Volume with Multiple Viewpoints. For the second painting, work from one object, perhaps a piece of fruit, placed in a very simple setting. Make a pencil sketch of the object in the space. Now shift your viewpoint very slightly, not radically as you may have in the first problem, and overlay another drawing from this new point of view. Do not redraw the space this time, only the object. Repeat this for a total of three drawings on the paper. Paint the object as you observe it. Be subtle in painting the added planes. The goal in this painting is to produce a slightly distorted object, smoothly bulging and full. In future paintings, you can achieve the same results by simply shifting your head and looking around the forms you paint to discover the extra bit that will augment fullness and weight.

Celeste Schexnaydre, student work, 11″ × 15″ (27.9 cm × 38.1 cm)

As the eye wanders about this complicated accumulation of multiple viewpoints, it comes to rest on the objects in the far background at the top of the painting. Here, Celeste Schexnaydre has simplified her discoveries and made subtle references to the original shapes of some of the objects she painted. They provide a comfortable backdrop for the frenzy of shapes before them. But even in this frenzy we can still discern some of the original contours. The forms are all exploded, but Celeste has managed to secure their original positions by using repeated verticals. She has also toyed with the edges of the paper by keeping the objects together on the stark white field, their commanding, jagged contour forming a new perimeter.

Shaun Aleman has incorporated the table and background into his painting and has used transparencies to record his shifts in viewpoint. He began by laying in the blue underpainting, which resulted from fragmenting the surrounding space. As he moved and viewed the changing space, he recorded only select planes suggested by the objects, clustering the smaller shapes in the center, letting the larger ones surround them, maintaining the integrity of the original group of objects. He varied the edges: some wet-in-wet, some wet-on-dry. The color temperature varies from one extreme to the other, with warmer colors patterned effectively across the cool bluish field.

Shaun Aleman, student work, 11″ × 17″ (27.9 cm × 17.8 cm)

DAY 3: Multiple Viewpoints

Robin Viallon uses color to simplify the complex drawing he initially made. You can see where he disregarded some of the new shapes he discovered and returned to the original objects, leaving a curious and effective interplay between pencil line and paint. This is especially true of the fruit in the center, which, although still very planar, most resembles the perceived object. Most of Robin's newly constructed objects still suggest very credible volumes despite the explosion and distortion of their forms. He ties the setup nicely to the ground plane with faint dustings of paint along the bottom edges—just enough transition to relate the mass to the white of the paper.

Robin Viallon, student work, 11″ × 15″ (27.9 cm × 38.1 cm)

Maureen Barnes has flattened the space considerably in her painting by letting some of the forms run off the page. White shapes are trapped across the top of the painting and become constituents of the mass and not just surrounding space. Remember—when shapes are cropped or placed very close to the edges of the format, the background or foreground will break up into shapes and look less like a field. So if you want more interplay of shapes, fill the page with subject.

Maureen Barnes, student work, 7″ × 9″ (17.8 cm × 22.9 cm)

Steve Erickson, student work, 10″ × 17″ (25.4 cm × 43.2 cm)

Joe Holmes, student work, 9″ × 13″ (22.9 cm × 33.0 cm)

Steve Erickson has produced a variation on the problem, painting the environment from one point of view and the objects from many. The juxtaposition is impressive, and I encourage you to experiment with this problem if you wish, but I feel this painting would not have been as successful if he had not been inspired to run the black line through the setup. It further distorts the objects as well as isolating and strengthening the colors, much as the lead does in stained glass. Notice his deliberate textural detailing on the fruit and especially the sponge in the background. This kind of symbolic description was also favored by the cubists.

In this painting, Joe Holmes retains the basic contours of his objects, but he sets their interiors and the surrounding space spinning with shapes he captured while moving his point of view. He has corralled small shapes and bright colors in the objects that contrast in scale and color with the background. It's curious that while these distorted shapes fill the objects with a tension that is on the verge of exploding, they also describe the natural surfaces and volumes.

Samuel Corso, NIGHT VISION: CHAIR RIDE, sumi-e/watercolor, 40″ × 27″ (101.6 cm × 68.6 cm)

This is my rendition of the second part of this problem. An eggplant is usually a very smooth object, but in my painting it takes on a lumpier appearance. This results from my shifting positions a couple of times to "see around" the form so I could exaggerate its volume. My initial drawing was much more distorted. I always feel it is best to shoot beyond your mark, then pull back a little. I used the paint to veil some of the increased planar activity, but the extra planes are still noticeable—the depression and bulge at the bottom right of the vegetable, for example. Granted, the eggplant is somewhat distorted, but its form is full and heavy, and that is what you get when you paint a bit more than you see.

Michael Crespo, EGGPLANT, watercolor, 11″ × 15″ (27.9 cm × 38.1 cm)

Joe Holmes's use of multiple viewpoints has produced an illusion of great depth from the spoon in the bowl to the chair in the back. As we look from object to object, the change of viewpoint slows us down, making the journey to the back of the painting seem like a long one. As we look at each object individually, we find clues to Joe's moving position: the handle of the cup as compared to its rim, the top of the coffeepot as compared to the bottom, the way the back of the bowl mysteriously lifts up. These distortions, coupled with some very clear planar rendering, produce objects that sit on the table with the weight of lead balloons. The high-key color and the bath of light also contribute to the success of this painting.

Like the objects in Joe Holmes's painting, this chair has been blown apart and reassembled. As you look at each part of it, you can feel yourself in a different position in the room. Distortion has breathed motion into the usually static form, and the chair seems about to gnash its way through the wall and into the light. The background is also alive with beautifully controlled washes interrupted by the harsh light below and the geometry above.

Joe Holmes, student work, 8″ × 11½″ (20.3 cm × 29.2 cm)

DAY 4
Self-Portrait

The self-portrait is, aside from the nude, one of the most popular subjects in painting; furthermore, you yourself are the most readily available model. Today you will do three paintings exploring various aspects of the self-portrait. You will need a mirror and some kind of light source, preferably natural light from a window. Before painting each phase of the problem, do some pencil sketches so you will be comfortable with this sometimes intimidating subject.

Exercise: Seeing the Planes. First, examine your head for what it is visually—a sphere with an undulating surface of planes. Look at your head in the mirror and paint from it, grossly exaggerating the planar structure. Begin with the obvious: the fore-head, cheeks, nose, and sides and top of the head. Then look for the smaller planes that make up the eyes, nose, ears, and other features. Feel free to overstate and invent new planes. You may have to make certain transitions. Change color or value as you move from plane to plane to keep them distinct. As you paint, feel with your hand the part of your head you're painting. Light exposes most of the planes, but your hand can show you those hidden beneath the surface.

Exercise: Close-up of the Face. In the second painting, depict only the features of the face, cram-ming them into the format of the paper. As you work on this one, place your mirror as near as you can to your face. Paint your eyes, nose, and mouth as you see them, paying close attention to the details of their structure. It is not necessary to exaggerate the planes as in the first painting, but keep the planar construction in mind. Fill the page with your face, letting the edges of the paper crop off any other parts of the head.

Exercise: Narrative Self-Portrait. Finally, you will investigate a more narrative, or storytelling, composi-tion that includes your self-portrait. Make a painting that contains your head and one of your hands. What your hand is doing will determine how dramatic a tale you tell. Also consider attempting some facial

expression, whether it be one of anger, joy, or simple disinterest. Be sure to investigate this carefully with your pencil beforehand. The hand and the expression may provide a little more of a challenge.

Caution: Any system of colors can produce flesh tones. Although the standard pinkish variety may work well for you, do not assume it's the only way. As always, experiment.

This drawing illustrates some of the many possibilities for constructing the planes of the head. Notice that it contains both open and closed planes. A closed plane is one that is completely surrounded by a continuous line. The shadow under the nose, the top lip, and the shadow under the bottom lip are examples of closed planes. An open plane is not completely enclosed but bleeds into another plane at some point. The plane of the left cheek flows into the vertical plane moving down to the neck, as well as the plane surrounding the eye and the plane under the left side of the nose. These are all open planes. In fact, the left side of the face is constructed with predominantly open planes, while closed planes prevail on the right side.

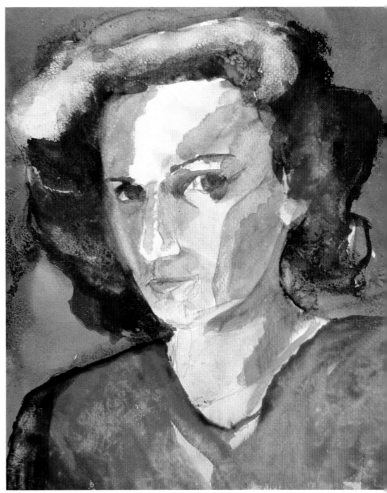

Alice Verberne, student work, 12½" × 10" (31.7 cm × 25.4 cm)

Joe Holmes, student work, 12" × 6" (30.5 cm × 15.2 cm)

Joe Holmes has chosen an analogous palette ranging from violet to blue-green to render the planes of his head. These closely related colors make the transition across the exaggerated planes a lot smoother. On the nose, neck, and top of the head he has used a warm orange to accent the dominant cool colors. His placement of values works well in giving the whole head a greater sense of volume. Where he wants a plane to come forward, he leaves white paper or applies a very faint color. When he traps a light value deeper in the space—the light plane under the right cheek, for example—it becomes a plane of reflected light.

The illusion is enhanced by the variation in the sizes of the planes, from the larger ones in the shirt and neck to the smallest in the detailed construction of the eyes. Note also the various techniques within the planes: Some are flat, some modeled, some textured.

Alice Verberne approaches the problem by drawing much larger, more generalized planes; however, her lush technique loads the simple planes with visual interest. The most successful area is the hair, where soft edges create smooth transitions between the articulate planes. See how she just overlays a transparent red to establish a new plane. Once again, a well-controlled value system defines the placement of forms, with planes dramatically changing from light to dark as they move from front to back. This is especially necessary if you plan to use a lot of subtle wet-in-wet planes.

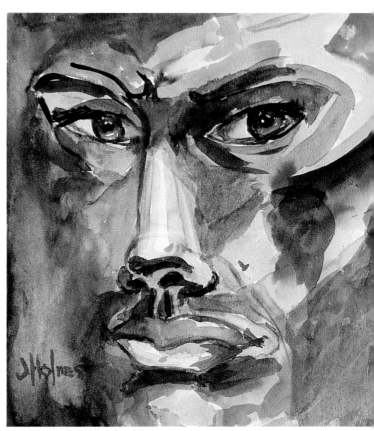

Joe Holmes, student work, 11½" × 12" (29.2 cm × 30.5 cm)

Joe Holmes used the complementary colors blue and orange, applied wet-in-wet, as the basis for his second self-portrait. Then he used drier strokes to develop the features into a disturbing, ominous stare. The distortion of the face melting to the edges of the page adds to the intensity of his expression.

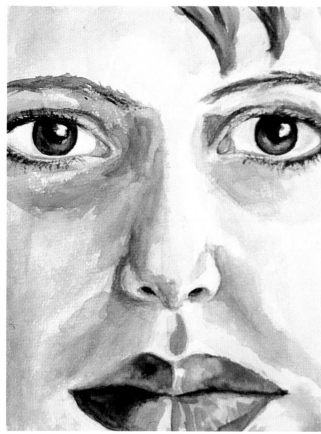

Madeline Terrell, student work, 8½" × 11" (21.6 cm × 27.9 cm)

Here's a face that is just bordering on a smile. These subtle expressions are often more difficult to depict than the more obvious ones. Do try to make some theatrical facial gesture in at least one of the three self-portraits.

Madeline Terrell chose a monochromatic gray and a lifelike rendering technique to make this painting, which looks a little like a snapshot. She creates a distinct scale distortion by pressing her features right up to the viewer's face, like Gulliver peering through a Lilliputian picture window.

Scot Guidry cheats a little and lets a sliver of blue background define one side of his head, but this is still in keeping with the basic premise of experimenting with the edges of the format. The blue not only works as a foil to the pale, watery color and paper-white that define the other edges, but also serves as a complement to the subtle orange hues that define the face.

Using multiple viewpoints, Scot looks around the left side of the face, exposing planes that are not usually visible in the three-quarter view. He sets up tension on that side by enlarging the left eye so much that the entire left side of the face seems to be trying to jump out in front, but the nose is constructed strongly enough to keep it in place.

Paul Cézanne sometimes painted the eyes two different sizes. The theory is that if the eyes are different, the viewer will spend equal time looking at each, moving back and forth and thus creating the illusion of space. If the eyes were identical, we would view them simultaneously as a unit, which would flatten out the space. The theory is illustrated well in this expressive piece.

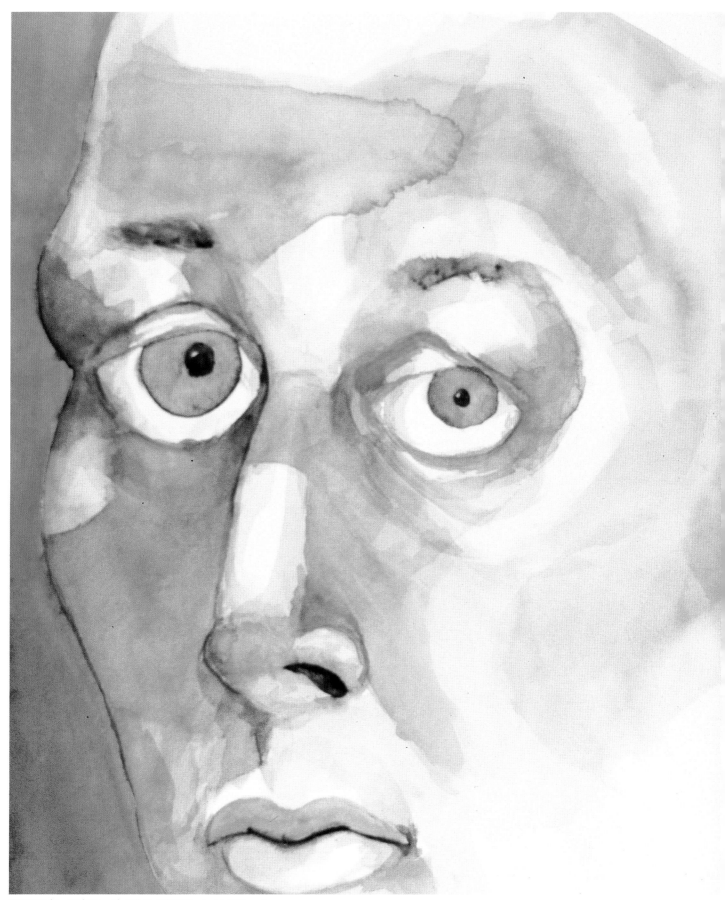

Scot Guidry, student work, 16″ × 13″ (40.6 cm × 33.0 cm)

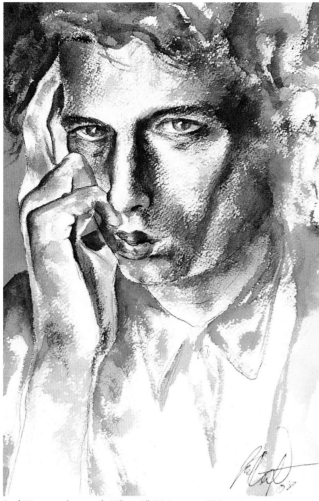

Joel West, student work, 13″ × 9″ (33.0 cm × 22.9 cm)

Joel West uses a drybrush technique over a wetter under-painting for his self-portrait with hand. He has carefully modeled the planes, which are smooth and distinct. The flurrying hair makes a fine frame for the contrasting planes of flesh. He has painted the hand in a different gray than the face it touches, probably to call attention to the narrative event. The hard edges and sharp value contrasts also draw the viewer's eye to this area. Notice how he chose to distort the cheek on the right, creating an entirely new plane in the face. We're always more willing to take liberties when painting self-portraits. You probably couldn't get away with such a distortion in a commissioned portrait or a painting of a relative.

Amy Karns, student work, 17″ × 15″ (43.2 cm × 38.1 cm)

Amy Karns's hands mask her self-portrait from the viewer. She uses a heavy, rambling black line that contrasts with the wisps of color that illuminate this funky painting. There is some delicate textural work in the hat and shirt that hints at decorative designs. Note how some of the black lines bleed, helping to establish contours in adjacent planes; this effect is achieved by laying down the line and then passing over it with a brush loaded with clean water. Amy alternates this melting line with a sharp, vivid line that focuses and softens the general space. The expressive rendering of the hands gives them the appearance of meshing together, knuckles white.

Alice Verberne evokes an unearthly light and makes a corresponding gesture of the hand in this furiously painted work. I asked that a narrative be explored, and she certainly answered that challenge. The many-layered spectrum of colors and techniques transforms the simple self-portrait into a dramatic enigma. She sanded areas of the paper prior to painting and sprinkled salt into most of the wet areas. I am particularly fond of how she changed the nature of the hair from one side of the face to the other. The right side is muted by wet washes of a grainy manganese blue, while the left side sparkles with strong values and built-up strokes. The finished work is a rich pool of painting techniques.

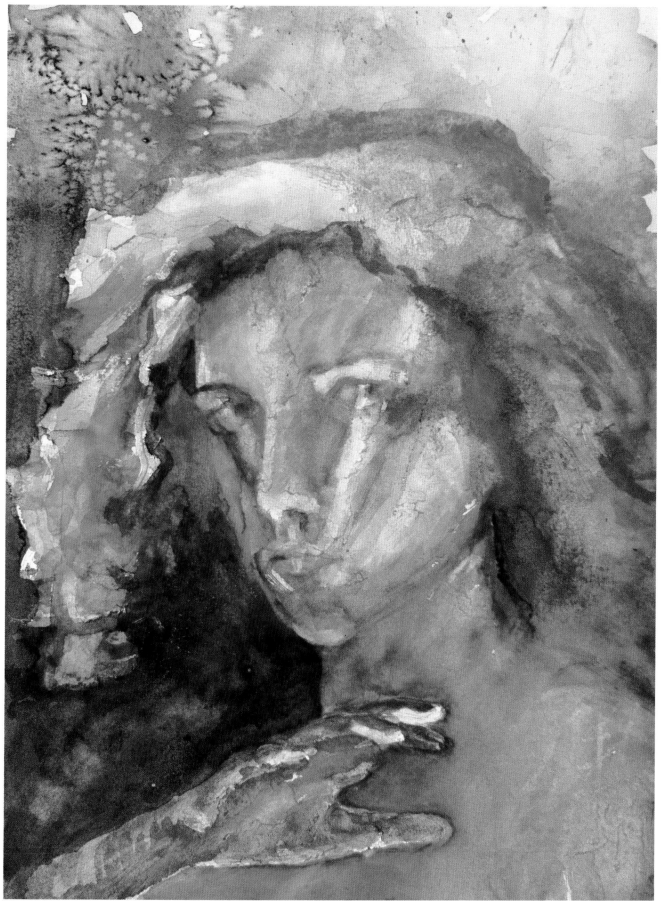

Alice Verberne, student work, 18½″ × 13″ (47.0 cm × 33.0 cm)

DAY 5
Drapery Anatomy

Drapery clothes, adorns, cleans, and dries our bodies; cradles our sleep; covers our tables; regulates the light in our rooms; sails our boats; and flies as banner and flag. And because we paint all of this and more, it's small wonder that so many artists have dwelled, both in sketch and in finished work, on folds of cloth in action and at rest. The simple measure of fabric has even become a motif itself, carefully arranged and placed in countless still-life paintings.

Drapery is not difficult to paint when it simply describes the form it covers, but when it also presents a maze of entangled folds, even the seasoned painter may balk or sigh with frustration. Let's begin by learning how to paint the basic anatomy of a drapery fold. Once we understand that, it will be easier to plot its complicated wanderings and embellish it with more detail.

Every fold has three surfaces protruding from a base: top, right side, and left side. The top plane will be left paper-white, as it reflects the most light. The sides should be painted a middle gray value, and the base dark gray (but not black). When a fold drops to one side or is viewed from an angle, it is said to be undercut. On one side, the top plane is viewed directly against the base; the side plane is no longer visible. A very dark, even black, value painted against the paper-white edge of the top plane and graduated to a lighter value from the fold out will imply that the side is tucked under, or undercut.

Exercise: Basic Folds. To practice painting the basic folds, attach a piece of white or near-white cloth to the wall, using tacks in strategic positions to make horizontal, vertical, and diagonal folds. To underscore the basic nature of the problem, try to mold the cloth into simple folds. Light it well, exposing the folds as dramatically as possible. As you sketch on your paper, or begin to paint directly, let the drapery fill the format to the edges. The painting should be filled with folds. Paint monochromatically, that is, in one color (a gray will look more natural), and follow the value system mentioned above. Remember to keep it simple, and remember to look for the undercut folds. Also, a basic two-sided fold can go for a distance and suddenly flop over with an undercut. You may use any technique you wish; it's the value placement that is important.

Exercise: Patterned Drapery. For the second part of this problem, pin up a patterned drapery on the wall. Again, compose your painting so the fabric fills the page; this time, use a full range of color. Although the basic fold structure still applies here, patterned draperies, with their lines, rhythms, shapes, and colors, elicit more varied and expressive responses. For example, the linear perspective of the pattern itself will describe a fold with no value changes whatsoever; different hues used inventively will wander in and out of the picture plane, delineating the hills and valleys of the folds. Feel free to search and express more with this painting.

Obviously this is not the only procedure for painting drapery; sometimes a few swats of the brush will effectively explain a bundle of cloth. But this rudimentary structuring will help you see and explain the most tediously posed fabric.

Your study of drapery should continue beyond today's lesson. Different weights and surfaces of materials provide endless variation in texture, not to mention pattern.

We can see both sides of the protrusion in this basic fold. The top is white, the sides gray, and the base dark, but not black. Sketching these diagrams will help you understand this form.

An undercut fold flops over, obscuring one side; the black base lies right next to the white top of the fold. On the other side, the value darkens gradually from the top to the base.

Here is a painted version of the basic fold. Although watercolor can produce many little aberrations in the paint surface, the value system follows the same scheme.

Here is a painted version of the undercut fold. Notice the amount of color that can be applied without hampering the effects of the value changes.

Here is a basic fold in a striped cloth. The perspective of the horizontal lines of the cloth does as much to indicate the peak and valleys of the fold as do the value gradations.

Just below the center of this painting, the basic fold abruptly becomes undercut. The undercut is emphasized by the extreme dark abutting the paper-white line at bottom center.

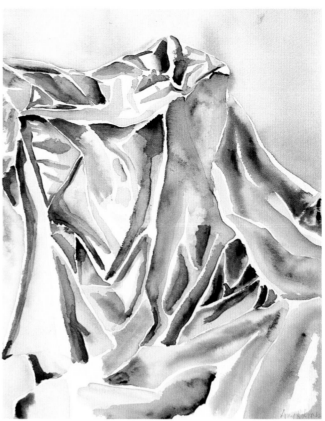

Steve Erickson, student work, 14″ × 11″ (35.6 cm × 27.9 cm)

Amy Holmes, student work, 14″ × 11″ (35.6 cm × 27.9 cm)

Steve Erickson has followed the formula closely, using a gray composed of blue and sienna. He lightened his value scheme somewhat in the folds in the lower right corner and across the top; they play second fiddle to the more rigorously rendered folds of the center. As I am always reminding you, hierarchies of dominance create space.

This drapery could easily masquerade as a mountain peak. Amy Holmes has rendered the deep pockets with dark shapes that move up the sides to sharp, white, linear, narrow peaks. She rendered the larger folds with wet-in-wet technique. This is a complicated setup, but Amy has tamed it with basic anatomy without losing the intricacy of the forms.

Dierdre Broussard presents both problems in a single painting, a diptych. In the monochromatic study, she reversed the value system that I suggested. I heartily support any deviations from my teaching, especially if they work. Who am I to argue with success? The tops of her simple folds are a middle value, the sides dark, and the base white. There may be small discrepancies in her ephemeral rendering, but the effect is fine.

The folds in the patterned drape are not as clear, but some broad planes of fabric are indicated by areas of different values and color intensity. The darker, more vibrant areas come forward over the milky, grayed surroundings.

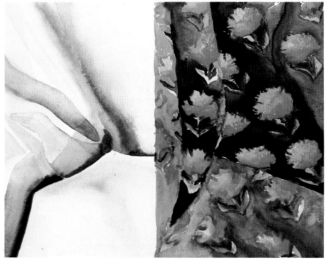

Dierdre Broussard, student work, 11″ × 14″ (27.9 cm × 35.6 cm)

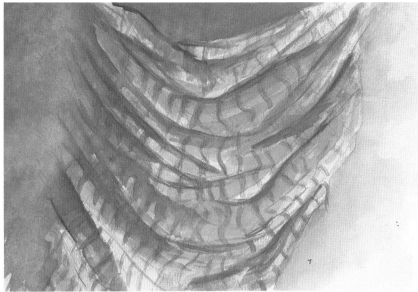

Eloisa Higgins, student work, 7½″ × 11″ (19.1 cm × 27.4 cm)

Eloisa Higgins lit her lines of folds from the lower right for a stunning effect that she has rendered convincingly in blue and red-violet. For the most part, she has used the basic formulas, including both basic folds and undercuts. She indicated the folds with variations in value and then reiterated them with the striped pattern of the drapes. The dark, smoky area on the left is beautifully painted.

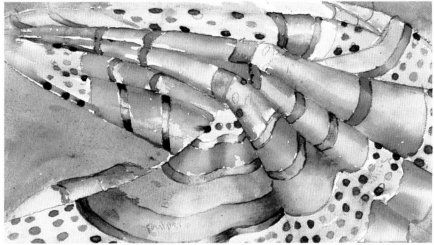

Marvin Carter, student work, 6″ × 10½″ (15.2 cm × 26.7 cm)

Marvin Carter laid out his drape on a table and then painted its folds in a highly stylized manner, making them look almost like shiny metal tubes. His manipulation of the pattern is excellent: Where the value changes on the fold, the value of the pattern changes as well. Too many times this is overlooked and the pattern contradicts the light source. Marvin has also made use of a controlled linear perspective system: The folds diminish as they vanish to the left corner, much like an unfurled fan.

I offered you the option of taking liberties with this pattern painting, and Robin Viallon did just that, making a drapery study into an energetic abstraction. But if he painted three lemons in front of it, it would immediately be transformed into a hanging drapery background like those of Henri Matisse. Come to think of it, I strongly advise you to research Matisse's paintings; they contain innumerable lessons in painting patterned drapes. I've placed Robin in exalted company, but I do think his exercise exudes great spirit in its vigorous markings and pure colors.

Robin Viallon, student work, 7½″ × 11″ (19.1 cm × 27.9 cm)

Steve Erickson, student work, 11″ × 9″ (27.9 cm × 22.9 cm)

Steve Erickson began constructing this patterned drapery by painting the folds in a neutral gray color without the pattern. After letting it dry, he worked the yellow, blue, and violet of the pattern over the underpainting. The values of the folds are seen through the transparent colors, uniting them with the contour of the drape. The fabric was intricately folded so the striped motif was broken up and dispersed across the page, resulting in a good compositional patterning.

Margaret Austin, student work, 22″ × 30″ (55.9 cm × 76.2 cm)

Drapery dominates the space in this fine painting by Margaret Austin. She has painstakingly rendered the drape in a very personal matter, its jagged contours echoing the linear movements in the objects it engulfs. She applied textured washes to areas that fall into shadow. A shower of light from above flows down over the surface of the cloth, illuminating the leaves of the iris and sparkling in sharp highlights on the dark green bottle. For me, this fabric is intense and magical, leaping back and forth between two roles, flowing drape and rocky crevice.

Mohd. Salim Hassan, student work, 15″ × 9″ (38.1 cm × 22.9 cm)

Salim Hassan has worked his drapery study on wet paper, producing a dynamic mass of soft edges and colors that bleed together. Here is a good example of an innovative approach to painting drapery. If you saw this painting out of context, you might not recognize it as cloth, but in a composition with other references, it might become a luxurious tangle of supple folds. Regardless, I also admire this painting just as a painting. The internal painting, as well as the transition from drapery to wall, is very sensuous.

Orlando Pelliccia, UNTITLED, watercolor, 30″ × 22″ (76.2 cm × 55.9 cm)

Orlando Pelliccia uses a simple but exceptional value and color system in this ingenious and humorous painting of a dress on a clothesline. After an initial drawing, the very pale yellow was laid in. When it dried, he planted the red and black decorative medallions throughout the entire dress. Then came the gray of the deep shadows and, finally, the intense yellow areas that are backlit by the sun. At Dino's hand, the cloth is imbued with light, driven from its inanimate banality into the persona of a lively, dancing specter.

167

DAY 6
Focus

A viewer looks at your painting. She sees what she wants to see. Her gaze finds the parts that she enjoys, that are meaningful to her, maybe to her alone. But there is also something in your painting, small but significant, that distracts her reverie and gently forces her to look at the painting, however briefly, as *you* would wish her to look at it. This is a focus, or focal point, or point of emphasis—yet another potent compositional tool.

As you will see, focuses can be easily varied and as clever and inventive as you can possibly make them. They can be intense or subtle. Focuses enhance space. There can be one focus or many. One focal point can establish a biased stance from which the rest of the painting is viewed. More than one focus can move the eye from point to point. Most focuses are made by contrast—one thing stands out in a field of things of another kind. Another way of focusing attention is by isolation—one thing on one side of the field, everything else on the other side. Or there can be a focus on an element of a story depicted in a painting—a letter suspended in space, falling from the hand of a drowsy girl.

Color. A spot of one hue alone among many colors, or a contrasting temperature, or an intense hue among grays, or vice versa, will draw attention to itself.

Value. A dark spot among middle and light values, or a light among middles and darks, or a middle among darks and lights, attracts the eye.

Scale. Usually a small shape among larger shapes is the focal point, but you could evoke a more obvious focus with a large shape among small ones.

Shape. A geometric shape among irregular forms, or vice versa, draws the eye, as does a square among circles, a triangle among rectangles, or any shape that is noticeably different from those that surround it.

Technique. Isolate any one technique in the field of another; a wet-in-wet shape, for example, in a field of drier, more defined marks. The possibilities here are staggering.

Narration. This may be a "realistically" painted form among distorted natural forms or, as mentioned above, a situation or drama, i.e., a letter falling from a girl's hand.

Exercise: Establishing a Focus. To investigate the effect of focus, choose a cluttered interior space. Before you begin to paint, decide on what kind of focus you wish to use. You can combine many, even all, of the elements listed to produce one point of emphasis. Should you choose to paint more than one focal point, be careful not to diminish the drama. I suggest you establish a hierarchy with one dominant focus and several subordinate ones. Keep the focus clear, even exaggerated, so that you can see the full effect of this demarcation. And in every painting that you make, always consider if, what, and where focal points will be used.

Focus on color. In zone 1, the red shape is the only color not repeated. In zone 2, the orange shape is the only warm shape in a field of cool. In zone 3, purple is alone in crowd of grays. In zone 4, a brownish gray sits amidst a group of more intense colors.

1

2

3

4

Focus on value. There are two focuses in this example—the dark red splotch and the pure white shape, both in a pool of middle value.

Focus on scale. All of these similar shapes are roughly the same size, with the exception of the very small one at center right. It is the focal point.

Focus on shape. It's not hard to find the focal point in this field of bullet-shaped lozenges. Do I even need to point it out?

Focus on technique. All of the constituents of this simple grid are painted with irregular water spotting except for the flat rectangle in the second row, third from the left.

This painting illustrates the final type of focus I discussed, focus on narration. In a field of very wet, breezy marks, a squid emerges as the primary focal point, complete with beady little black eye. My intention in this painting was to make a very vague space in which the gentle creature could swim—or fly, for I made the reference to sky stronger than that to water. The viewer assumes the squid swims in water, but his eyes whisper sky. This is just the quiet tension I sought. Everything else was intended to elicit peace and contentment.

Michael Crespo, SEASCAPE, watercolor, 22" × 30" (55.9 cm × 76.2 cm)

Madeline Terrell, student work, 15″ × 10″ (38.1 cm × 25.4 cm)

Madeline Terrell provides a fine example (right) of a color focus that reinforces a narrative focus. There is definitely a red spot in the center of these blues and greens and grays, but there is also a living, clucking rooster attached to that red. We cross a broad, vague abstraction to get to his well-defined head; a surrounding warm green emphasizes its redness. This fellow rules this roost and I find his position in the space so uncanny, I'm not going to even mention any other focuses. I'll just let you muse over them alone.

Madeline Terrell, student work, 9" × 16" (22.9 cm × 40.6 cm)

I don't think that there is much doubt about the primary focal point in Jack Knopp's misty, damp painting of a typical rural Louisiana home. The red chimney glows amid muffled grays. It is supported as a focus by the explosive tree shape that surrounds it. Obviously there are a lot of other events that attract the eye—the green door for one—but there's no denying the force of the red beacon. This is a lovely painting, filled with energetic strokes and deftly orchestrated wet colors.

Jack Knopp, CABIN, watercolor, 12" × 18" (30.5 cm × 45.7 cm)

Madeline Terrell gives us levels of focuses to ponder in this painting (left) of a corner in her house. The air plant is highlighted with blistering opaque yellow-whites. I think we can agree that these form the primary focus, and they are conveniently located dead center. We relate them to the vertical of light on the left side, in the doorway, which illuminates them. This is a secondary focus, as is the blue of the furniture and the blue of the pot in the lower left, vibrant colors in a gray field. Madeline enjoys a great command of the medium, providing us with puddles of delight throughout the composition.

DAY 6: Focus

Joe Holmes struggled a little with perspective to give us this view through his apartment. He has drenched the space with a harsh incandescent yellow light; all the shadows are gray. His intended focuses are clear. I zoom first to the small red box on the table: not only is it an intense red object in a field of yellow, it's a *tiny* red object in a large room. The obvious big blue window catches my eye next; there is another focus in the strong yellow of the overhead light. Note that Joe has chosen the three primary colors for his focuses. When there is more than one focus, our attention tends to move around from one to the other. This is an obvious benefit of having more than one, but a certain scale and drama are sometimes lost because of it.

Joe Holmes, student work, 8″ × 11½″ (20.3 cm × 29.2 cm)

Christy Brandenburg also uses the primary colors as focuses in this articulate rendering of her apartment in Florida during spring break. At the immediate left of the table, yellow moves to blue, blue moves to pink. For me, the primary focus is a toss-up between the shirt and the yellow and blue. The shirt is a prime candidate because it's an isolated color in the painting. There's only a faint glimpse of it elsewhere—in the mirror to the right. The empty shirt also acts as a surrogate figure as it stands there behind the table.

The interaction of the intense yellow and deep blue is also a strong focal point, but it's diffused a bit by the other yellows and blues on the table. Actually, the pink shirt and all of the yellow and blues cluster to form one massive focal point. The suitcase at the far left becomes another focus, by virtue of its isolation from the other strongly defined objects. Everything else is muted. They're all focal points, all interacting; the viewer determines their hierarchy.

Christy Brandenburg, student work, 10″ × 14″ (25.4 cm × 35.6 cm)

Patricia Burke, student work, 22″ × 30″ (55.4 cm × 76.2 cm)

Romi Maegli, student work, 5″ × 8″ (12.7 cm × 20.3 cm)

Patricia Burke has painted a landscape with a remarkable diversity of brush-strokes. She seems to describe every square inch with a different kind of gesture. The painting is alive with different brush movements. Not only does she describe a space, she also expresses it. The painting is unified by its dominant palette of cool blues augmented with occasional splashes of warm gray. But deep in this swampy space is a screaming red-orange focal point, beautifully executed as a focus but baffling as an element of the narrative.

In this flurry of agitated, irregular marks, Romi Maegli reveals a dark triangular monolith deep in the space. The eye is drawn to it not so much by its dark value as by its solidity in the rain of purple, blue, and red chaos that obscures its edges with flurries of dynamic dripped paint—an excellent example of focus on a contrasting shape.

173

DAY 7
Aerial Perspective

When I first mention aerial perspective to my students, many of them assume that it has something to do with drawing the landscape from an airplane. It certainly sounds like an exciting idea, but as a painting term, aerial is defined as "of the air," that is, perspective of the air, or atmospheric perspective—a system that produces a logical two-dimensional depiction of three-dimensional space.

As we gaze across a landscape, especially over an unobstructed deep view, distant forms seem hazy, muted, indistinct—much less certain than the things at our feet. This is caused by distance, light, weather, and the inefficiency of our eyes. Although it does not always occur naturally, this is the basis of aerial perspective, which we produce by combining our knowledge that the clarity of forms diminishes as they recede into the distance with certain elements of our *craft*: color, focus, and value.

Exercise: Aerial Perspective. Choose a location in the landscape where some deep space is visible. If you're fortunate, you may happen on a day when the natural phenomenon is clearly evident. It doesn't really matter, however, for once again we are going beyond vision and applying a painting concept.

In your painting, modulate the color from very intense in the foreground to gray in the background. The edges of the forms should be hard and focused in the foreground, soft and watery in the background. Wet-in-wet technique would serve well for the background; for the foreground, allow layers of color to dry before overpainting. Some lines drawn in the foreground can also strengthen the focus. Strong value contrasts move forward, so use strong darks and lights in the foreground and a very close, limited range in the background. The depth of space will be directly related to how drastically you modulate all these elements.

Exercise: Reverse Aerial Perspective. To glimpse the other side of this system, make another painting in which you reverse all that you did with the elements of the first exercise. Intense colors, contrasting values, and hard edges will now appear in the background, while gray colors, close values, and blurred edges huddle unfocused in the foreground. Although this painting may not look as natural, the depth of the space will still be intact. In future paintings, you may wish to introduce more spatial irony by juggling the different elements. For example, focus and value may still diminish from front to back, but color intensity could be reversed. Regardless, atmosphere is a very vital element of our paintings. Keep it in some kind of perspective.

Here, the foreground colors are the most intense; as they move back in space, they gradually become grayer. The farthest color is almost neutral.

Here, active shapes and lines are sharply defined because they were painted on dry paper. The background was laid on wet paper and thus is very nebulous.

In this example, strong value contrasts in the foreground gradually diminish to faint differences in the background.

In this energetic landscape, John Eblen uses the entire surface for his foreground. He applied the rules faithfully, painting the nearest trees and scrub grass with heightened color, value, and focus. Although he doesn't make any great changes of color through the painting, the greens do diminish, eventually becoming gray back along the horizon. Although there is some visual interest in the background, it doesn't compare to the dramatic tree trunk that spans the center of the composition.

Everything in this system is relative. If you have gray color in the foreground, you have to have even grayer color behind it. You don't have to follow the system rigidly, though. Don't worry if your gradations fall off a bit. It's the overall effect that counts.

John Eblen, student work, 11" × 15" (27.9 cm × 38.1 cm)

Van Wade-Day uses the last three mountains in this little painting, one at the top left and two at the top right, to mark a sudden plunge deep into the space. Until that disjunction, colors are more saturated, value differences are crisper, and edges are more certain. All of this degenerates into wonderfully faint plains dragging us miles into the terrain. Another emphasis in the foreground is the horizontal band that shifts the entire natural space over to the left. This insert widens the gap between the foreground and the waning mountain in the distance.

Van Wade-Day, LANDSCAPE, watercolor, 4½" × 5" (11.4 cm × 12.7 cm)

In this painting from the stage of an amphitheater, Shaun Aleman reverses the rules of aerial perspective but still constructs a very effective and decidedly tense space. Unfocused strokes of gray gain strength as the space moves up and away to the background, where harsh primary colors, cutting values, and strong linear accents inhabit the most distant zone.

Shaun Aleman, student work, 10" × 17" (25.4 cm × 43.2 cm)

John Eblen has also reversed the system, although not as drastically as Shaun Aleman did. The focus moves from watery trees and shrubs in the foreground to slightly more definition in the middle ground to the more pronounced resolution of the building in the background. Color changes from grayed blue-greens to yellow-greens to dull red in the flag to a rather intense spot of orange on the building. Accordingly, the light intensifies, as if it were changing from a shadowed area in the foreground to a dramatic spotlight on the building. John proves that with subtle and even gradation, space can be just as seductive when the principles of atmospheric perspective are reversed.

John Eblen, student work, 11" × 15" (27.9 cm × 38.1 cm)

Stanley Sporny, U.N. HEADS, watercolor, 12″ × 26″ (30.5 cm × 66.0 cm)

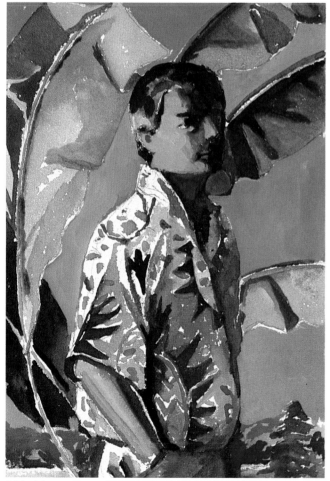

Libby Johnson Crespo, BOY IN FRONT OF A BANANA TREE, watercolor, 9″ × 6″ (22.9 cm × 15.2 cm)

Stanley Sporny is a gifted painter whom I met when he was a visiting artist here at Louisiana State University. He lives in Sri Lanka, and his paintings reflect his world travels. In this painting of a New York City street, he uses classic aerial perspective to push us to the end of the tunnel-like avenue. The foreground is rich and vibrant, with two heads sitting like sentinels on either side, guarding the threshold of the deep space. Color, value, and focus fade progressively as the eye moves along the lines of perspective to the far background.

My wife, Libby, paints a more abbreviated, but equally impressive, version of aerial perspective. The entire surface of the painting is flooded with the foreground information of boy and leaves. They are painted with intense colors, extreme lights and darks, and sharp, detailed focus. Behind them, at the bottom of the painting, the space moves quickly to a paler middle ground with a slightly distinguished evergreen, and then to the deep background, a vague tree line of icy blue. There are no subtle transitions here. The aerial perspective is abrupt and dynamic.

DAY 8
Color Expression

Of all the elements that define painting, color is by far the most complex, abstract, spiritual, and forceful. The colors that we paint most often, the ones we wear, the colors in our dwellings, the ones we cherish most, those that identify us like fingerprints, are apt to change many times as our experience accumulates. This exercise will help you determine which colors make up your personal banner right now.

Exercise: Color Expression. With your full palette of color at hand and a sheet of paper no smaller than 5″ × 12″ before you, load your brush with a color that you like very much or that reflects your mood. It may be straight from the tube or a mixture. Brush the color on the left side of the paper, making a swatch about one inch wide by three inches high. Study it for a while, then choose another color that you like and that harmonizes with it. Paint a swatch of that next to the first. Continue to put colors down until you have ten, all of which you like, all of which you feel harmonize with one another. They do not all have to be completely different hues; they may be any colors you wish.

Repeat this exercise often in the months to come, each time painting the colors you like or want to see at that precise moment. Stagger the time lapses between the exercises—weeks between some; days, even hours, between others. After you have completed eight or so, study them to find any similarities regarding hue, value, intensity, or temperature. These similarities may point out your particular color impulses and will help you use color as a tool for personal expression.

Color Theory. In the previous exercise, I directed you to paint colors that harmonize, harmony implying friendly colors chosen by intuition. Color theory does supply us with four basic harmony schemes. The most elementary is monochromatic harmony; one hue moved through a value range is, if anything, harmonious. Analogous harmony is achieved by using colors that are adjacent on the color wheel, such as red-orange/red/red-violet or green/blue-green/blue. We get complementary harmony by painting with colors that are opposite each other on the color wheel. Blue and orange together produce a dazzling color scheme, as do red and green, or blue-violet and yellow-orange. Finally, there is the triadic harmony of colors that are evenly spaced on the color wheel, such as the primary red/yellow/blue triad and the secondary orange/violet/green triad.

When there is no harmony, there is discord, and color discord occurs when colors are visually disquieting because they seem to share no intimacies with one another. Like harmony, discord tends to be somewhat subjective—my harmonies could well be your discords—but most often the culprit is the use of colors that are widely separated on the color wheel (ruling out the complements, of course). The discord is especially distasteful when there are no value contrasts between the colors. Strong, dramatic value contrasts can make disharmony palatable. My favorite discordant pair is red and blue-purple. I'm not necessarily presenting you with an evil. Someday you may find it necessary to make your point by irritating, rather than soothing, your viewer's eye.

As painters, we tend to stray from theoretical color formulas and work from intuition, or perception, or need. But a theory can provide us with a place to start, a platform from which to seek freedom and expression, or even a concept to disprove.

Exercise: Arbitrary Color. Keeping in mind some of today's theory, go out and find a composition in the landscape and paint by observation everything except the color, which should be arbitrary. Invent the color; don't paint what you see. You may work in harmonies, discords, colors you like, or colors you dislike. Just be sure that they have nothing whatsoever to do with the landscape you are observing. You'll discover while painting that this problem forces you to be more aware of how values and forms are constructed once they are separated from their colors.

Here, a bottle of ink is painted solely in Payne's gray. It is always easiest to work with one color, provided you make a strong value statement. Aside from the intrinsic qualities of the hue itself, drawing and manipulation of values are your only tools. Make those paper-whites sizzle for you.

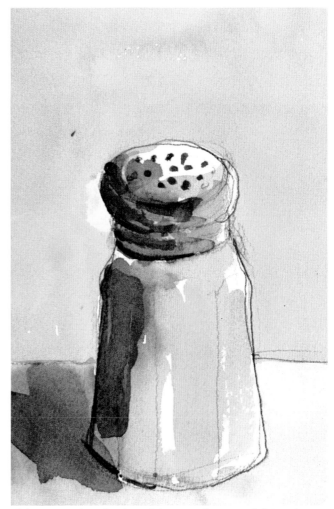

This was my favorite. I used the complements violet and yellow because together they just reek of light. I tried not to let the complementary gray appear; I wanted the full force of their marriage.

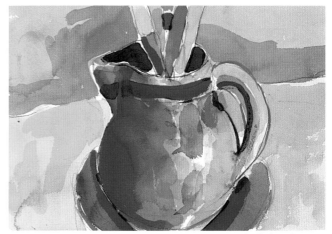

This bottle, containing a liquid watercolor that I never tried, served as my model for an example of analogous harmony. I used green/blue-green/blue as my color scheme. These colors just melt together. It's very difficult to muddy them.

Naturally, I used the primary triad to depict my little brush jug. Nothing equals the power of the primary triad, although sometimes it is a little difficult to model objects with it. I had my troubles with this one, but in the end the harmony will usually disguise any faux pas.

DAY 8: Color Expression

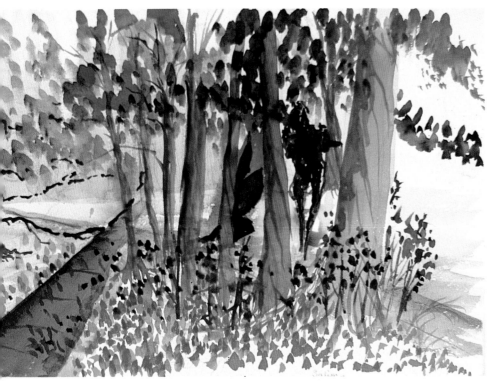

Mohd. Salim Hassan, student work, 11" × 15" (27.9 cm × 38.1 cm)

In a painting distinguished by invigorating brushwork, Salim Hassan has used the primary triad as a general color motif. He does introduce quite a bit of the secondary orange, and just a stroke of green, in the tree trunks. As he was painting, he informed me that it was very difficult for him to work with arbitrary color. Discarding personal preferences and searching for the new is difficult, but that's what I'm always asking you to do. I think it's essential in the painting process. When painting, I always try to assume that I'm not quite sure of who I am and that I absolutely don't know what I like. This doesn't last very long, but it does coax me to peek outside my tunnel once in a while and look at things a little differently. In the end, Salim admitted that the exercise was worthwhile. He didn't like his painting that much, but I did.

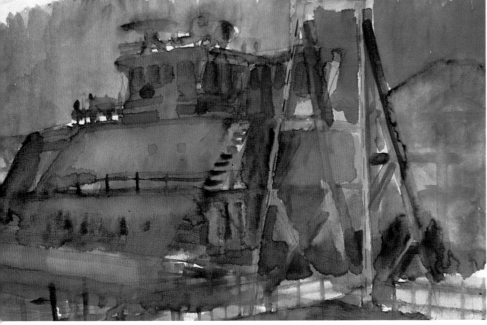

Jack Knopp, UNTITLED, watercolor, 12" × 18" (30.5 cm × 45.7 cm)

Jack Knopp exhibits his wonderfully fluid technique with a palette of analogous colors capped on either end with the complements blue and orange. He has run through all the possibilities between them: orange, red-orange, red, red-violet, violet, blue-violet, blue. It is a rich and heavy scheme that he manipulates to give us somber, shadowy, almost nocturnal areas and bright, dazzling light coexisting in almost perfect accord. I spoke of his fine technique; I really believe it is more than good wet-in-wet control—it is a brazen self-assurance that the marks will work if you just believe in them.

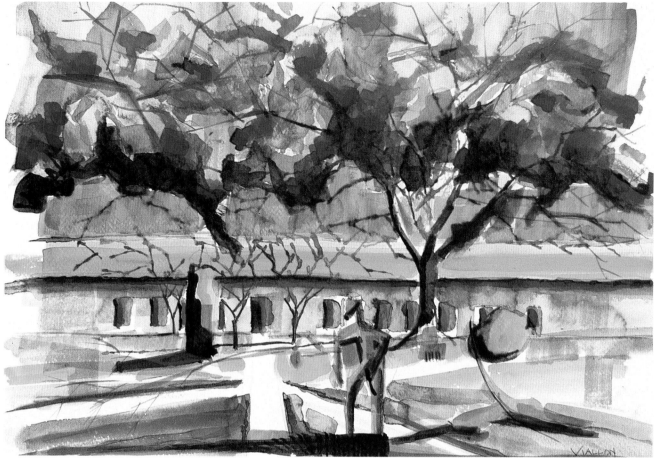

Robin Viallon, student work, 15″ × 20″ (38.1 cm × 50.8 cm)

Dierdre Broussard, student work, 12″ × 9″ (30.5 cm × 22.9 cm)

Robin Viallon magnifies the intensity of the complements blue and orange with an equally hard-hitting value range. He accents the strategy with smaller doses of the other complements green and red and yellow and violet. Basically it's a complementary harmony that uses all of the primaries and secondaries. Should you attempt such a system, be sure to let one pair dominate. The web of spindly lines drawn in the rocklike clumps of the trees is a fitting and effective counterpoint. That man posed so jauntily in the space is actually a sculpture; we spent the day painting in the sculpture department's courtyard.

Here is another view of a figurative sculpture in the landscape. Dierdre Broussard has used two pairs of complements, blue and orange and yellow and violet. I feel the color here has more to do with discord than with harmony: The analogous yellow and orange play havoc on the analogous blue and violet. Dierdre has also introduced a rather sickly green sky to disturb the space even more. I'm not attacking Dierdre—she is a fine painter who has made good use of discord to transform the campus landscape into a ravaged wasteland, complete with nightmarish soldier.

181

DAY 8: Color Expression

Phil Rabenhorst, INTERIOR, watercolor, 11″ × 7½″ (27.9 cm × 19.1 cm)

Phil Rabenhorst finds the quiet murmurings of monochromatic harmony perfectly suited to his splendidly designed interior space. He used an array of greens, both warm and cool, in a very personal, "almost dry" damp technique. The open door confronts us in exaggerated perspective. To the right of the white vertical door edge is crisp, organized geometry; to the left is a slab of misty atmosphere pointing us into the adjoining room. It is a well-designed event in a silent, enigmatic painting.

Steve Erickson's arbitrary color shrouds an old Louisiana home with an eerie, exaggerated light that evokes the tales of ghosts that usually accompany such places. It's also the kind of light that might occur in the silence that looms before a major storm. Steve deadened the dominant yellow and violet and used their gray as a transition. He used equally subdued reds and greens as secondary colors. All these repressed colors flood a well-conceived value range and fine, literate drawing.

Steve Erickson, student work, 21″ × 15″ (53.3 cm × 38.1 cm)

DAY 9
Multiple Tactics

Another innovation in twentieth-century art is the practice of making space by combining a number of different techniques within a single painting. You have learned that you can evoke a sense of space with contrasting two-dimensional elements because opposites usually separate rather than attract, forming different levels of illusionistic space. For example, darker values may appear to be relatively distant in the space of a painting, while lighter values appear closer to the viewer. The same principle applies to contrasting techniques. It's easy to imagine the space implied by planting a flat-painted shape in the middle of a billowing wet field.

Exercise: Varying Tactics. Today, we will go well beyond such simple abstraction by applying the very liberating practice of multitechnique painting to the logical, continuous space of a still life—objects related by perspective and scale but tugged apart and relocated by contradicting techniques. We have made limited use of this tactic in previous paintings, employing two or three maneuvers within a single work. Now we will move to extremes, however, rendering unique each form and facet of the space.

Let's review some possible techniques that could be applied.

- More or less conventional rendering, light to dark, loaded brush with dry paper, not much brushstroke indicated, painted directly or with layered transparencies
- Very realistic rendering (known as trompe l'oeil or trick-the-eye painting)
- Any of the various brush techniques: stampings, strokes, or compound strokes, wet or dry, made with either tip or heel of the brush
- Any of the wet-in-wet techniques
- Any of the four washes: flat, graded, wet-in-wet, or irregular
- Any of the myriad of textures: lifting out with tissues, paper towels, or napkins; stamping with objects; applying paint with squeegees or palette knives; splattering with a toothbrush; dripping paint, causing blooms and water spots; using masking solutions, crayon resists, or salt lifts; wirebrushing or sandpapering the paper first
- Pointillism: creating the illusion of volume and light by building a form with hundreds of dots of different colors and values
- Multiplanar, or multiple-point-of-view distortions
- Opaque gouache technique
- Edge variations
- Collage: gluing other materials to the painting—fabrics, photos, cut-up fragments of discarded watercolors, newspapers, magazines, or whatever may be at hand

Of course, you may have developed other techniques in your painterly wanderings. Anything goes in this painting. Work from a still life with a number of objects. Use different techniques to paint each object and the background space. The more objects, the more techniques, the more excitement. You might consider making a plan for each component before you start painting, or you might work intuitively from object to object. Remember that variations in color and value can also push the different areas farther apart or draw them together.

Michael Crespo, STILL LIFE WITH CRAWFISH, watercolor, 11" × 15" (27.9 cm × 38.1 cm)

In planning for this painting, I decided that I would plot techniques for the two largest shapes, the pineapple and the eggplant. The others would be painted one by one so I could be open to happy accidents and surprises. I painted the eggplant wet-in-wet very quickly and moved on to the pineapple, on which I layered some yellows and greens. When they dried, I used my nylon bristle brush and some clean water to scrub out the lights; to insinuate a little texture, I flicked in some strokes of dull red. The closest crawfish was painted indirectly, first rendered in shades of gray and then overpainted with a transparent red-orange. The next was drawn with watercolor pencils and washed over with clean water. The third was constructed with hard-edged horizontal planes. I decided the onion should pull away from the pack, so I built it up with nervous drybrush marks and noted the light with gouache. At this point I felt some unification was needed, though I could easily have decided to pursue the opposite strategy and dissociate the parts even further. The eggplant and pineapple were both soft and glowing, and I tried for the same feeling in the background, lifting some vague lights out of a wet wash with tissue. I finished off the ground plane with a flat, undistinguished blue. Relationships founded with varying techniques can be just as significant as the oppositions in molding the space.

Joe Holmes, student work, 8½" × 17" (21.6 cm × 43.2 cm)

Joe Holmes approached his painting in a random fashion, and in the end he uncovered a striking structural dimension. There is a lot of contrast between the large strokes that describe the objects and the fanatically decorated environment. The oranges in the bowl are the exception; their pointillist construction links them to the background and ground plane. The latter is made of layers of multicolored cross-hatchings, while the busy decorative hanging drape is accented with gouache. The other objects and the square patch of light on the right are painted in various more traditional techniques. Joe never really ventures from the brush, but he varies its handling considerably.

Note the crisscrossing of space as our eyes are directed diagonally across the painting, following the bland techniques of the objects to the light source on the right, while the more intensely decorated areas imply a counter diagonal movement from bottom right across the oranges to the background drape.

Joel West, student work, 8" × 12" (20.3 cm × 30.5 cm)

Dynamic fractured light dominates this painting by Joel West. The colors and values of the slipper, wine bottle, and pitcher are carried over from the background, but they have gained their independence through the contrasts in technique. The oranges in the blue bowl are a powerful focus in the field of red and green and the grays they produce. Joel changed tempo dramatically in the foreground with an undulating wet-in-wet ground plane mysteriously, but successfully, overpainted with dry graffiti that brings to mind chalk squeaking across a blackboard.

Scot Guidry, student work, 13" × 14" (33.0 cm × 35.6 cm)

Scot Guidry establishes a bull's-eye focus by keeping the colors bright, the value contrasts sharp, and the brushwork agitated around the center of this painting. The group of objects is dominated by the fragmented planar surface of the bottle, which looks like a shattered mirror. Wet, relaxed techniques frame this area. Scot also creates a slight tension by deliberately setting everything off the vertical.

DAY 10
Surface Unity

Learning about painting often means painting the extremes of a particular concept in order to better understand its core. Yesterday, you created space by using a different technique for each object and zone in the painting. There were little conflicts at every boundary in the painting that caused the eye to bounce around space from object to object, moved about by their different constructions. The other extreme would be to use one technique for all the components of the subject matter. You may have come close in previous paintings, but I doubt that you have ever maintained *one* technique throughout. By now you're used to letting your tactics change somewhat as you move from form to form, but today I ask that you be rigorous in maintaining one particular manner of working throughout. This painting should evoke slower, more flowing transitions from object to object to background, the continuity drawing the parts together into a whole. Space will be as a single breath, not a storm of many little winds.

Exercise: Using a Single Technique. In a simple environment, organize a still life with three or more objects of different colors. Make a light pencil sketch on your paper and meditate a bit on what particular technique you should use. You may want to go with one in which you are very fluent. I suggest that you decide whether you want a quiet, somber surface, perhaps using smoothly graded value modulations, or the exaggerated activity that rhythmic stroking might indicate. There's little need to review possible techniques; just refer to the list in yesterday's lesson. When you've selected one, proceed to paint, doing your best to develop every nook and cranny of your painting with the same technique.

Since the goal of this problem is to produce a unified surface, you might consider applying one or two flat washes of color across the entire surface of your completed painting, just to strengthen the unity. Choose a color, preferably a nonstaining transparency, that you feel would work well laid over the existing colors in your painting. Consult the chart you made early on. Apply a basic flat wash. If the color doesn't work as well as you might have expected, apply another to modify the first. Do not go beyond two, or you may find yourself in too deep.

Renee Maillet relies on a buildup of splatters to generate this unusual little landscape painting. She began with a vague shape of wet paint to indicate the row of trees, then spattered on more paint by holding a loaded brush just over the surface and tapping it on a finger of the opposite hand. A wide variety of colors was used in the process, but they play second fiddle to the prickly needle shapes of this common stroke that she put to fantastic use.

Renee Maillet, student work, 7" × 8½" (17.8 cm × 21.6 cm)

Stella Dobbins, FOREIGN RESONANCE, watercolor, 26" × 40" (66.0 cm × 101.6 cm)

Stella Dobbins pieced together a multitude of tiny flat shapes to make this incredible still life. She began by making a very complete pencil drawing, consolidating all of the intricate fragments into the objects and environs of the still life. Then she colored in the shapes, paying particular attention to value, for it is the ebb and flow of lights and darks that gives credibility to this space, allowing identities to continuously appear and disappear in the vast woven fabric of her consummate technique.

DAY 10: Surface Unity

Johanna Glenny painted this puddle of a still life by repeating the mark of a single brush. She painted quickly, responding very directly, with no initial drawing. When certain areas got too wet, the strokes dissolved into one another, but her mark prevails even in the very faint regions at the top. Johanna had a very determined compositional structure, concentrating the stronger colors and values in the rough triangular shape. To keep it from being totally isolated, she makes a transition in the lower left corner, where some middle values are clustered. The rest of the space is airy, with occasional stampings of pale color.

Johanna Glenny, student work, 19″ × 24″ (48.3 cm × 61.0 cm)

Leslie Wagner painted this profusion of ivy leaves with layers of erratic, splotchy marks within well-defined shapes. The obsessive transparent buildup transforms the usually flat leaves into crystalline globules trapping occasional warm bursts of light. Departing from the problem a little, she painted the background flat to better display her handiwork. I applauded the decision and felt there was sufficient unity of technique to maintain the flow of space.

Catalina Stander paints native Louisiana irises with a very deliberate scheme of decorative brushwork. First she painted leaves, stems, and blossoms in flat colors. Then she methodically zigzagged a more opaque color over each, magnifying the stroke over the white background. Her aim was to create a lively but regular movement that linked the entire surface. It is a lesson from the master, Vincent van Gogh, who put brushstrokes to similar use.

Leslie Wagner, student work, 12″ × 12″ (30.5 cm × 30.5 cm)

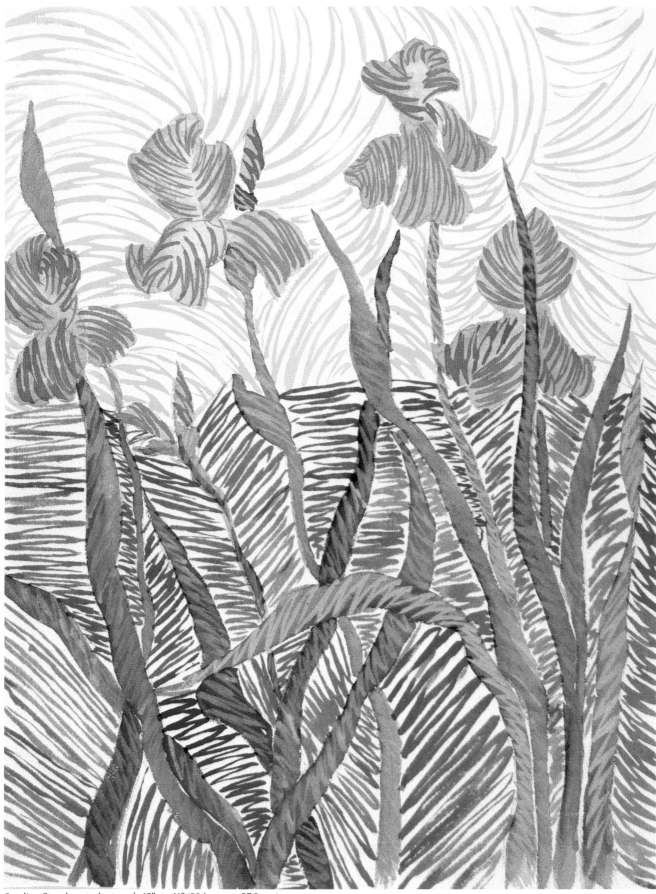

Catalina Stander, student work, 15″ × 11″ (38.1 cm × 27.9 cm)

DAY 10: Surface Unity

This painting from my ever-expanding fish series is a self-portrait of sorts: The three disjointed figures are personal symbols of my own memory. The technical challenge was to render a vision of my mind. I chose to paint a big, vague, cloudy soup of color—a continuous depth in which to unite the three players. I chose to restrict myself to wet-in-wet techniques, contrasted only with a few lines to clarify forms and the development of the eyes.

I began the painting with the black lines of the fish and wing. When they were dry, I established the soft volumes of the figures by mingling wet colors. I allowed these areas to dry somewhat before I began the sequence of wet-in-wet washes of different colors that drenched the forms. The first wash sullied the still-damp edges. There were at least ten applications of wash, which I alternated in horizontal and vertical passes. These changes of direction are clearly evident in the painting. I allowed some of them to dry before wetting the surface again and painting another; others I worked directly into while they were still wet. When the effect of murky depth was achieved, I let it all dry and defined the eyes, making them sparkle with tiny drops of Chinese white.

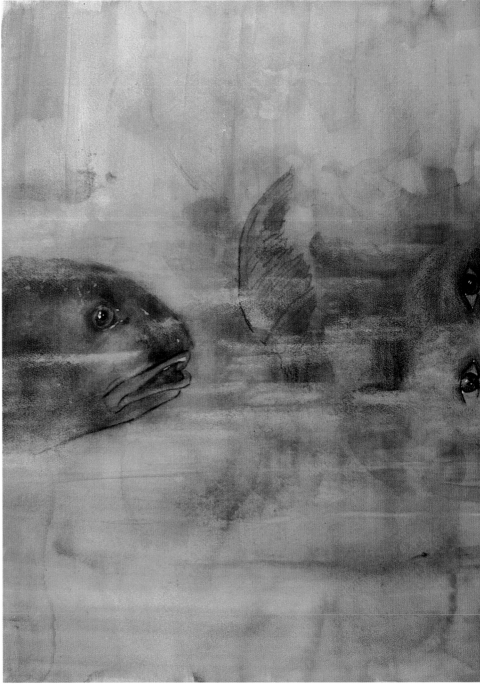

Michael Crespo, MEMOIRS, watercolor, 30" × 22" (76.2 cm × 55.9 cm)

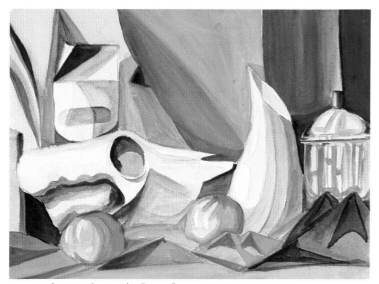

George Chow uses a very definite planar approach to the many objects that populate this still life. In his initial drawing, he exaggerated surfaces to make them appear to be flat planes, like objects constructed out of scraps of mat board. Then he applied color in a methodical value system, clearly identifying gradations of value. He remained consistent with his difficult technique, even rendering the reflections in the polished coffeepot at right as planes. Despite the many color changes and the excitement of the dancing forms, George's painting remains tightly woven together by the uniformity of his technique.

George Chow, student work, 9″ × 12″ (22.9 cm × 30.5 cm)

John Eblen used a forceful, jagged stroke to mark the different areas of this active still-life composition. He began by painting the space as a series of flat shapes. Then he worked around the composition, fleshing out the forms with his expressive stroke. The various objects take on drastically different characters as he changes the color, value, and number of his marks. The light-filled glass fishbowl in the center is activated by a conglomeration of faint pastel colors that contrast sharply with the harsh black strokes on the yellow object in front of it. Also compare the bluntly geometric candlestick on the right with the loosely rendered vase next to it. John's boisterous still life is a fine example of a single technique providing unity to the whole without sacrificing the character of the parts.

John Eblen, student work, 11″ × 15″ (27.9 cm × 38.1 cm)

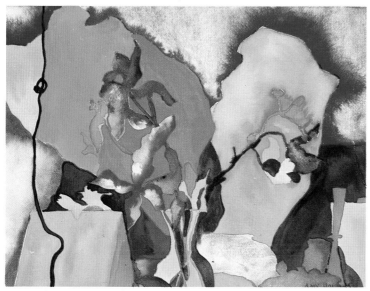

Amy Holmes pieced together wet shapes to form this exuberant abstraction from the still life. In practically all of the shapes, she lifted out color with a dry brush and a tissue, leaving concentrated residues of pigments along their borders. This repetition of technique makes the shapes appear to bulge softly from the surface of the paper in varying degrees, much like low relief sculpture. The persistence of the intense, dazzling colors works with the contrasting soft modeling to maintain surface unity.

Amy Holmes, student work, 11″ × 14″ (27.9 cm × 35.6 cm)

193

DAY 11
Shorthand Diary

As students master the theory and technique of painting, they tend to spend more and more time obsessively planning compositions, deliberating over every brushstroke, and working long and hard to make paintings *look* spontaneous. This is part of the learning process, and your paintings usually will improve, despite a little overworking now and then. But today I insist that you lay down your education for a brief time and begin a diary of sorts, in which watercolor is practiced as it is best defined: a quick, fluid vehicle for recording both moving and static events. I am not necessarily speaking of sketching ideas for future paintings, or just painting practice, but a flurry of serious works, quickly sighted and quickly rendered with as little clutter as possible between your mind's eye and your hand. These little painterly glimpses of your life can be as fertile and inspiring as your most deliberate painting.

Recently, I stumbled on the David Hockney/ Stephen Spender collaboration, *China Diary*, in which Hockney, the contemporary British artist, illustrates the poet Spender's prose during a trip they made to China. His many watercolors, in their stunning, abbreviated bursts of color and marks, reveal an artist enjoying, quizzing, commenting, seeing, and painting, uninhibited and direct, powerfully depicting each subject in its essence. This is what we lose when we assume that quality in a painting is somehow measured by the time we spend making it.

Exercise: Watercolor Diary. You can use a bound journal of watercolor paper, or you may divert some energy and time into designing and assembling one yourself with your favorite paper. These periodic endeavors could also be painted on loose sheets and stored in a portfolio, but keep them separate from your other work. They make up your diary and, kept intact, will be gratifying to leaf through in the future. Whatever format you decide on, take the diary with you to a site where people move about and congregate, such as a park, campus, or other public grounds. Start to make little paintings of the people and animals about you, capturing their movements or resting poses. Paint what you see and sense as directly as you possibly can. Don't worry about anything except doing. You may make separate compositions or just stuff some pages with gestures and ramblings. Do them quickly; try not to spend more than three minutes on each painting. Vary your color concerns as much as you can from sketch to sketch. When you are tired of painting figures and animals, look at the forms of the landscape and repeat the process. Finally, take your work back into your studio, or kitchen, or any room in your dwelling, and paint found still lifes and intimate interior spaces.

Try not to write too much in this diary; let it be a visual accounting of your life and surroundings. Return to work in it whenever you are worn out by the burdens and responsibilities of making Art. As you paint these little works, have faith that even though you are not analyzing every motion, the knowledge you have acquired in previous, more labored pursuits will leap from your brush in color and form, singing the essence of what you see and feel.

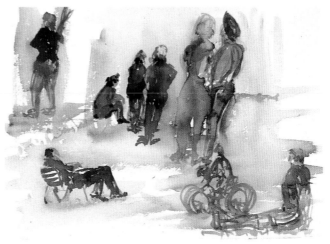

Mohd. Salim Hassan, student work, 11" × 15" (27.9 cm × 38.1 cm)

There is lively gesture in the brush of Salim Hassan. On this page of figure studies he has sketched, with great confidence and a rich palette of grays, the walkers, bikers, sitters, and ballplayers that inhabit our campus. His use of broad washes surrounding the vignettes has the effect of unifying them into a casual composition.

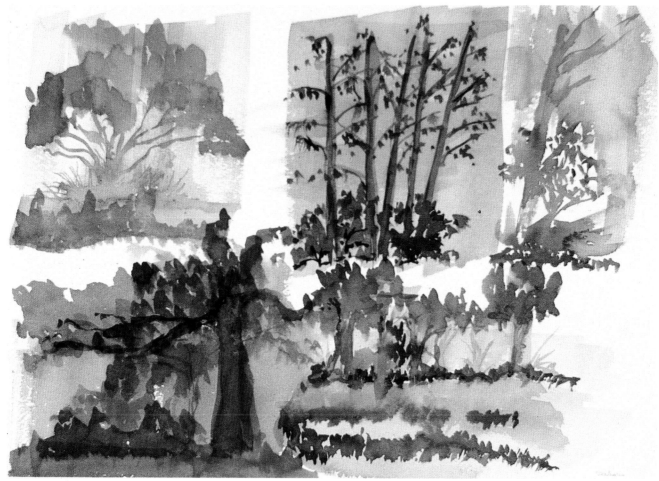

Mohd. Salim Hassan, student work, 11″ × 15″ (27.9 cm × 38.1 cm)

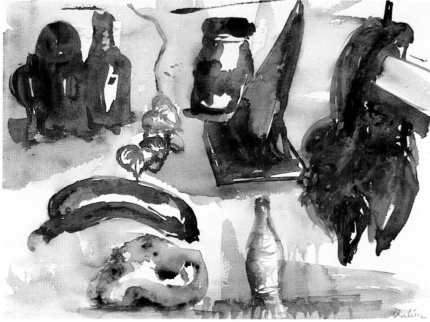

Mohd. Salim Hassan, student work, 11″ × 15″ (27.9 cm × 38.1 cm)

Here is Salim Hassan's page of landscape sketches, painted with the same vitality as the figures. Salim usually deliberates over his paintings for hours and is always the last to leave class, but when assigned these sketches, he adapted his technique accordingly. He assures me that he remained well within the three-minute limit for each painting. I suggested that some of this instantaneous response could be filtered into his lengthier enterprises.

This last page of Salim Hassan's sketches is filled with some impromptu still lifes. More aggressive light and color play over these objects, perhaps because of the harsher incandescent light indoors. I especially admire the paint handling in the two pairs of objects at top left and center. Once again, Salim draws the sketches together with fluid connecting washes.

Michael Crespo, THE FLICK AND QUEENIE SCROLL, sumi and watercolor, 12″ × 23″ (30.5 cm × 58.4 cm)

Michael Crespo, THE FLICK AND QUEENIE SCROLL, watercolor, 12″ × 24″ (30.5 cm × 61.0 cm)

Michael Crespo, THE FLICK AND QUEENIE SCROLL, sumi ink and watercolor, 12" × 23" (30.5 cm × 58.4 cm)

These three paintings are sections of an ongoing chronicle of my two beloved young rat terriers at rest and play. The puppies make difficult but fascinating models. In the section at top left, I first sketched them rapidly with a sumi brush dipped in sumi ink. Then I made the color notations with watercolors. These antics are painted on a continuous scroll of sumi paper, which gives that characteristic blurry edge to the wetter ink and color. I calculate that when I'm done, I will have about 25 feet of puppy antics recorded on this particular roll.

In another section of the scroll (below left), I sketched the dogs first with lines of red watercolor and then emphasized certain movements and edges with blue. The smudges of yellow, blue, and violet washes were casually laid in to inject a sense of overhead light. This passage of primary colors sparkles in comparison to the muted hues I used in painting the rest of the scroll.

In yet another expanse of the continuing painting (above), I filled the paper with one image of sleeping pups formed with rapid gestures of a loaded brush. I grayed the color with sumi ink to parallel the muted brushwork and visually quiet the scene of slumber.

Vivian Beh, student work, 7½" × 10" (19.1 cm × 25.4 cm)

Vivid analogous colors load Vivian Beh's brush in her sketches of various flora that interested her. Her talent and skill with the brush are evident in the expressive calligraphy that modulates equally expressive color from form to form.

Vivian Beh, student work, 7½" × 10" (19.1 cm × 25.4 cm)

Birds, bugs, and bystanders inhabit another page from Vivian Beh's sketchbook. First she records them in flat, animated shapes. Then she may drop in another color or two or scribble in some lines of definition, as in the insect at bottom right. The standing man makes a stable center for the circle of characters dancing about on the white paper.

Steve Erickson loitered about the sports complex on campus to track down subjects for this page of sketches. He contrasts heavy-handed strokes with soft, wet passages to capture the action of life around him. With a puddle here and a line there he also provides surroundings for each of his players, isolating them in their own little arenas.

Steve Erickson, student work, 17″ × 11½″ (43.2 cm × 29.2 cm)

Maureen Barnes, student work, 18″ × 24″ (45.7 cm × 61.0 cm)

Maureen Barnes constructed a grid to house her studies of landscapes, figures, and interiors. The rectangular formats make decided compositions of the casual sketches. Maureen forsakes the ease of random placement and is forced to consider her forms in relation to four edges in each of the fifteen little episodes. It did not seem to inhibit her, for the subjects are fresh and lively as well as thoughtfully composed.

Fred Mitchell, BOARDING MISS LIBERTY II, watercolor, 22″ × 26″ (55.9 cm × 66.0 cm)

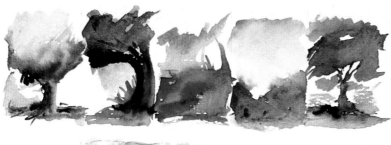

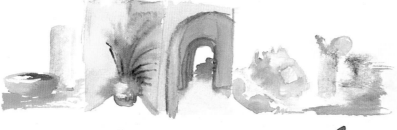

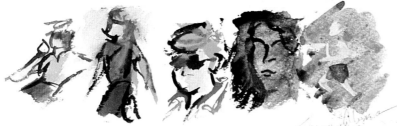

Shaun Aleman, student work, 12″ × 12″ (30.5 cm × 30.5 cm)

Fred Mitchell rapidly records a throng of people lining up to board a boat. His perceptive eye and talented hand transform abstract strokes and a maze of colors into a very believable depiction. It's really a great lesson in painting the essence of a subject rather than trying to render its parts, an approach that is especially useful when time is limited and the scene is crowded.

On this sketchbook page, Shaun Aleman uses three linear sequences to quickly grasp his various models. In the top row, he lines up heavily modeled trees and deep space panoramas. In the middle line, he warms his palette to delicately record both interiors and still lifes. And at the bottom, he paints cartoonlike lines and colors that effectively animate his figure studies. His compositional decision to make three distinct rows of subject matter also influenced the three tiers of different techniques and colors.

201

DAY 12
Horizons

Although we often speak of the horizon, or horizon line, when discussing landscape paintings, the landscape itself, or even still lifes and interiors, the term itself is somewhat ambiguous. As painters, we have two definitions. The apparent junction of earth and sky is what we call the "visible" horizon line; the "actual" horizon line is your eye level, or the imaginary line drawn as you look straight out into space at right angles to the vertical. It is possible for the two to be one and the same, although it is not usually so. Your work today will dwell on the actual horizon, for that is the key to understanding how to draw space as you, the painter, stand in it.

It is instructive to see how the dimensions and proportions of an object change as your eye level shifts. Place a clear water glass on the edge of a table. View it first with your eyes level with the surface of the table. Rise, keeping your eyes on the glass, and note what happens to the front surface and the ellipse of the rim as they change form with your movement. Repeat, moving downward until you're sitting on the floor. You have just witnessed the fundamentals of basic perspective, and although I would never try to make you plot the world in linear perspective, it is important that you grasp a little of how it works.

Exercise: Shifting the Horizon. Today, I want you to make two paintings, the first illustrating a *high* actual horizon, the second a *low* actual horizon. For the first, find a spot overlooking the landscape. Go out and paint from a mountaintop or hill, or paint from your roof or the top of a building. Go paint in a tree if you like; just be sure to get your eye level up there so you can look down on a lot of things. For the second painting, I suggest you find a fairly flat area and sit on the ground to paint. Lying on the ground would be even better, if you can figure out a way to paint comfortably. Wherever and however you decide to paint, be sure the two paintings clearly depict opposite positioning of the horizon.

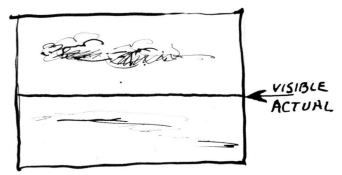

In this sketch of an unobstructed horizon, the visible and actual horizons are one and the same.

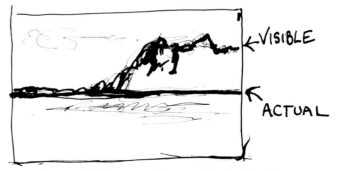

Now I have added a mountain; the visible horizon becomes the line along the top of the mountain moving down to the left over the boulders at its foot. The actual horizon is still visible and remains the same.

More mountains and trees obscure the actual horizon line, but its position remains the same, whether you see it or not. The visible horizon is now the heavy line marking where the peaks meet the sky.

202

One-point linear perspective. The black square indicates one side of an object. Draw straight lines from the corners of the square to a vanishing point at your eye level (the actual horizon). Then construct the rear edges with vertical and horizontal lines that intersect on the vanishing lines; simply estimate the depth of the object. The eye level is high for the bottom box, low for the top one.

Two-point perspective. A corner edge of a form is indicated by the heavy black line up front. The two sides vanish to different points on the actual horizon line. Simply draw straight lines from the top and bottom of the given vertical to each vanishing point. Estimate the depth with vertical lines (marked with little arrows). Draw the top by extending lines from each vertical to the opposite vanishing point. This drawing illustrates perspective from an eye level above the box.

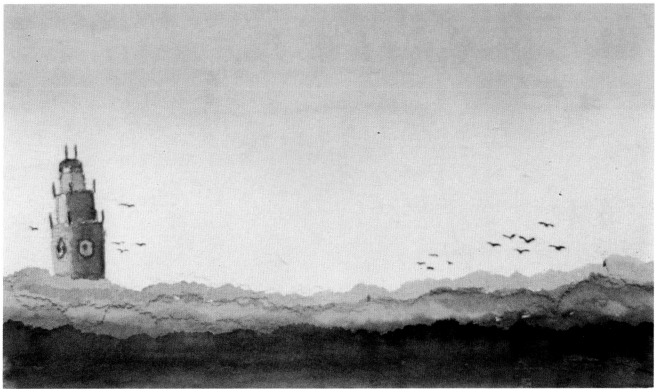

Marvin Carter, student work, 5″ × 8½″ (12.7 cm × 21.6 cm)

Marvin Carter paints from an unusual viewpoint at the same level as the birds he has strewn across the treetops. The space seems bizarre because his eye level is a little below the visible horizon line, and both horizons are low in a painting done from high above the ground. The birds establish the scale, as does the tower that stands alone in bands of treetops painted like choppy waves at sea.

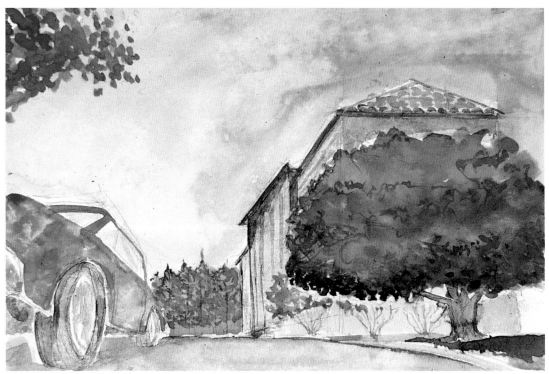

Rob Jarrell, student work, 7½″ × 11″ (19.1 cm × 27.9 cm)

Van Wade-Day, LANDSCAPE AT ROSTHWAITE,
watercolor, 10½″ × 7″ (26.7 cm × 17.8 cm)

Rob Jarrell got low on the ground to paint this bleached view down a street. The parked automobile and building are extremely distorted because they vanish to points on an actual horizon so low it is almost out of the picture plane. Rob lets his concise drawing dominate by painting with rather scant amounts of very limited color.

Van Wade-Day painted this very graphic linear landscape while perched high on a hill in the English countryside, with what must have been an exhilarating panorama before her. From the point of view clearly evident in her perspective, I would venture to say that the high actual horizon corresponds to, or is very near to, the visible horizon at the top of the picture. The ledge on which she worked is visible at the bottom, giving us another reference to the artist's location in the landscape. Notice how she isolates warm colors in the middle zone, sandwiching them between the cool tones in the background and on the foreground ledge. This emphasizes the deep space even more by defining three distinct zones of space.

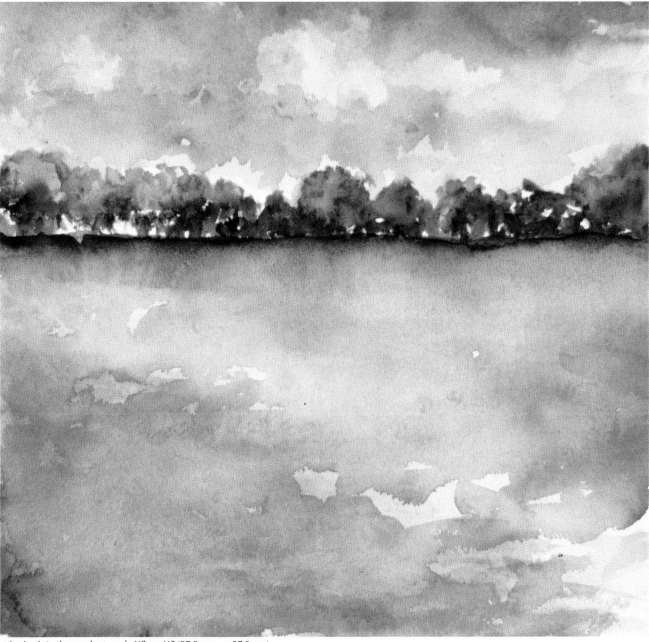

Elizabeth Jenks, student work, 11" × 11" (27.9 cm × 27.9 cm)

Elizabeth Jenks's eye level is the line at the base of the trees, and there is a visible horizon where the sky meets the tops of the trees. Both are situated high in the painting, leaving a large expanse of unpopulated foreground to be kept flat. It would have been easier to locate the tree line low in the painting, but Elizabeth tackled the problem and solved it with subtle maneuvers on the ground plane. Well-positioned abstract shapes, nuances of wet-in-wet technique, a pool of glowing light, and a diagonal line marking where a giant cool shadow turns to yellow heat—all help keep the vast foreground lying flat for us to skate across, leading the eye back into the trees.

DAY 12: Horizons

In this vacation painting, Jack Knopp paints an almost unobstructed view of the classic horizon far out in the sea—the actual and visible horizons are the same. It's obvious that the diagonal lines of roof and porch vanish to points along the line where yellow sky meets blue water. The painting is fresh and light-filled; the vibrant red chair and pocket of concentrated light that surrounds it form a distinct central focus.

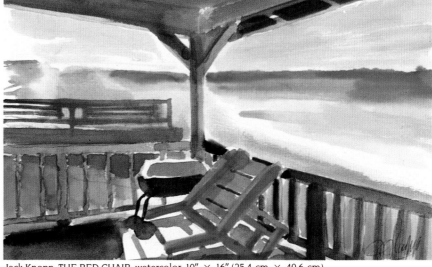

Jack Knopp, THE RED CHAIR, watercolor, 10″ × 16″ (25.4 cm × 40.6 cm)

Scot Guidry got the idea for this painting while lying down in a field recovering from a game of lacrosse. It's nice to know that some students are always thinking of painting! The actual horizon line is probably about one-third of the way up the cup, while the visible horizon is higher up, along the distant tree line. The depth of the space is dramatically depicted—a paper cup is the same size as a high-rise dormitory; a line of grass is larger than a line of trees. The arched wash of the sky makes this particular staging of space even more grandiose and absurd.

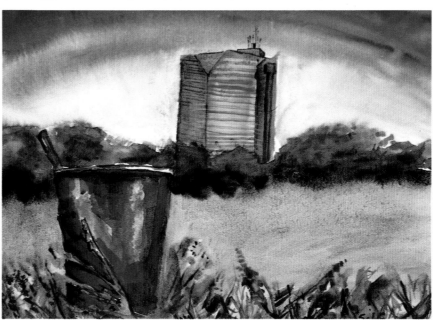

Scot Guidry, student work, 11½″ × 15½″ (29.2 cm × 39.4 cm)

The horizon line is brought indoors in this still life of bitter color and acute light. There is a strong visible horizon along the back edge of the table, but the fact that we see so much of the top of the basket-shaped object indicates that the actual horizon is much higher, out of the picture plane. The clarity of the space in this painting is staggering, and the peculiar color, light, and objects breathe a surrealistic air into this scene on an arid tabletop.

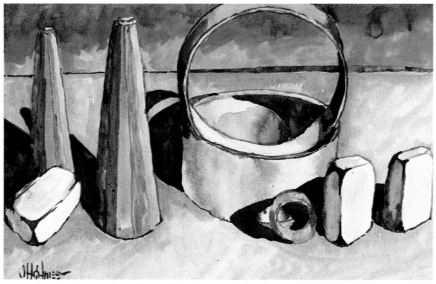

Joe Holmes, student work, 10½″ × 16″ (26.7 cm × 40.6 cm)

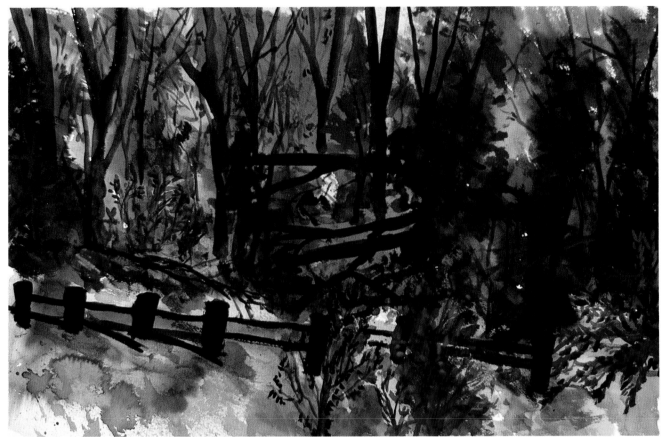

Patricia Burke, student work, 15″ × 22″ (38.1 cm × 55.9 cm)

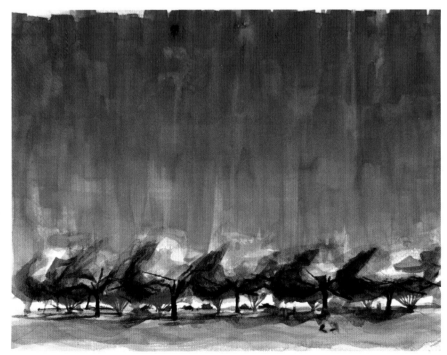

Robin Viallon, student work, 15″ × 20″ (38.1 cm × 50.8 cm)

Dramatic backlighting and the primary triad give life to this woodland scene by Patricia Burke. There is no visible horizon in the cluttered view she chose to paint. We are given a clue to the actual horizon by the plane of ground just in front of the fence. This indicates that she was looking down, with her eye level near the top of the painting. The heavy black lines that contrast with the sharp explosions of red, yellow, and paper-white are as thrilling as the marks of the exuberant hand that painted this excitement.

The actual horizon is low, as is the visible horizon, in this painting by Robin Viallon. Very active paint and color contradict the placid composition of this scene. The commanding vertical strokes of the sky seem to rain the yellow light down onto the treetops and the ground. Along what appears to be the actual horizon, Robin uses paper-white, bright cobalt blue, dark tree trunks, and red-clothed people to articulate the ins and outs of the arcade formed under the trees.

207

DAY 13
Light of Day...and Night

Claude Monet, the great French impressionist painter, was obsessed with the way light in the landscape changed during the passage of a day and the effect this changing light had on color and value in painting. He made more than thirty paintings of Rouen Cathedral, recording the different impressions light made on the massive facade at different times of the day. The hue, intensity, and value all changed. Shadows shifted position, shrinking and swelling as the earth changed its position in the sun's light. You are probably also familiar with Monet's series of paintings of haystacks in the fields, in which he studied the changing colors produced by light as it drenched the French countryside.

Trees are green; their trunks are brown; the sky is blue. These are examples of local color, which is defined as the actual color of forms in the light of day. In truth, it's more a fixed concept than a product of perception. Monet found that the light of day and the colors it produces are constantly changing. He used what is known as optical color, which is the color we perceive an object to be in a given light situation. It may be the color at high noon, just about midnight, or under a fluorescent light. Color is in light's domain: the light changes, the color changes. Optical color is our concern today. Incidentally, there is another kind of color we make use of as painters, one you already explored on Day 8—arbitrary color.

In the morning, the cooler, less intense hues generally saturate the landscape. The value range is subdued in the very early hours but expands as the light increases. As the day moves on, the cooler colors begin to warm up, just like the air, but they seem to become less intense around noon. This is because the sun is directly overhead, lighting forms more evenly, which reduces the contrasting shadows. Color intensity and value contrasts steadily increase

to full crescendo in the late afternoon, when dark, cool shadows stretch out in dramatic contrast to the hot orange light. And occasionally at dusk, when the shadows disappear, the earth becomes a cool, flat silhouette pressed against a sky of pink, orange, and red-violet from the waning sun. This breathtaking excess of nature is known as crepuscular light. I stress that these general observations are not always certain. Weather can be a great spoiler or enhancer of optical color effects. Think about the color of the landscape on overcast days, or before a raging storm, or in rain itself. Everything changes as we move around the world. Henri Matisse traveled the globe searching for the perfect light. For this problem, you'll only have to go into your own backyard.

Exercise: Capturing Changing Light. Go out in the landscape—your backyard is perfect—and find some structure or object to paint, such as your house, a garden shed, a tree, a chair, a birdbath, or perhaps a simple still life set up outdoors. Choose three distinctly different times of day to paint your subject. Scrutinize the color and value carefully, and record what you see as accurately as you can. If you're painting deeper space, you may notice how the aerial perspective changes. You do not have to do all these paintings in one day. Some students burn out from staring at one subject so long. And by all means take advantage of any interesting weather effects, like storms, fog, mists, sleet, or snow. (Being a deep Southerner, I'm not too well versed on the last two.) Don't hesitate to go out and paint at night, either. James Abbott McNeill Whistler's splendid nocturnes should inspire you. Your investigations of the light of day and night will supply you with many discoveries, directing you to a more thorough approach to the majesty of light.

I enlisted my wife, Libby, who is an accomplished landscape painter, to make some small sketches from a single point of view and record the effects of the light. She made this first painting in the early morning, from a vantage point looking due east into the rising sun. There was no sky color; the sunlight was white. Forms were backlit because of her position, and the colors had a bluish cast. The dense humidity was visible, permeating the atmosphere, and natural aerial perspective was more obvious than at any other time of day, at least in this part of the country.

Libby Johnson Crespo, CITY PARK GOLF COURSE, EARLY MORNING, watercolor, 4″ × 10″ (10.2 cm × 25.4 cm)

At noon, Libby found the trees lit strongly by the sun above. This direct overhead light produced small shadows directly under the forms. Colors were considerably warmer than in the morning and slightly bleached. The sky appeared blue. The values were fairly evenly dispersed over a wide range.

Libby Johnson Crespo, CITY PARK GOLF COURSE, NOON, watercolor, 4″ × 10″ (10.2 cm × 25.4 cm)

In the evening, the sky changed from blue to a warm yellow-orange. The value range increased dramatically because of the lower angle of the sun, which threw long shadows out behind the trees. Color was at its warmest, with the deepest shadows beginning to cool in contrast.

Libby Johnson Crespo, CITY PARK GOLF COURSE, LATE EVENING, watercolor, 4″ × 10″ (10.2 cm × 25.4 cm)

DAY 13: Light of Day . . . and Night

Joe Holmes chose an ornamental bird-bath in his yard for subject matter. He decided to paint all three paintings in the late afternoon and evening. I quote him directly: "I had been wanting to paint this birdbath in the late afternoon for some time, and when Michael suggested painting one subject at different times of day or weather, I dove in. I faced the sun directly, because I wanted that glow behind the bath. The secret was to butt bright yellows against darker violets, changing not only value but temperature, and keeping some edges sharp."

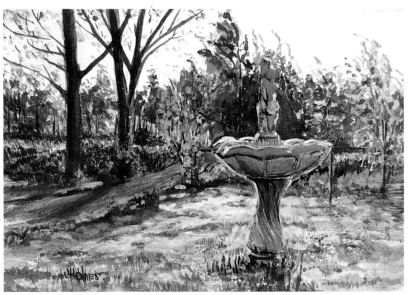

Joe Holmes, student work, 9" × 13" (22.9 cm × 33.0 cm)

The day moved into dusk for Joe's second treatment of the subject. Again I quote from his notes on these paintings: "At sunset everything is low-key. It seems that no matter what I did, the light and color of the sunset itself were more important than my subject, or any subject. In this painting, the birdbath is secondary."

Like most of us, Joe was enraptured by the stunning orange and violet light that can permeate the late evening. This is known as crepuscular light.

Joe Holmes, student work, 9" × 13" (22.9 cm × 33.0 cm)

For his final painting in this series, Joe actually sat outside and painted in the dead of night. It can be a unique painting experience, and I heartily recommend it. He had these comments scratched on the back of this one: "I was overwhelmed at finding that I *lost* so much detail at night. What the afternoon revealed in such sharp contrasts of violet and gold and green became an indistinguishable mass of blurred foliage. The light on the utility pole in my yard was all the light that I had to paint by. I more or less guessed at some of the colors I used. I'm quite pleased (and surprised) at the results."

Joe Holmes, student work, 9" × 13" (22.9 cm × 33.0 cm)

Steve Erickson, student work, 7½" × 10½" (19.1 cm × 26.7 cm)

Jack Knopp, VIEW OF THE LSU CAMPUS, watercolor, 12" × 16" (30.5 cm × 40.6 cm)

Steve Erickson painted the dark silhouette of a neighborhood bordering a lake in his nocturnal painting session. Although color is virtually absent in the scant night light, Steve painted more than he could see, generating a subtle but fertile fabric of hues. The foreground plane alone contains traces of red, blue, green, red-violet, blue-violet, and various grays. He used opaque white to paint the clouds, the street lamps, and the dots of window lights and their reflections in the still lagoon.

Jack Knopp painted this liquid view of the campus in the middle of the day. There are no shadows cast on either side of the forms; the sun is directly above. His color conveys the bleached look of high noon in a Louisiana summer. The painting is thoughtfully organized; the eye is carried through its various zones to the tower in the back. This is partly achieved by using a broad value range within a very limiting high-key system.

211

Stanley Sporny, THROUGH THE PARK, watercolor, 22″ × 30″ (55.9 cm × 76.2 cm)

The light of day is never predictable. Sudden changes in weather condition, or just the obstruction of the sun by a passing cloud, can completely transform the existing light. Stanley Sporny paints the mysterious light after a storm with lush encounters of warm and cool color. These contrasts, which reflect off puddles in the saturated earth and weigh heavy in the air, are born of a neutral light in the center of the sky. Stanley uses a luxuriant wet technique for the sidewalks of this English park traversed by passersby who ignore our spying eyes.

The light of late evening is resplendent in this harbor scene by Fred Mitchell. The orange of the sun melts into a pink band that infiltrates the powerfully contrasting cool blues and greens of the water and the rest of the sky. The distant city, the clouds, and the boats are painted gray, as if overwhelmed by the radiance of the light. Tiny defined flecks of color are built up over big wet washes for further contrasts of scale and technique. There is no doubting Fred's mastery of the medium—his brush has danced about with limitless versatility to produce this glorious depiction of light and place.

Fred Mitchell, TWO DEPARTING HARBOR, watercolor, 14″ × 20″ (35.6 cm × 50.8 cm)

Orlando Pelliccia, 1235 MAGNOLIA, watercolor, 34″ × 26″ (86.4 cm × 66.0 cm)

Orlando Pelliccia was a visiting artist here for two years, and he roamed the neighborhoods on the fringes of campus painting the architecture. He would brazenly set up shop in the neutral grounds of busy boulevards in order to paint *in situ*. This ably rendered facade was made in late evening on a winter day when nature's display was not as spectacular as we have seen in the other paintings. The distinct value of the light sustains the repressed drama. Orlando is a meticulous draftsman who paints with unrelenting efficiency and clarity. Here the subdued colors of the houses and environment almost seem to be cut out and pasted on the white light of the chilly evening sky.

213

DAY 14
Water

Early in the morning, I walk down to the small pond behind my house. A large-mouthed bass is spawning in the shallow water near the bank. The usual morning winds have not been aroused yet and the water's surface is tranquil, perfect for viewing its submerged inhabitants. Looking beyond the mirror image of the sky reflected in the pond, I spy the fish hovering over a dark circular depression, her nest. The soft edges and indistinct surfaces of their forms are comforting to observe. Something alarms her—perhaps it is my presence—and she turns and darts, her swirling dorsal fin breaking the surface. I can still see the fish, but I am momentarily distracted by a rippling pattern of dark and light values on the surface that she sliced. Sparkles of light appear and vanish in the swells and valleys. The image of the sky is no longer discernible. I can still see the fish, but now she is distorted, her image transformed by the disturbances of the surface. As a breeze suddenly begins to blow, broken rows of pulsing rhythms of value and color march in endless procession across the entire pond, erasing all that is submerged. My fish-watching is ended, but I have had a thorough lesson in painting water.

Water, like drapery, appears repeatedly in various subject matter, from seascapes to rain-drenched streets to vases of flowers. It can be painted with very little thought and with any technique and color if there are enough narrative references. After all, what would we call that purple plane those children are playing in just on the edge of the sandy beach? What is that gray stuff the boat is sailing through? But water does manifest some very basic special effects that we are able to translate into watercolor. You will be dazzled by the incredible water illusions some artists are able to render. You may stumble on some stunning ones yourself, but today let's consider some simple approaches to depicting this sometimes elusive element.

Exercise: Painting Water. Make a painting of a large body of water. If you have no access to a lake, pond, or river, paint at a swimming pool or even a large fountain. The water should dominate as subject. Carefully scrutinize its surface qualities and develop

some simple method of rendering it. Note reflected images, if there are any, as well as submerged objects.

Exercise: Still Life with Water. In a second painting, find a way to use water as the commanding element in a still-life setup. Think about this one awhile, for you may arrive at a very novel solution.

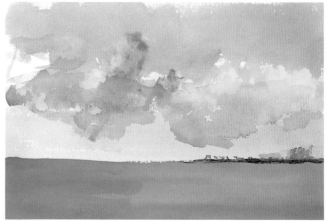

A plane of color serves as the undisturbed sea stretching into the distance. I've varied the value to indicate varying depths, but a flat wash would also have worked. The shoreline and sky provide the references to identify the plane of color as ocean.

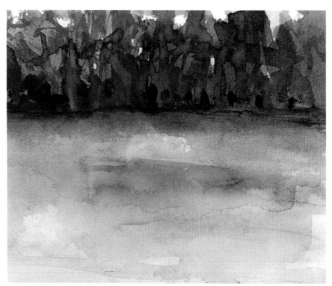

Here I made some subtle color variations, and the nuances of the wet-in-wet technique indicate activity beneath the surface. Vague murmurs of light or submerged objects are visible.

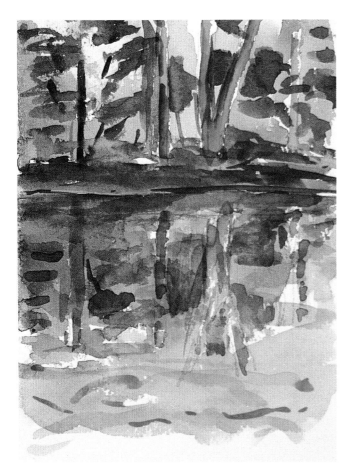

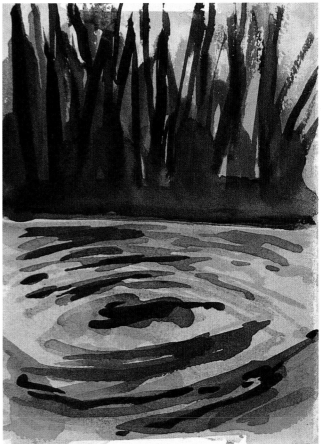

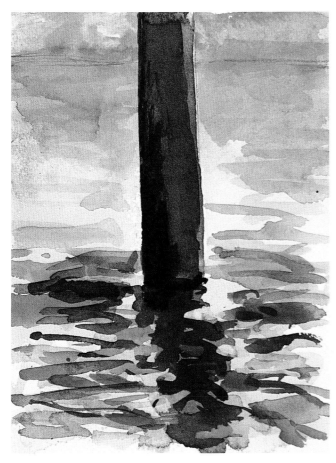

The water's surface is paramount in this little scene (above left), as it mirrors the world above. In most situations, reflections will have softer edges, less intense color, and closer values than what they reflect. On a perfectly brilliant day when the water is as still as glass, you might observe and paint an identical mirror image. However, the surface of the water in this painting is moving slightly, as indicated by the slight distortions in the reflections.

The circular strokes, built up in layers, indicate an interruption in the natural flow of the water (above right). I laid in a light green wash, let it dry, then worked methodically toward the surface with layers of value, graduating to the darkest value at the top. The lighter marks appear to be shadows beneath the surface of the water, echoing the darker agitations above.

I often use monochromatic color to depict water, but in this example (left) I used short, choppy strokes of a number of colors for the backlit reflection of the pole in this restless surface. The brighter colors and strong value contrasts refer to a more brilliant light of day. Notice also the aerial perspective produced by diminishing the color, value, and edges of the foreground strokes as the plane of water passes beyond the post and toward the horizon.

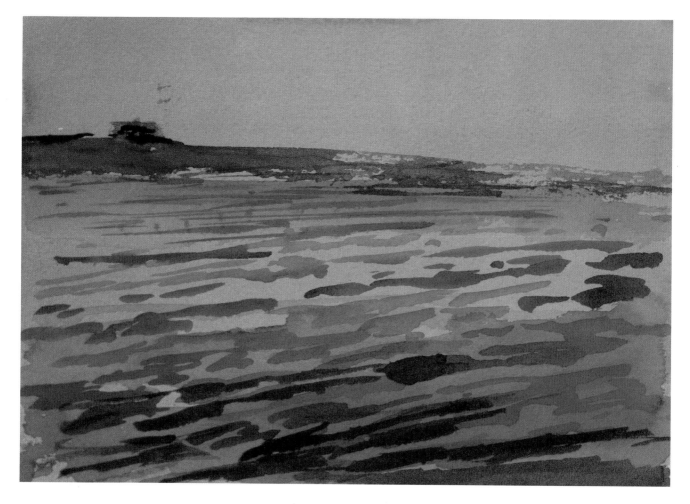

A steady wind makes a gentle chop on this bay water. It was painted by laying down a light blue wash, allowing it to dry, and then making the fairly regular diagonal strokes of darker values. Often, as is the case here, the water will reflect the exact color of the sky. In this painting, the sky was part of the original wash.

The problem here was to render submerged objects fairly distinctly, while at the same time depicting the surface. I accomplished this by first painting the fish and the green of the water onto wet paper, keeping their edges very soft but marking strong darks to keep their forms visible. After letting it dry, I took a brush with some darker green pigment and drybrushed it over the entire surface in horizontal stripes. I then applied some milky shapes of dilute opaque white before painting the sparkling highlights with full-strength white.

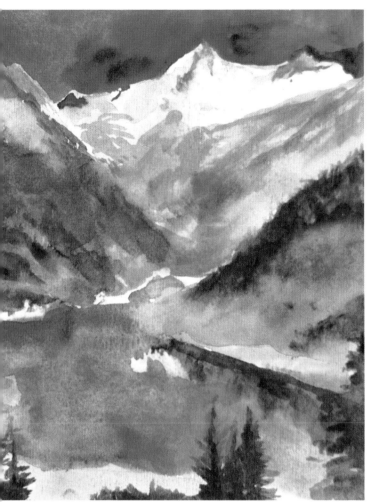

Alice Verberne, student work, 9″ × 7″ (22.9 cm × 17.8 cm)

Alice Verberne paints a body of water trapped high in the Alps. She renders the water with the same soft, wet strokes that dominate the rest of the painting. The reflections of the blue of the sky and the diagonal image of the green trees near the left shore add to its watery appearance. The jagged whites of the snowy peaks are also found in a solitary reflection on the surface. The frilly evergreens popping up off the page at the bottom make a very effective framing device for the heavy atmospheric forms beyond.

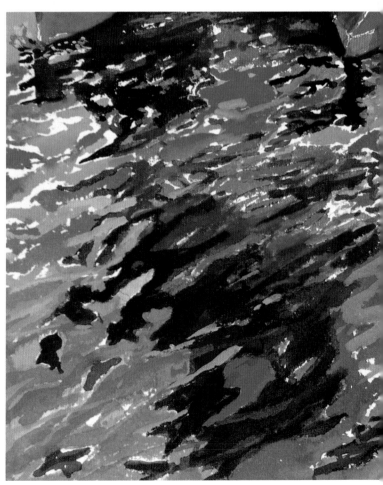

Libby Johnson Crespo, CATYAK REFLECTIONS, watercolor, 7″ × 6″ (17.8 cm × 15.2 cm)

My wife, Libby, lost herself in the sizzling reflections of an approaching catamaran, whose twin hulls enter the picture at the top. The fractured image was caused by a steady wind across the water's surface. With a discerning eye and a direct, robust technique, Libby captured the raucous abstraction of harsh color and value. She used three values of blue and the glistening white of the paper to lay down the primary field of reflected sky, then punctuated it with two values of red and one of black.

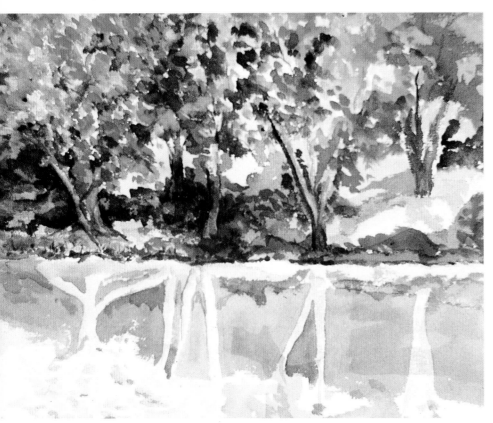

Leslie Wagner, student work, 13½" × 16" (34.3 cm × 40.6 cm)

Leslie Wagner makes a strong distinction between forms and reflections in this lakeside painting. It's obvious that she delighted more in rendering the landscape above the water than in painting its reflection. Her flurry of facile dabs and strokes defines a wonderful scene ablaze with color and definition. I expect satyrs and nymphs to appear in the cool shadows beneath the trees. The image in the water is an enormously diluted version of the shore; the likeness is not completely lost, however, for the tree trunk reflections are strongly defined as white counterparts of the dark trunks above. The drift of red in the foreground also helps to draw it all together. The water is not weak in its understatement; in fact, it is a bold contrast.

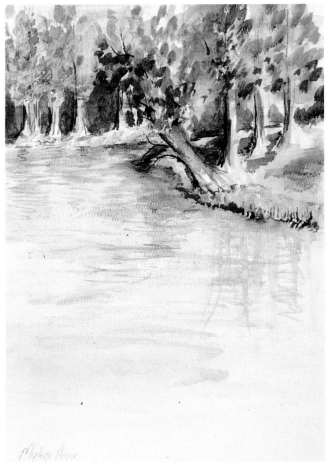

Mylene Amar uses subtle color and brushwork in the large foreground plane of water in her painting. She achieves a reflective surface with a combination of broad, soft washes and some very nervous linear calligraphy. These marks do not reflect any of the forms on the bank but shatter the plane of water, producing the effect of reflected light on its surface. Mylene has also reversed aerial perspective, moving from an almost imperceptible foreground to a focus in the deep space.

Mylene Amar, student work, 14" × 9½" (35.6 cm × 24.1 cm)

Scot Guidry made water a force in his still life by immersing a cup, saucer, and spoon in a bathtub full of water. The resulting painting is a humorous and provocative exaggeration of the assignment. The curious linear treatment of the objects was achieved by sketching with watercolor pencils, which bled somewhat as he developed the fuzzy surroundings. The lilting blues and greens were painted into paper so wet there were puddles standing on it. The yellow and faint red traces of the watercolor pencils electrify the subject of this outrageous submersion.

Scot Guidry, student work, 11" × 15" (27.9 cm × 38.1 cm)

Joel West introduced water into a still life by pouring water into objects that he likes to paint and positioning each so that it displayed its aqueous contents. The water in the large dish is almost imperceptible except where the spoon breaks the surface; this discontinuity is marked by irregularities and added color. His rendering of the water in the warm-hued goblet is similar to his handling of the goblet itself; the point here is that the water's surface can at times resemble that of highly polished metal. Small unidentified objects are submerged in the water of the blue glass vase, reflected and refracted in such a way that they fill the form with abstract patterns.

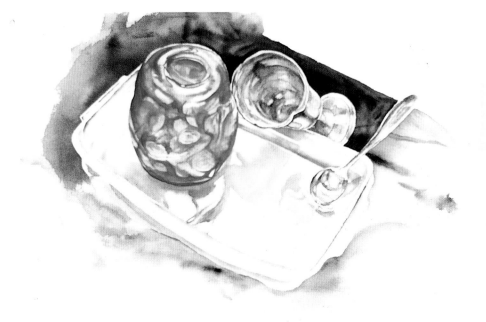

Joel West, student work, 14" × 20" (35.6 cm × 50.8 cm)

DAY 15
Processes of Abstraction

Abstraction is the alteration, distortion, or simplification of subject matter. Unlike nonobjectivity, it is the result of observing or experiencing our environment. As painters, we all use some degree of abstraction. We distort the three-dimensional world when we translate it onto a two-dimensional piece of paper. We remove the entire dimension of depth and then restore it in a multitude of illusions. I maintain that *all* painting is abstract; however, the term "abstract painting" refers to a composition in which the painter is more concerned with manipulating the formal elements (color, value, line, shape, and texture) than with realistically rendering the subject matter. The painter observes ordinary objects in space and depicts them in new and exaggerated ways on paper. Recognizable objects are either veiled or completely transformed. You did this when you painted a still life from multiple viewpoints. Today, you will try three more processes that result in abstract paintings, but instead of painting abstractly from a real subject, you will paint descriptively from abstract subjects: one you will find, another you will arrange, and a third you will construct.

Exercise: Cropped Composition. For the first painting, make one of those little compositional peepholes everyone used in basic drawing class. It's just a little one-inch rectangle cut in a piece of mat board or heavy paper. You look through it to isolate compositions from their surroundings. Use yours to find a composition that is absolutely unrecognizable and abstract. For example, right now I have a portion of the rough oak grain in the top of my desk sighted in mine. I could paint this tiny composition quite realistically on a large piece of paper and have a

dazzling abstract painting. Once you have isolated an image you like, go ahead and paint it. It's not necessary to handle the paint in a hard, realistic way. Paint as you would from any subject, and feel free to let go and push things a bit.

Exercise: Obscured Still Life. For the second painting, I would like you to assemble a still life, arranging the objects in such a manner that any reference to what they are is destroyed. This can be achieved by stacking them so they hide key parts of one another or by masking out areas of the setup with fragments of paper or strips of fabric. A little creative lighting can also conceal identities. One of my favorite solutions is to shroud a still life in heavy clear plastic wrap like that used on greenhouses. When this is brightly lit, some very bizarre effects are produced. Play around until you successfully destroy the original setup and then paint what you see.

Exercise: Constructing the Subject. The final setup involves you actually constructing an abstract sculpture of sorts. With a tube of super-glue, or one of those hot glue guns, and a wide array of junk, you can put together an interesting construction. Or you can make a nice little arrangement of geometric shapes by scoring, bending, and taping together scraps of mat board. Consider applying paint to your construction. The field here is wide open; the possibilities are endless. Have fun composing in three dimensions. Don't get frustrated. It doesn't have to be high art; it's only subject matter. When you're done, make a painting of it. I advise some preliminary sketches to find out a little about it two-dimensionally and to investigate placement on the page.

Dierdre Broussard, student work, 11″ × 14″ (27.9 cm × 35.6 cm)

Dierdre Broussard cropped this flickering moment out of a landscape element. It's a little like looking through crystal beads. I never ask exactly what the subject was in this first assignment; too often the class winds up discussing whether or not a painting really looks like pine bark. Remember, the problem is to transcend the subject matter by lifting it out of context.

Dierdre has created an enormous buildup of translucent colors with a staggering display of marks. A vague horizontal passage is overwhelmed by a host of vertical droplets that resemble rain running down a windowpane. The grays and low-intensity colors predominate, which makes the cobalt blue focus even stronger. It is seconded by the red splotch at the upper right.

Christy Brandenburg, student work, 10″ × 14″ (25.4 cm × 35.6 cm)

In another version of the first exercise Christy Brandenburg puts the primary colors to work in gentle movements of very directional strokes. The leggy marks seem to stretch out in different directions, like plants finding the sun. Yellow dominates, red plays second fiddle, and intertwined wisps of blue and violet are the key focuses by virtue of their sparseness. The color is well tuned. There is no doubt that light dwells here.

Donna Britt, student work, 4½″ × 6½″ (11.4 cm × 16.5 cm)

Donna Britt got this little-piece-of-the-world abstraction from a small portion of filigree on a decorative picture frame. The spontaneous gestures look more like the nova of a blue planet. It's really a very pure and simple painting, with paint transparency providing the luxurious color.

221

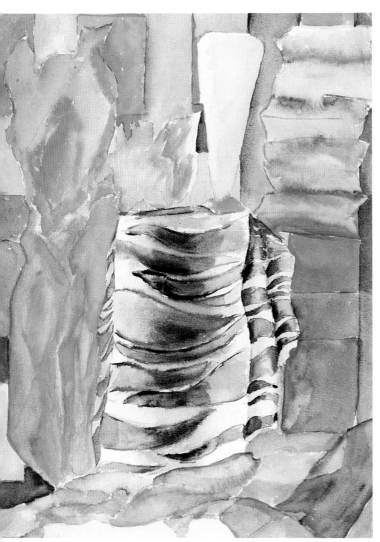

Lisa Schober, student work, 17½″ × 24″ (44.5 cm × 61.0 cm)

Lisa Schober constructs a still life that completely loses its identity in this response to the second assignment. A sharply lit gray and white central form, wrapped somewhat like a mummy, is flanked by a wide array of colors applied wet-in-wet. The sharp definition and strong value contrasts of the central form distinguish it from its more nebulous, lower-contrast surroundings. The flaming red and orange apparition on the left and the yellow cone on top also claim the spotlight in this mass of amorphous shapes in a geometric space.

Joel West, student work, 14½″ × 10″ (36.8 cm × 25.4 cm)

Joel West worked from the same wrapped still life as Joe Holmes (opposite), but he sought out smaller, more abrupt passages. Instead of a large mass on a ground, he has found a field of frolicsome shapes defying any significant organization. His broad range of color is all displayed on the white of the paper, which gives structure to his freedom. His brush must have been burning after all the paces he put it through.

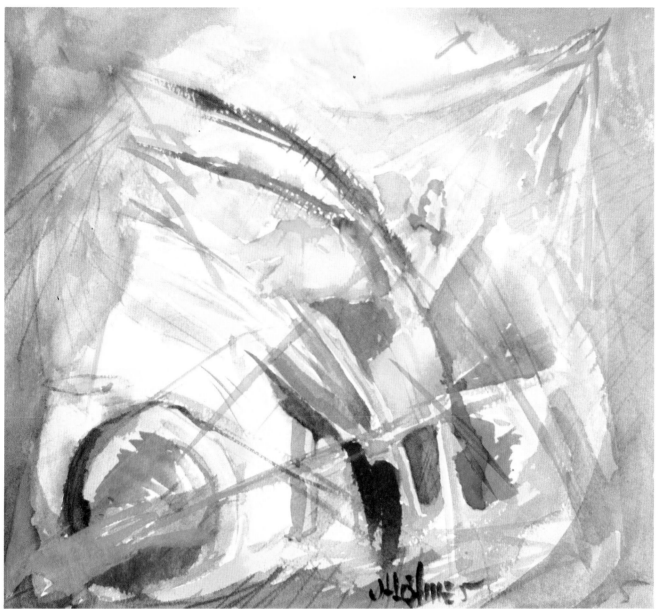

Joe Holmes, student work, 13″ × 14″ (33.0 cm × 35.6 cm)

Joe Holmes has painted a still life wrapped in clear plastic with the light source inside the transparent film. The outcome is this web of warmth engulfed in a field of a more reluctant blue. Obscured by the plastic, the once recognizable still life is reduced to a melee of vicious slashes. The thinnest lines result from scoring the paper with a blade prior to painting. Hard and soft edges mix with warm and cool colors and light and dark values, and to tame it all there is one small red shape in a tiny puddle of green just above and to the right of the center.

Charles Brown, student work, 22″ × 30″ (55.9 cm × 76.2 cm)

Charles Brown constructed a simple sculpture of two cones attached to a board to serve as his model for the third painting in today's assignment. He organized the color into two sets of complements: The cones compete with each other, blue against orange, while the yellow background confronts a violet ground plane. This simple, logical structure is undercut and enlivened by the tumultuous handling of the paint. Charles used resists coupled with complicated mazes of daggerlike brushstrokes. And although each form expresses a single dominant color, each major hue is made up of a number of other colors.

I can't help but feel a certain sense of mystery brought on by the banal simplicity of the two geometric turrets and the energy they seem to be stirring up on the table plane.

This painting is one of a series I made painting directly from three-dimensional mat board mock-ups. They were left unpainted, and I used various lighting tactics to produce different visuals. This painting suggests a much flatter space that actually existed in the more elaborate sculptural construction. At the time, I was working with distemper, which consists of powdered pigments ground into rabbit-skin glue. I kept the glue pliable on a hot plate and mixed in the pigments as I needed them. This paint produces a very chalky, matte surface, but it can be remarkably transparent, as can be seen in the central colors. The background Prussian blue is more opaque. Traditionally, the medium is used to produce very flat, even colors, as in my central pink triangle; I scraped back through the layers with a palette knife to produce the surface irregularities because I needed a compositional dispute to further the metaphor suggested in my title.

Michael Crespo, STORM WARNING, distemper, 20″ × 18″ (50.8 cm × 45.7 cm)

224

Patricia Burke, student work, 22″ × 30″ (55.9 cm × 76.2 cm)

Patricia Burke fabricated her setup with folded paper and pieces of painted wood. Mists of pale colors surround the accordion-shaped backdrop, which is alive with variations on the primary colors fused together with an impressive wet-in-wet technique. The gnarled surfaces of the wood in the foreground are subjected to an amplified scrutiny that transforms the commonplace into the unreal. Space is marked with diagonals that speed the eye through this energized galaxy.

DAY 16
Chiaroscuro

There are some light situations that exist only in painting: They may be influenced by nature, but they are inevitably resolved in the domain of paint on a flat surface. Such is the system of chiaroscuro, from the Italian words *chiaro*, meaning light, and *oscuro*, dark; it is also known as Tenebrism, from the Latin *tenebrae*, or darkness.

Most of us have seen and painted another extreme light/dark situation: backlighting, in which objects appear dark because they are located between the viewer and the source of light, literally lit from the back. Tenebrism is the reverse of this. Objects are strongly lit from the front. Imagine your eyes not only seeing but also illuminating what is observed with a ray of light that falls only on objects. The rest of the space absorbs the light and remains dark. This is the aspect that rarely occurs in nature.

Some of the great practitioners of Tenebrism were Michelangelo Caravaggio (1573–1610), Georges de La Tour (1593–1652), and Francisco de Zurbarán (1598–1664). It would be worth your effort to research their work, especially the still-life paintings of Zur-barán; his exquisitely rendered objects emerge crisply glowing from their dark surroundings, good models for our work today.

Exercise: Chiaroscuro. For your venture, select three objects. They should differ in some respects: size, shape, texture, material, color. Arrange them in a row on a black or very dark drapery that continues up the wall behind them. Strongly light the setup from the foreground and proceed to paint. The background material will probably reflect some light. Disregard it and paint the background black. Remember that this can be either black pigment itself or one of the dark mixtures such as alizarin crimson and phthalo green, or burnt umber and phthalo blue. Another possibility would be to lay down separate layers of color until a satisfactory dark is achieved. You may also keep the ground plane a little lighter than the background to provide a visual resting place for the objects. Regardless of your approach, the resulting painting should be one of brightly lit forms resting in a pool of darkness. Extreme light, extreme dark. Chiaroscuro.

This is the system, the exact opposite of chiaroscuro, that many of you are already familiar with. This cup is backlit; it is located between the painter and the light source. A shadow is cast forward by the light that emanates from the white background.

The same cup is depicted with chiaroscuro lighting. It is lit from the front and appears to be enveloped by the contrasting background.

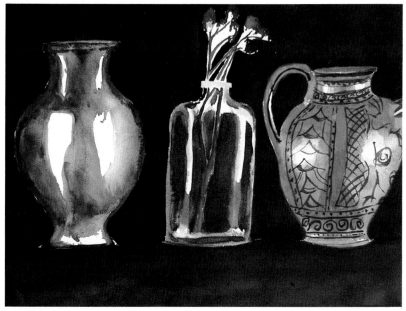

Salim Hassan used paper-white shapes very effectively in his terse solution. He has rendered a wonderful harsh light on the objects, literally making them shine against the background of layered black pigment. He has not indicated a ground plane, but he did draw a bit of the overlapping drapery on the bottom of the objects. This creates a slight distortion but also gives us a reassuring indication of the ground plane. The blatant positioning of the cool glass vase between the two warm pitchers causes the objects to interact. Salim had to use his imagination to make this structural detail work, as the decorative pitcher was white. I always endorse this kind of fudging.

Mohd. Salim Hassan, student work, 11″ × 14″ (27.9 cm × 35.6 cm)

Alice Dommert kept her objects small in order to magnify the surrounding black space. Wet sienna and blue mingle to shape the mottled form of the pitcher on the left. The center bottle echoes the monochromatic gray of the foreground. The pitcher at right is simply blue drawing on white paper; the linear pattern describes the volume. The effect of light bathing objects in darkness is not the only compositional attitude here; the visible horizon line runs across the space as a slight diagonal, making us look sideways at the objects. The downward flow of the ground plane wash gives the poetic impression that the background is melting downward; this top-to-bottom movement plays directly against the diagonal horizon.

Alice Dommert, student work, 11″ × 15″ (27.9 cm × 38.1 cm)

Sabrina Lauga, student work, 8″ × 12″ (20.3 cm × 30.5 cm)

Sabrina Lauga softens the space in her painting by overlaying blues, browns, and grays to yield a shadowy darkness. Her expressive hand allows the objects to sit with a casual air, the strokes of the surrounding space settling them in. Note how she's used a transparent overlapped edge on the orange vase to relate it to the environment. That same muted orange, as well as the complementary blue, lurks beneath the surrounding blackness.

DAY 16: Chiaroscuro

Bryan Murphy has used chiaroscuro and asymmetrical placement to create drama in this study of a woman. Her position at the extreme left allows the stark whites of her form to be located in the center for a very emphatic focus. The value transitions are a series of gradations moving from the edges of the white highlights across the figure and on into the veiled violet shadows. Dull reds and blues add a hint of color while sustaining the darkness of the surroundings.

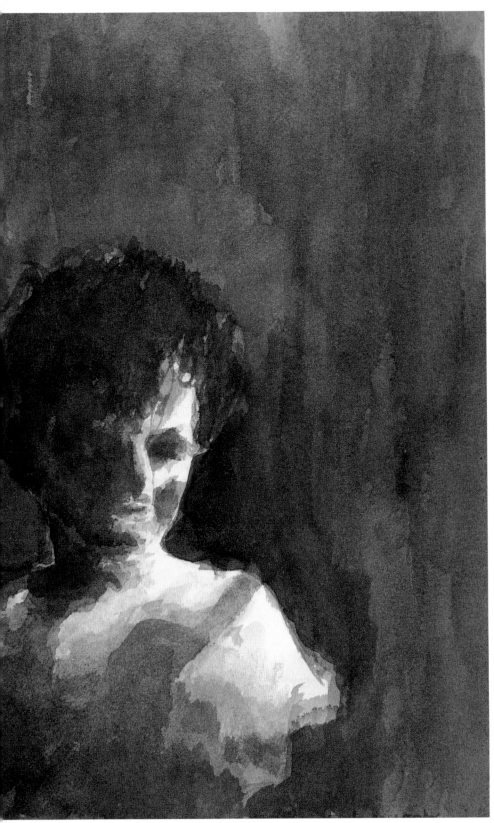

Bryan Murphy, student work, 18" × 10" (45.7 cm × 25.4 cm)

The body of a stunning nude figure descends into dark swirling depths in this painting by Samuel Corso. He overpainted the figure with varying transparencies of the inky stain, leaving the head and shoulders to glow in strong contrasting light. The sharply drawn planes of her anatomy sing out against the murky, ambiguous water. The alternating light and dark under the surface of the water define an arabesque current formed by sweeping gestures of the artist's brush. Color also seems to rise out of the dark ink, gradually unfolding in the full light as a subtle resonance of warmth and coolness.

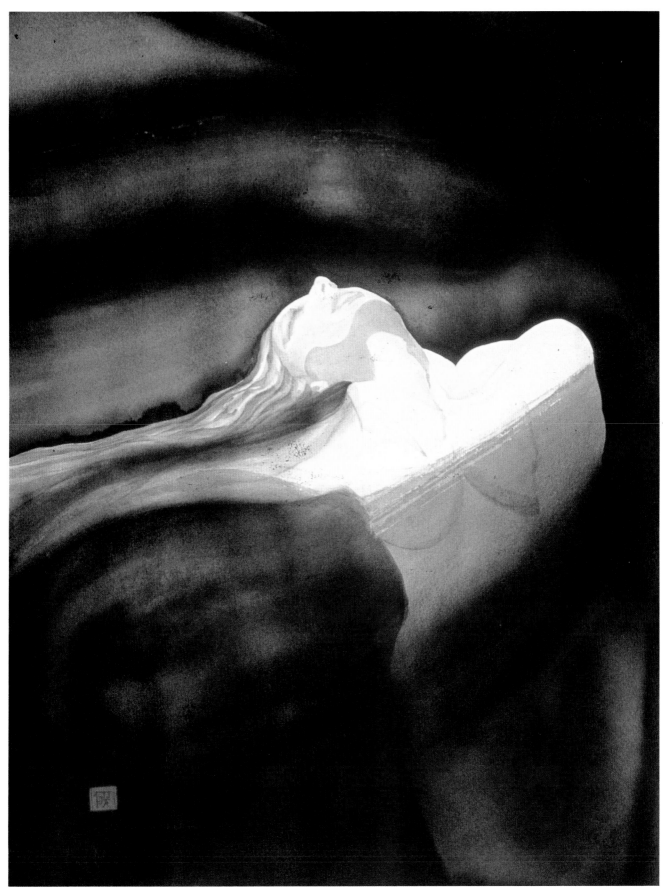

Samuel Corso, FLOATING FIGURE: LAY QUIETLY ON MY BED OF ROSES, sumi and watercolor, 40″ × 30″ (101.6 cm × 76.2 cm)

DAY 16: Chiaroscuro

Jim Wilson, SELF-PORTRAIT, gouache, 13½″ × 17″ (34.3 cm × 43.2 cm)

Jim Wilson's self-portrait materializes smack in the center of complete blackness and rampant light; he seems to be either emerging into the white or slipping into the black. It's a powerful design, vigorously executed in sure flourishes of pure white and stinging color. The contrasts of chiaroscuro are definite. Jim's Hawaiian print shirt explodes into the space, scattering debris across the entire surface, but it does not diminish the astonishing black shape that discloses his smiling countenance and spews spots of darkness into the light side.

Michael Crespo, AN ANGEL'S WING ADRIFT, watercolor on handmade paper, 21″ × 29″ (53.3 cm × 73.7 cm)

This sheet of paper was made for me by a printmaker, Debi Bennett. I usually investigate the wing motif in oil paintings with heavy impasto textures. Debi's paper has a rich three-dimensional surface and is further textured with occasional shreds of silk. Its irregular absorption of paint allowed me to suggest that the chiaroscuro lighting is of a more celestial origin—the torn wing forever suspended in the dark void of space.

In this mixed-media painting, we find the activity of light gently revealed in a room constructed from dark, cool planes. There is a brief recognition of a grand piano, a favorite subject of Edward Pramuk. He began this painting with watercolor washes. As it progressed he switched to acrylic colors, which give him the option to go opaque with a much different surface effect than that of gouache. Acrylic washes have a slightly varnished look that contrasts subtly with the original watercolor.

A network of shapes lives in the darkness, perhaps lit by the moon or a glimmer from the stronger light entering at the right. The illumination divulges only enough to evoke a mystery.

Edward Pramuk, NIGHT MUSIC, watercolor and acrylic, 16″ × 10″ (40.6 cm × 25.4 cm)

DAY 17
Give and Take

"In the old days pictures went forward toward completion by stages. Every day brought something new. A picture used to be a sum of additions. In my case a picture is a sum of destructions. I do a picture—then I destroy it. In the end though, nothing is lost. . . . But there is one very odd thing—to notice that basically a picture doesn't change, that the first 'vision' remains almost intact, in spite of appearances."

Pablo Picasso

The master's remarks impressed me deeply, providing an alternative that affected not only my painting process, but also my preliminary planning as to how to approach a particular painting. I consider two points of departure for each work. One approach is to contemplate and sketch my subject for a time and then attempt to paint it as quickly and efficiently as I can—*alla prima*, all at once. The other way, inspired by Picasso's statement, is to draw the subject directly on my watercolor paper as a very generalized sketch. Then I layer enormous amounts of painted information onto the paper, some of it describing the subject, most of it sheer indulgence in technique. At some point, when I feel that I have sufficiently overworked the painting and there is a generous amount of color and surface variation, I begin my search for the original subject, using a "lifting out" process, digging through the layers of paint, simplifying the complex, destroying much of what I have done, exploiting the residue.

No matter which procedure I choose, I give myself options. If I attempt spontaneity and fail, I revert to the second method. Conversely, if during my application of colors and marks I discover a painting before I begin lifting out, I stop and let it be.

Obviously I want you to embrace the second process, for it goes beyond overworking and lets you release all of your pent-up energies brushing, slinging, and splashing around loads of color. Of course, at some point you have to be responsible and find a painting in all of this.

Exercise: Subtractive Painting. Since you'll wind up doing a lot of scrubbing, it's important that you select a paper that will withstand some abuse. If you've been experimenting with papers all along, you'll probably have an idea of which to use. As I mentioned early on, the best I've found for such work is the Saunders Waterford Series 140 lb. cold pressed. If possible, use a full sheet for this painting, especially if you have not attempted a large painting yet. Your subject should be a single form. It may be an object or figure in space, or perhaps a landscape that you've reduced to a single mass of trees. Or you may draw on your inner resources for subject matter—a fantasy image or a geometric figure. A simple shape in a field will suffice. Once you have decided on something, sketch it out on your sheet of paper and start painting. Begin by loosely blocking in your subject and surrounding space. Vary your marks, color, and value. Paint some lines, build some texture. Once the image starts to develop, you might want to ignore it for a while and act on the paper as a whole. Paint a sequence of various washes, especially irregular ones. Pick up the corners of the paper and flow the paint in different directions. Put the painting on the floor and drip paint from on high. Squirt the surface with water. Try things you've never done before. Review all the ways of applying paint to paper and choose some that seem right. Let the paper dry completely between these applications. If it remains wet throughout, you may get mud. You want *layers* of all that you do. Also include some layers of traditional brushwork. Exploit rhythms and motions. Return to your subject occasionally, drawing it back up to the surface.

When you're exhausted, or you feel that the painting may be on the verge of self-destruction, it's time to reverse your process. But before you begin to lift out, choose one very opaque color such as cadmium red, yellow, or orange; Indian red; cerulean blue; yellow ochre; or any commercially prepared gouache color. Your choice should be one that you feel is

appropriate to your subject. It may well end up dominating the picture. Mix a thick puddle of the opaque color, paint it over the entire surface of your painting, and let it dry.

Now you are ready to paint by destruction. Have plenty of clean water, tissues, and paper towels on hand. You'll also need an appropriate scrubbing brush. I use one of those stiff nylon bristle brushes designated for acrylics. Begin by wetting the area of your primary shape with clean water. Scrub into the surface, constantly sponging up the layers with dry paper towels or tissues. Develop your subject in this manner until it begins to emerge in light. Your lifting out will bring out the light values. Vary the number of layers you lift out as you move around the painting developing form and space. You may want to add some detail as you work, swinging back and forth, adding and subtracting. You will discover some remarkably beautiful and seemingly impossible effects as you sort back through the layers of your recent efforts. As always, be conscious of what you're doing, and when it feels right, stop.

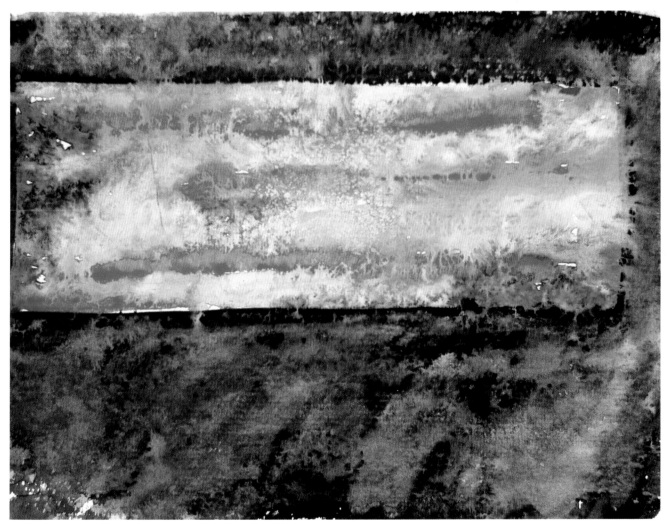

Shannon Cook, student work, 9″ × 12″ (22.9 cm × 30.5 cm)

Shannon Cook embellishes a wide rectangle with intense, splattered color in a field of warm gray. Both areas were the result of layers of wet-in-wet painting, the paper carefully soaked again after each layer dried. Her lifting-out process involved subtly modeling the rich texture into a more gentle presence. The push and pull of focus and blur inside the rectangle maintain the tension of trapped energy.

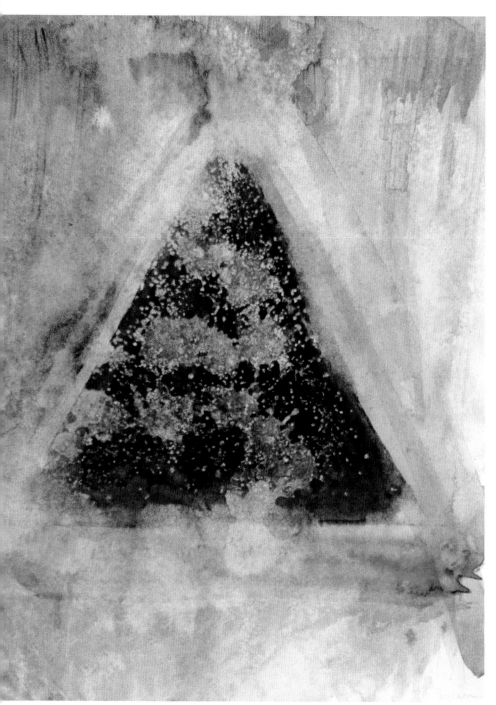

Mohd. Salim Hassan, student work, 12" × 17" (30.5 cm × 43.2 cm)

This fish (opposite), as a symbol of the soul, was not intended to swim in normal waters, and I wanted its image to be somewhere between a fish and a shimmer. The process I have described suited the ethereal nature of the subject. It would be impossible for me to remember every way that I abused this piece of paper. I began by splattering grays over the surface, concentrating on the fish shape. In the ensuing layers, I splashed on broad strokes, painted a variety of washes over the entire surface, and continuously reaffirmed the shape and surfaces of the fish with painted line. After hours of such play, I brushed a strong layer of Grumbacher red over the entire surface, including the fish.

Then came the process of searching back through the layers. I lifted the most out of the fish itself, but I also removed areas of the surrounding field of red. I softened the edges of the fish's form, being careful not to remove all of the linear development that occurred during the building-up process. My final act was to paint in the eye, obviously a crucial focus and significant to the narrative. The blue shape surrounding it was originally an unintentional splatter but was salvaged as a major color focus that contrasted with the hot red.

The mystery I sought was evoked, but only through the enigmatic results of this unorthodox process.

Salim Hassan built up fragile washes of grays over the entire surface (left), developing the triangle at the same time with outlines of primary color. Before he began his process of destruction, he dumped coarse salt into the wet paint of the dark triangle, producing a burst of white specks. The rest of the painting was reduced to very faint textures of the different lift-outs he used. There are traces of vertical scrubbing at the top, and the soft impressions of tissue are evident at the bottom. What is left of the primary colors complements the scaly triangle. Salim has evoked the curiously rich look of ancient frescoes decayed by the elements and the passage of time.

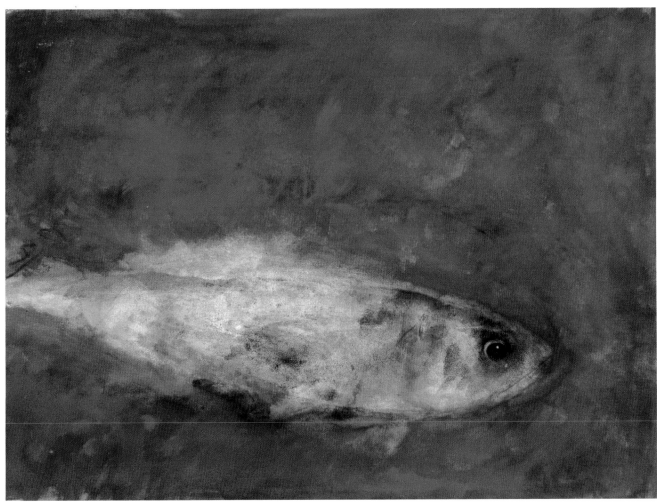

Michael Crespo, L'ANIMA, watercolor, 22″ × 30″ (55.9 cm × 76.2 cm)

In this painting, a commentary on un-necessary fish slaughter, I varied my approach to the technique. I built up the fish shape quite differently from the rest of the painting, using a variety of strokes, dips, and squiggles in a wide array of colors. The rest of the painting was covered with a series of orange and yellow horizontal washes; I kept my many passes as visible as I could. After covering everything with a thick coat of a dark green mixed from black and yellow, I began the scrubbing process, this time pulling out most of the final overlay, letting the remnants serve as a somber accent. The fish in this painting is notably less distinguished than the one in *L'Anima*. Here, it is decaying. But there is life in the eye and that suggests there is still hope.

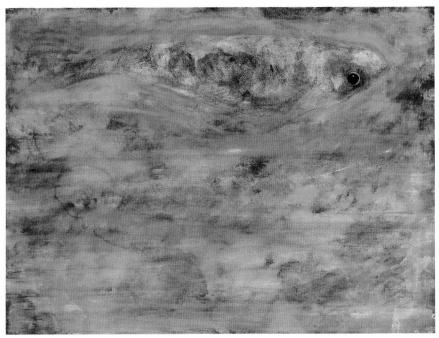

Michael Crespo, DEAD FISH, watercolor, 22″ × 30″ (55.9 cm × 76.2 cm)

DAY 17: Give and Take

Joel West went through quite a few additions and subtractions before he was satisfied with this composition. Most of the foggy space in the lower portion is the result of monoprinting: He applied wet paint to a large piece of window glass and pressed his wet paper onto it, adding color to the glass and flipping the paper over until he had something he liked. The linear activity around his rectangle theme was also introduced onto wet paper. It seemed that for every application, he took something away. The swirling marks and more regular stripes were all part of the reduction process, as was the softening of planes at the bottom and the mutilation of the linear strokes. It's a lively event built on sporadic impulses of give and take.

Joel West, student work, 22″ × 30″ (55.9 cm × 76.2 cm)

In this very determined little painting, Amy Karns reveals the simple sphere as her subject. She used a limited color scheme of red-violet and blue-violet to build her layers of texture and implied geometry, which were unearthed as she scrubbed back in. The dramatic white pedestal of light on which the ball rests was made by applying a masking solution at the onset and letting it stay until the very end. This enabled her to vigorously apply the subsequent layers without worrying about spoiling the paper white.

Amy Karns, student work, 6″ × 8½″ (15.2 cm × 21.6 cm)

Regina Tuzzolino, student work, 20" × 15" (50.8 cm × 38.1 cm)

Regina Tuzzolino used a still life as the basis for this cacophony of shapes and textures. She built up information, tore it down, and built it back up again. Deep levels of space are revealed as soft, rubbed-out areas collide with harsh, nervous ones. The logically organized color reins in the swirling action: The circular blue and white focal point is bordered by red and green, with a shower of dominant yellow raining from above. Regina used no traditional implements to apply or remove the paint: It was poured on, thrown on, rubbed on with her fingers, scratched with sticks and spoons and any debris available. Although this volatile painting may be on the threshold of vaporization, it was conceived and orchestrated in an orderly fashion.

Johanna Glenny, student work, 15" × 11" (38.1 cm × 27.9 cm)

Johanna Glenny began this well-organized abstraction with a pencil drawing and some scoring of the paper. A series of washes and other spontaneous paint handling, including a very pronounced sponge lift on the left, followed. When the delicate pastel space was formed to her satisfaction, she slashed in the brilliant red-orange right triangle. Then she went to work digging in and softening most of the right side of the painting, as well as modeling the jagged edge and the interior of the monolithic subject. The result is a feast of inspired paint handling.

DAY 18
Grids

Picture plane is a term that is frequently bandied about and just as frequently ill-defined. Many try to make more of it than it is. It is simply the surface on which we paint. We are constantly grappling with its flatness, edges, and size. We confine images within its boundaries and make allusions to space extending beyond it. At times we sustain its flatness, and at other times we invent illusions to deny it. We glue things onto it, pushing it to three dimensions. We crowd it with a multitude of forms and images, or we adorn it with just one. We alter its edges from the traditional rectangle and make geometric and amorphous configurations. We refer to these machinations as denials or assertions of the picture plane.

Today we'll address yet another way of confronting the picture plane: the grid. A grid divides a picture plane into segments or units that may or may not be sequential or even related. Grid compositions insist that we view the whole at first glance but then force us to study the structure segment by segment.

Grid compositions are wonderfully variable, offering a vast arena for your more creative thinking and painting. A grid can contain *any* subject matter, from bananas to nonobjective splashes, repeated or altered from frame to frame. Its units may be geometric or amorphous or both. They may be all of one size or varied. The units may be ruled off and separated from one another with color or white paper, or they may abut, or both. Their boundaries may be deemphasized or only implied.

Exercise: Grid Painting. I would like you to paint a grid composition, the only instruction being that you divide the picture plane into segments. Your technique may be consistent or varied. You may do whatever suits you with regard to color and value.

Johanna Glenny, student work, 10″ × 10″ (25.4 cm × 25.4 cm)

Clare Crespo, student work, 12″ × 18″ (30.5 cm × 45.7 cm)

My daughter Clare was excited about the prospect of a grid painting and produced this garish, smiling vision locked in the irregular geometric divisions. The bizarre figure was painted with watercolor pencil shadings brushed over with water. The surrounding shapes are straight watercolor. The continuous flow of the eyes and mouth through various shapes suggests the methods of stained glass, which is very definitely a grid structure. Clare has kept most of the values in the middle range, so when she darkens a few of the shapes in the background, some focuses are established that help disperse the central image.

Johanna Glenny tracks the contours of the face to organize this grid of narrative geometry. Keeping strong paper-white borders, she applied clean water to each shape and dropped in one or more colors, letting them dry as they may, producing a classic confrontation of hard edges and soft surfaces.

Fifteen identical rectangles containing fifteen compositional variations on a slab of watermelon are the components of this fluid grid of observations by my wife, Libby. As we view the grid as a whole, the all-red center unit forms a hub for the surrounding activity. There is a linear sequential movement of red wrapping around the top left, while a more staccato lineup runs across the bottom. We sense how the green moves, and the blue, and the white. We follow the seeds around or let the different values guide us. We are also led to study the individual units, assessing them on their own as fifteen different paintings.

Libby Johnson Crespo, WATERMELON GRID, watercolor, 9″ × 10″ (22.9 cm × 25.4 cm)

Joel West presents a different experience in his grid, which is derived from the landscape. He has repeated the composition twelve times in slightly irregular formats. This repetition of an identifiable subject prompts us to view the work sequentially, looking from each part to the next, expecting something to change. Nothing really does, but there are some slight variations: The last frames at the right on all three rows are compressed, and the top two rows have yellow strokes that cross over into the frames below. The obvious event is the horizontal ornament on top of the mass of rectangles, which are all joined with paint in one way or another. It's a grid of fused repetition.

Joel West, student work, 22″ × 30″ (55.9 cm × 76.2 cm)

239

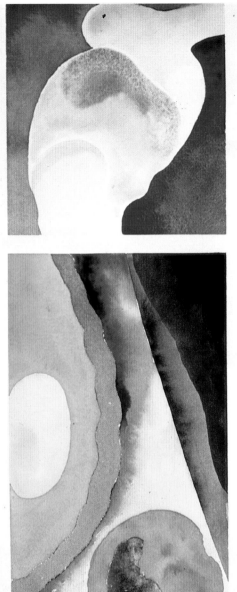

Fred Mitchell, LAUGHING ASTRONAUTS, watercolor, 18″ × 24″ (45.7 cm × 61.0 cm)

Fred Mitchell paints a grid of rectangles, each having different dimensions, and fills them with his imagined sightings as a space rider. The clean white divisions emphasize the rigid structure of the grid and enhance the diverse values and brilliant colors. Recurring oval shapes lead the eye from segment to segment, and Fred lets some of his shapes cross over boundaries. At the right, the shapes in the top rectangle spill into the composition below it. The orange shape in the middle rectangle in that column is completed in the bottom rectangle. Edges also correspond between the top center panel and the one below it. Fred makes these connections only from top to bottom, never horizontally. He also aligns the sides of the different components vertically but never allows their tops and bottoms to meet. These tactics clearly establish a vertical bias in the overall composition.

Fred Mitchell stages this grid composition in simple horizontal bands that are separated by distinct edges but united by overlapping washes. In dramatic contrast, two of the sections contain shape information, establishing focal points that break the monotony of the striped format. The primary focus is obviously the band containing the red ball of the setting sun, which bleeds into the yellow stripe above it and is flanked by two blue ovals. A secondary focus is the blue band farther down that depicts a less defined, more mysterious semicircular shape.

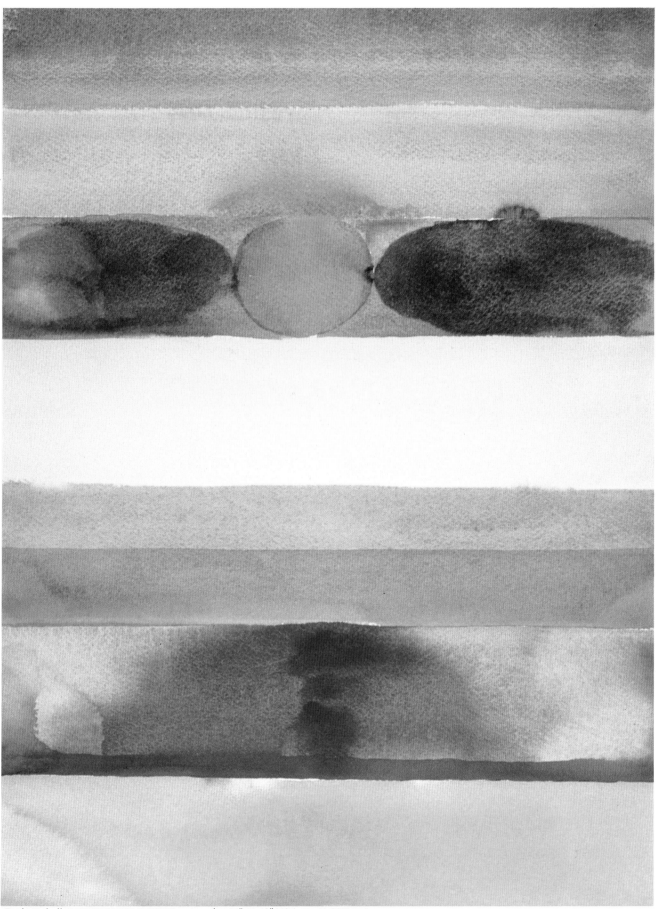

Fred Mitchell, BATTERY PARK SUNSET, watercolor, 16″ × 12″ (40.6 cm × 30.5 cm)

DAY 19
Remedies

I'm certain that you've accumulated quite a body of respectable paintings by now, some of which you actually feel quite good—maybe even ecstatic—about. But if you're like me and most other painters, you've also stowed away a cache of the ones that just didn't thrill you but were not bad enough to throw out. Perhaps you couldn't resolve them, or maybe you overworked them a bit, or you decided they might look better after a year of hiding in your portfolio (sometimes they do!). Today, pull them out and look them over. Although I can't promise a cure, there are some things you can and should try to revive them. Even if these last-ditch efforts fail, the pursuit can be enlightening and fun, and there isn't too much pressure to succeed. After all, you were probably going to toss the paintings out at some point anyway.

Lifting out. Soaking, scrubbing, and dabbing dry with a tissue can lighten a color to any degree you wish or prepare a form or area for repainting or alteration. Although some of the more potent stains may resist, you can remove enough to rework them. Lightly scrubbing with an ordinary eraser can lighten the value of a small area without wetting.

Transparent overpainting. Colors can be warmed, cooled, intensified, or grayed by simply painting transparent colors over them. Consider a transparent wash over the entire painting. I've salvaged many an ailing painting this way.

Opaque overpainting. You can make a number of changes by overpainting with the more opaque colors or with transparents to which Chinese white has been added. If you don't want the lighter values the Chinese white produces, use designer's gouache or casein. The flat, opaque areas will contrast with the transparencies, adding another dimension to the painting. Sometimes a white highlight or two will snap a painting together. Chinese white used full strength will accomplish this.

Cutting shapes from the surface. Extremely hard-edged paper-white shapes can be reclaimed in a painted area by cutting partially through the paper with an X-Acto knife or a razor blade and peeling off the surface layer. You can leave the new shapes white or apply another color; just remember that the texture will be slightly different from that of the rest of the painting.

Adding line. Drawing into a painting with pen and ink can transform it dramatically, enhancing contours and producing new textures. Lines of ink or opaque colors can also be applied with a brush.

Modifying edges. Consider changing or altering some or all of the edges of forms by overpainting or by lifting out and repainting.

Collage. More radical, but sometimes most effective, is gluing on prepainted shapes of paper or unpainted shapes that can be left white or painted after application. You're not only masking undesirable areas but also producing surface variation.

Cropping. If you can't resolve a painting, look for smaller compositions within it. Search around, using sheets of white paper to make new outer edges. Sometimes just a quarter of an inch taken from one edge can satisfactorily reposition everything.

If the painting is still failing, take it outdoors and hose it down. The water pressure will remove most of the color without disturbing the surface. You can then begin again, using the faint traces of line and color as underpainting.

Exercise: Rescuing a Painting. For today's assignment, find an old painting you consider a failure and seriously attempt its resuscitation. In fact, why not spend the entire day reviving all your old dogs? Approach these pursuits with the optimism you'd have at the start of any painting. This is another assignment, not a desperate act.

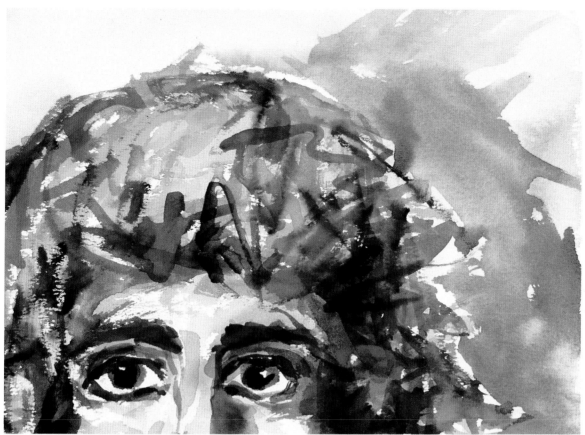

Christy Brandenburg, student work, 9″ × 12″ (22.9 cm × 30.5 cm)

This self-portrait humorously "peeking over the fence" was once a full-face composition. Christy Brandenburg was not pleased with the handling of the mouth, so she bravely sliced out that portion. There is no doubt that she found a superior, if unorthodox, composition; it is bolstered by some exceptional brush gyrations and invigorating color. There are big risks in cropping a face. Usually the form flattens out, but in Christy's painting the planes of the face are so well sculpted that they hold up well under the knife.

Michelle Lowery originally painted a still life of her small potted garden of cacti. At some point the painting died from overworking, a situation we've all experienced a few too many times. She detected an interesting light on the cacti and tried to lift out the background, but all she got was a muddled mess, so she abandoned the painting. Later, with my encouragement, she carefully cut the three cacti away from their surroundings and experimented with the cutout on some new backgrounds she had painted. She settled on this warm, skylike wash and glued the cacti down, transforming them into major desert vegetation. Because the cacti were originally painted on heavy 300 lb. paper, the three-dimensional effect of a shadow box is evident. The little arcing highlight on the cactus on the right was made by cutting away a thin layer of the paper with a knife. She added a little color to tone down the white.

Michelle Lowery, student work, 7½″ × 7″ (19.0 cm × 17.8 cm)

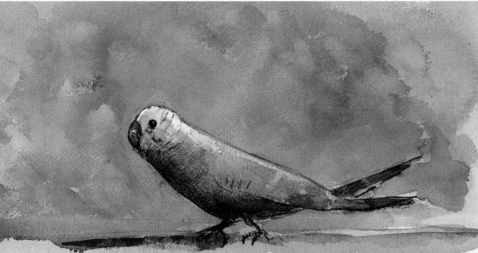

This painting of my charming little parakeet hung around in my portfolio as a nondescript pencil and light wash drawing for years. It was not very impressive, but I kept it because of its subject. One day I decided to take the risk and try to make a painting out of it. Voila! With a little glazing, Uffi was parading through a smoky yellow space in full-color plumage.

Michael Crespo, UFFI, watercolor, 6½″ × 12″ (16.5 cm × 30.5 cm)

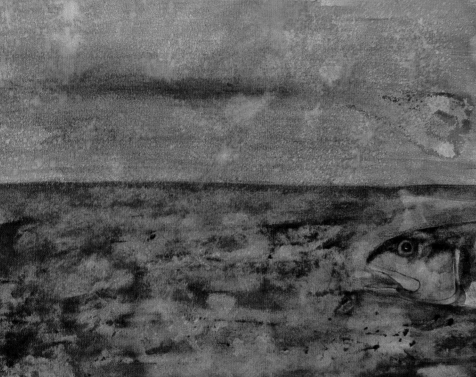

This painting underwent major revision as I transformed it from a simple fish swimming in water to a more surrealistic image that commented on environmental pollution. The original painting was not only unresolved visually but, more importantly, had not a hint of any personal statement. After some thought, I introduced the horizon line and painted the terrain that immediately set the fish in flight. I "polluted" the environment by laying down irregular washes, the last of which I sprayed with my mister to form the dense texture of water stains in the sky.

Michael Crespo, LANDSCAPE, watercolor, 22″ × 30″ (55.9 cm × 76.2 cm)

Scot Guidry's zany portrait of his cat exhibits the most farfetched compositional solution yet. He drew the cat with watercolor pencils, then gently wet the marks to form the light washes that describe its gentle volumes. I would have been satisfied with the very astute portrait, complete with cleverly detached tail, but Scot wasn't. He later convinced his friend and subject to dip his pads in some dilute colors and collaborate in the effort. The cat resolved the painting by "walking in" the decorative paw motif in the background.

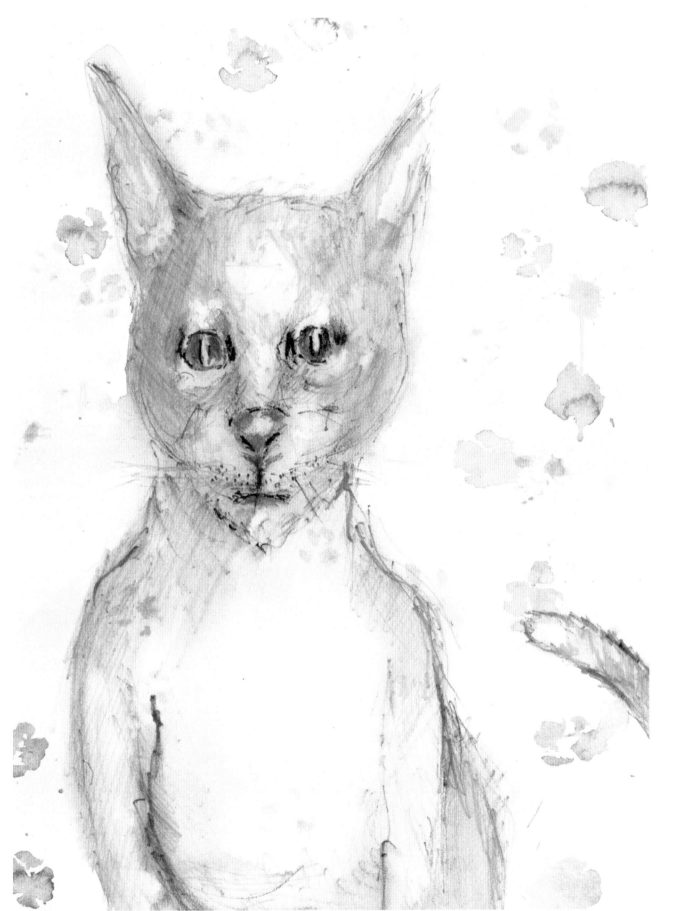

Scot Guidry, student work, 22″ × 15″ (55.9 cm × 38.1 cm)

DAY 19: Remedies

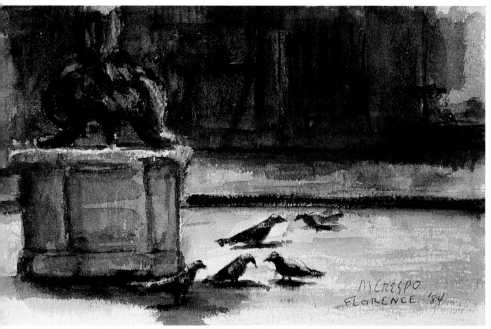

Michael Crespo, PIGEONS IN A PARK, watercolor, 7½″ × 12″ (19.0 cm × 30.5 cm)

I made the first version of this painting while sitting in a park in Florence one afternoon. I was well pleased when I finished it, but when I looked at it a few weeks later, I was less satisfied. At the time, the dark gray background was very developed, with columns and dark arched doorways. I decided that this was distracting the eye from the foreground plane, where the pigeons who were my main subject matter were. I gently scrubbed the area down with a brush and clean water, not really lifting out but melting the forms together into a subtler focus. There are a few remnants of the original. I emphasized the foreground further by scumbling some Chinese white to form the speckled highlights. My instincts proved correct; the painting took on new vigor.

Michael Crespo, ASPARAGUS, watercolor, 11″ × 15″ (27.9 cm × 38.1 cm)

I transformed the entire nature of this painting of four asparagus stalks on a purple drape. It was once a very careful, conservative rendering that was deadly boring. At first I didn't want to admit defeat because of the time I spent on the rendering. But obsession eventually got the better of me, and I set out to make it a painting I could live with. First, I scrubbed the entire drape down to the grainy texture of the paper. Then I scrubbed some of the detail out of the stalks and deleted the rest with thick, sloshing strokes of phthalo greens and cadmium yellows. I found excitement in bold animation and followed through with the strong blue shadows and some occasional flurries of my no. 3 script brush. The more blatant contrasts of light and color fell on my eyes much more comfortably.

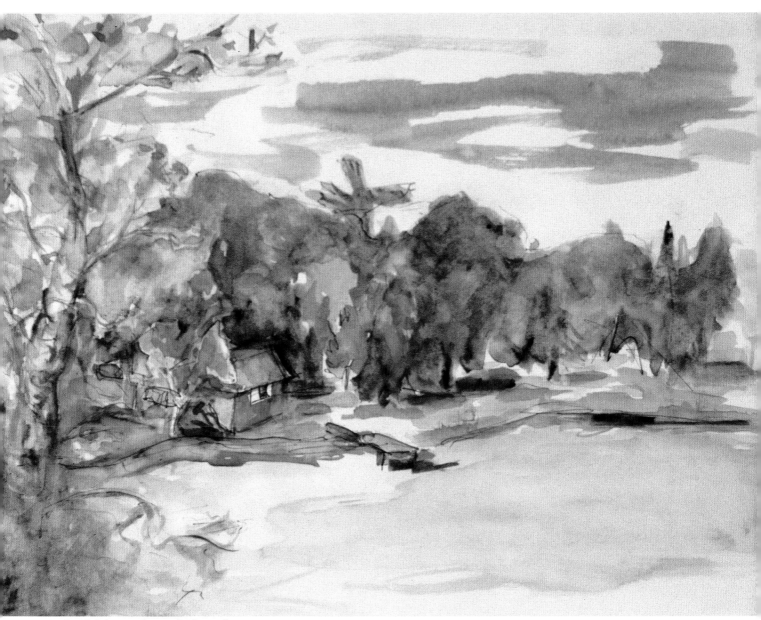

Louise McGehee, student work, 9″ × 12″ (22.9 cm × 30.5 cm)

Louise McGehee was dissatisfied with this brimming bird's-eye view of a fishing lodge when she returned to her studio from a vacation. There was no major flaw, but somehow the infusion of light throughout the painting diminished the focus of the red structure in the complementary green surroundings. Likewise, the foreground tree, in sharp focus at the bottom of the painting in the first version, was also drawing attention away from the camp, which she was determined to nudge into the role of primary subject. So she made two minor alterations that accomplished the task. First she scrubbed out the base of the offending tree, then she outlined the camp and immediate surroundings with pen and ink. Wisely, she made a few perfunctory lines elsewhere in the painting so the remedy would not appear too deliberate. As Louise demonstrated, sometimes drastic measures are not needed to reclaim a seemingly lost work.

DAY 20
Painting in Series

The transition from student to independent artist is not an easy one, as I learned when I completed my formal education. I was brimming with ideas and anxious to get on with the work of painting, but the busywork of buying supplies and preparing my studio seemed to consume a lot of my time. In fact, I probably had the cleanest, best-stocked, best-organized studio of my career—but there were no paintings. Just plenty of procrastination.

The problem was that there was no longer somebody coming in daily with a project for me to work on. I would have been happy to work once again with even the most boring of my teachers, just to be told one more time what to do and how to do it. But I knew it was time for me to take that responsibility myself, to become my own motivator and guide.

Then I remembered some advice a teacher had given me years before. He said that If I ever had absolutely nothing to paint, I should slap down a couple of objects and paint a still life. So I did. And that painting became a series of still lifes that steered me ahead into the language of paint and form, ahead into the ongoing search for *my* marks and *my* voice. This series of still-life paintings was the first of many, and I learned that the life of an artist is primarily occupied with sustaining subjects and ideas through periods of time and scores of paintings, moving to the next series only when the present one is exhausted.

You've painted these past nineteen problems (thirty-nine, if you worked through my first book) very much as a student. Now I assign you one last problem that involves slipping into the transition zone and taking on the responsibilities of an artist. Decide on a subject and begin an ongoing series of paintings. Remember, if you can't think of a subject, just start with a little still life. I'm not even going to require a set number for you to make. Let each painting direct you in some way into the next. Define your own problems and expressions as you work.

In hopes of providing a little insight, I've extracted some paintings that are parts of ongoing series by students, seasoned professionals, and me.

Michael Crespo, SEARCHING, watercolor, 22″ × 30″ (55.9 cm × 76.2 cm)

I have used fish as subject matter throughout my career; my treatment of them has ranged from strict observation to symbolic fantasy, as you can see from my paintings illustrated in this book. These particular three paintings initiated a yet-unfinished subseries in which a hand and a fish interact in various ways. I invited the question of whether the hand had entered the fish's domain or vice versa—or perhaps they are both out of their element and the rendezvous is occurring in more spiritual surroundings. In this painting, the hand is drawn from and meant to be my own. Aside from that, the title discloses about as much meaning as I care to divulge.

I began with a drawing of fish and hand. Then I applied a number of irregular washes, immediately lifting out the interiors of the two subjects with tissue. The fish and hand were developed separately. The blue of the fish is the significant focus, contrasting with the warm space. I brought the hand into the dialogue by washing Indian yellow over it to bring it luminescence. In fact, it literally lights the belly of the fish; this effect was an afterthought and I achieved it by considerable scrubbing and lifting out.

A strongly delineated child's hand enters from the left, releasing a more indefinite fish, in another of my series of hands and fish. I wanted the environment of this painting to appear as if the viewer were underwater, seeing without the aid of a snorkling mask. I accomplished this by first painting the fish and the small area of debris at the bottom onto wet paper. After some drying time I wet the paper again and applied a yellow wash, dropping in the blue-gray that appears as the unfocused forms at the right, and the sienna that surrounds the hand. The hand was drawn in last, over the sprawling puddle. I drew it with dark color and a tiny brush. A little bit of lifting out gave it a gentle volume, but my intention was for it to remain a harsh, linear form to contrast with the murky, soft-edged depths.

Michael Crespo, EVERY LAST TOUCH, watercolor, 22″ × 30″ (55.9 cm × 76.2 cm)

In this third variation on a theme, I drew a boundary separating a hot, brightly illuminated world from a cool, smoky abyss. The fish metamorphoses as his heavy, dark volume moves into the light and immediately becomes linear, like the beckoning hand. I was strongly influenced by the drawing in Indian miniatures while this painting was in progress. I painted the washes on either side of the border separately, allowing them to mingle but careful not to let the indigo move too far into the yellow. I stood over them as they were drying, manipulating the flow of color by constantly adjusting the tilt of the board to which the painting was attached. Finally the waves settled into place, disclosing a painting that is far richer in symbolism than I had intended.

Michael Crespo, INTO THE LIGHT, watercolor, 22″ × 30″ (55.9 cm × 76.2 cm)

DAY 20: Painting in Series

Madeline Terrell chose the ducks that inhabit her yard as subjects for part of a lengthy series of barnyard animal paintings. This elegant bird poses in a space that consists of three distinct zones held together with a broad, operative value range. The foreground is graced not only with the duck's presence but also with intense contrasts of color temperature and value contained in short, jabbing strokes. Paper-whites confront dark shadows as the cool tones of the duck set the yellow-green grass ablaze. In the middle ground, just behind the center tree, values and colors are closer relatives, blurred together in a horizontal band of wetter technique. In the background are larger, more simplified shapes than in the foreground, but the value contrast is repeated.

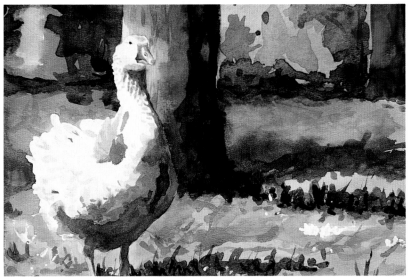

Madeline Terrell, student work, 9½" × 13½" (24.1 cm × 34.3 cm)

Madeline uses the hard, dark shapes as stepping-stones through the space of this two-duck painting. She's shoved the creatures into the middle of the space; their strutting white forms are juxtaposed with bright yellows to form the predominant focus in this painting of many focuses. Our eyes move into the space not only on the horizontal shadow planes but also along the strategically placed vertical trees that take us back beyond the hedge. There, color, value, and focus dramatically change, signaling the deep space of aerial perspective.

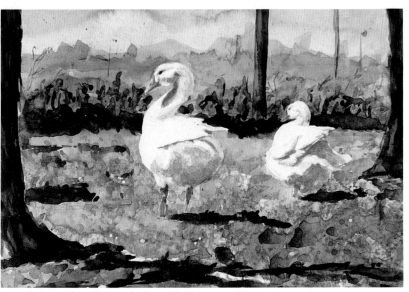

Madeline Terrell, student work, 9" × 13" (22.9 cm × 33.0 cm)

Madeline almost fills the space of this painting with the two preening ducks. She uses a subtle mixture of blue, gray, and violet to paint their backlit forms. A cool, dark foreground plane is topped with two almost black shadows that suddenly give way to a shrieking bright middle ground. The background darkens just behind the webbing of the fence, sandwiching the streak of light. The shapes are bolder and simpler in this painting. All three zones of space are alarmingly distinct, but they are bridged and interlocked by the mammoth Pekins.

Madeline Terrell, student work, 9½" × 13½" (24.1 cm × 34.3 cm)

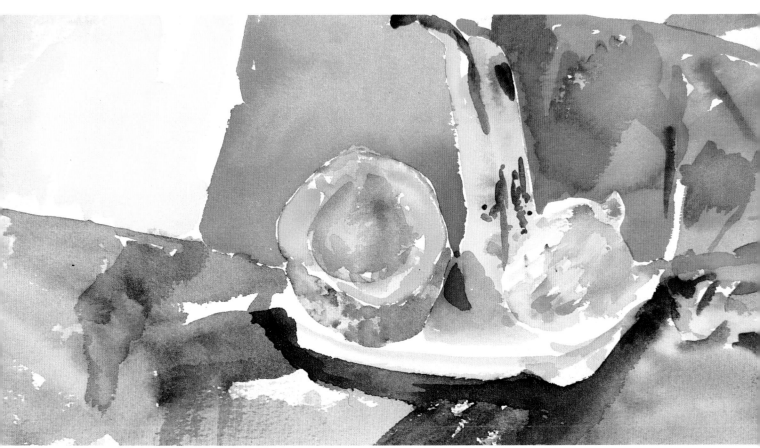

Leslie Wagner, student work, 9″ × 16″ (22.9 cm × 40.6 cm)

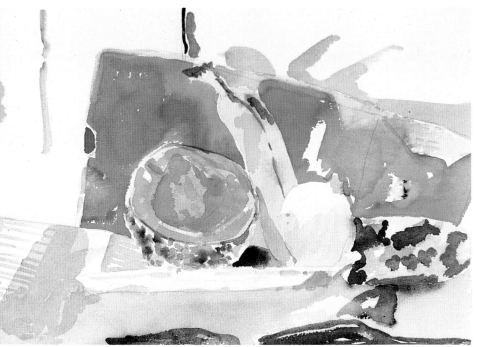

Leslie Wagner, student work, 11″ × 16″ (27.9 cm × 40.6 cm)

Here are two paintings out of a series Leslie Wagner made from a simple still life with a cantaloupe, a banana, and an onion as principals. Leslie uses exuberant sweeps of her brush to describe the objects. Notice how casually her brush scampers around this painting, depositing the yellow of the wall into the gray at bottom left and the orange of the cantaloupe into the dull red at top right. The banana reigns, sporting its dark accents and standing straight in the horizontal surroundings.

Leslie moves to the right and zooms in closer on her subject in this second painting in the series. The racing diagonal ground plane rights itself somewhat, with some textural hints on the left indicating that it is covered with newspaper. The white of the paper rules; the color is distributed simply but dramatically. The pink plays backdrop for the fiery yellow-orange of the melon, and a deeper cadmium yellow smear on the pale banana appears again as the brazen half-circle clinging to the left edge, keeping our eyes moving.

251

Walter Rutkowski, BONFIRES ON THE LEVEE, watercolor and graphite, 40" × 30" (101.6 cm × 76.2 cm)

On Christmas Eve in this area of Louisiana, huge bonfires of burning rubber tires light the night for miles along the levee of the Mississippi River. Walter Rutkowski has chosen this festive ritual as the subject of this series, which, unlike the other examples, is complete in four paintings. He even intends that they be exhibited together in sequence.

Walter insists on the hardest of edges dominating his work. These edges join with menacing shapes, jolting color, and strongly contrasting values to conjure an eerie vision of this south Louisiana rite. There are areas here and there where he employs a fuzzy, contrasting edge: in the dark shadows surrounding the white smoke, for example, and in the shadows of the clumps of weeds in the foreground. But these are the only relief from the razor-sharp contours that rule the painting. He achieves such astounding clarity by laying in transparent watercolor shapes and bordering them with a graphite pencil. Surprisingly, all of the black shapes that suggest ink or black paint are drawn with graphite pressed hard into the surface of the paper. The force of his manipulation of media and formal elements blisters the eye in this intense vision.

Walter Rutkowski, BONFIRES ON THE LEVEE, watercolor and graphite, 40" × 30" (101.6 cm × 76.2 cm)

This second painting in the series presents a fire that rises more vertically, as if the wind died momentarily. The placement of objects in the foreground has changed slightly, and the black has become more dominant, with the "eyes" of the whirling flames much more evident.

Walter Rutkowski, BONFIRES ON THE LEVEE, watercolor and graphite, 40″ × 30″ (101.6 cm × 76.2 cm)

The yellow shape of flame is now gesturing on the other side of center from the very first painting. The foreground tree form has returned to the right corner, but the arcing line retains its right-to-left direction, and once again we are at a greater distance from the fire. In this series, Walter has moved us systematically through space and time, assembling the parts into a logical experience. But I'm still not certain if there is one fire viewed four times from four viewpoints, four different fires, or some other combination. I'm more satisfied thinking there are four separate fires; I seem to move along the river at a faster clip that way.

Walter Rutkowski, BONFIRES ON THE LEVEE, watercolor and graphite, 40″ × 30″ (101.6 cm × 76.2 cm)

The point of view seems to have shifted to the other side of the foreground tree form, which was on the right in the first two paintings. The bonfire is closer, now manifesting another slightly variant structure. It is even more vertical than in the last painting, and the components of the swirls are more complex. Notice that the line that begins at bottom right and traces the curved contour of the foreground runs in the opposite direction. It's almost as if we are circling around these fires in this sequence of paintings as the river snakes along its course.

DAY 20: Painting in Series

Jim Wilson, BAR SCENE IN CHALMETTE I, gouache, 13½″ × 17″ (34.3 cm × 43.2 cm)

The bright lights and colors flow as fruits from a cornucopia in this painting from Jim Wilson's series on night life. The black line flows with steady energy, promoting itself as well as identifying the inhabitants of this bristling scene. The imposing large palm fronds on the left join with the vertical walls of the right and rear to frame and stabilize the tangled mass of musicians and customers. Jim's hand is remarkably confident and expressive, and this composition exemplifies the reaches of freedom to be attained within the artist's self-imposed structures.

Jim Wilson, BAR SCENE IN CHALMETTE II, gouache, 10″ × 14′ (25.4 cm × 35.6 cm)

Again the plant and walls envelop the space, but in this version of the same scene, the focus is shifted to a more narrative element. The white light on the man in the foreground moves us back past an eerie visage making eye contact with us to a singer belting a song into a red microphone. There is also a wonderful dialogue between the casual linear construction of the foreground space and the dense color shapes of the background. I also sense an implied "x" movement across the painting from corner to corner, intersecting at the standing man's gray head at dead center. The isolation of hot reds in the icy field is a powerful compositional ploy.

INDEX